OVERWRITE

Translated by
Nils F. Schott

Sternberg
Press

OVERWRITE

Ethics of Knowledge — Poetics of Existence

Armen Avanessian

CONTENTS

Preface to the English Translation — 8

Introduction — 19

PART I — Genealogy of Academic Morality

Critical Legitimacy: Legitimate Crisis — 29

Knowledge, Desire, Economy — 46

The Art(s) of Academic Knowledge: On the Promise of Critical Research — 54

Inventing the Good 64
Old Days: The Nostalgia
of the Contemporary
University

Universal Depression: 72
Research on the
Verge of a Nervous
Breakdown

Resistance and Minority: 78
The Outer Face of Power

Critical Aesthetics: 87
The Triumph of
an Academic Discipline

Speculative Poetics 95
and the Poeticization
of Philosophy:
Contemporary Forms
of Temporality

PART II Sites of Writing, Sites of Speaking

Contexts: Qualification and (Self-)Evaluation — 110

On the Use and Abuse of Formulas for Thinking: The Discourse of the University Gives Free Reign to Hatred — 120

Fetishism as Antidepressant: In Praise of Conflict — 130

Abductio ab nihilo: Jokes and Their Relation to the Superego — 141

Formation of the Self 150
and Speculative Poetics:
Needs, Demands, Desire

Othering of the Ego: 160
The Desire of the Other

Setting: 166
Against Local Amnesia

Two Subjects Writing: 173
You Must Know

Epilogue: 181
Poetic Existence

Preface to the
English Translation

Among my academic colleagues and friends (mostly leftists, but not all), there is hardly anyone who *doesn't* criticize the status quo of universities. In most cases, however, such critique ends up being just that, mere critique, even when supplemented by some kind of political content to one's work in research, teaching, and publications. This is a fundamental problem of critical self-reflection or self-reflexive critique. Yet the question of politicizing the university—rather than merely spurting out political content that poses no threat to the status quo of academic institutions in the context of (global) neoliberalism—seems to me to be a question that touches on a decidedly (local) ethical dimension. It concerns the problem of one's own entanglement and speaks to the general difficulty of situating oneself, of rendering transparent the position of one's own thinking and writing—something that cannot be done simply by adding an extra dose of self-reflection. Rather, a proper understanding of my situation—the place one is thinking (from)— can only occur with manipulations and transformations of my surroundings and myself: my thinking changes concurrently with my world and with me.

I first had the idea for this book during a stay as a research fellow in the German department at Yale University in 2012; at a remove, that is, from my everyday life in Berlin. And in the course of the two years during which I worked on it—other projects permitting—writing this book has given me a kind of orientation, or more precisely has helped me in fathoming alternatives to the usual academic practices. On the level of content, too, I sometimes thought I was working in a kind of inner exile, or laboring at constructing an as yet nonexistent public interested in the same questions and authors as I am. This hyperstitional practice, as it may be called, concerns, on the one hand, topics in contemporary speculative philosophy and new radical approaches to political theory that I've been involved in introducing in Germany; on the other hand, it concerns various books I've written as part of the research platform Speculative Poetics.[1]

[1] On hyperstition as a productive force in which the future changes the present or a fiction becomes a reality, see Ccru, *Writings, 1997–2003* (Time Spiral Press, 2015). Meanwhile, together with filmmaker Christopher Roth, I have dedicated an entire film to the topic: *Hyperstition: A Film on Time and Narrative* (2016, 103 min.). For more on the research platform, see http://www.spekulative-poetik.de/.

Another element is the obviously privileged position I was able to assume in surveying contemporary philosophy and theory from the perspective of what is commonly referred to as elite institutions and their (more or less self-professed) excellence. But here, too, is an "on the other hand," which we might call a double dislocation: first, my work draws increasing attention outside of Germany and German academia; second, the academic appointment I then held at the Freie Universität in Berlin had focused on topics that are also of interest to an extra-academic and "artsy" public (with immediate backlash from the academic establishment). Such a dislocation, of course, makes situating oneself more difficult, yet also makes it seem all the more necessary.

Accordingly, this book, first published in German in 2015, has its starting point in Berlin's unique amalgamation of art world and academic thought, of lifestyle and political (theory) trends; in short, in an expanded academia that is a phenomenon not exclusive to Berlin, but that is particularly obvious there. What we witness in Berlin is the completion of a historical development; namely, the triumph of the comprehensive aestheticization of thinking that begins with the invention of aesthetics as a discipline as well as the founding of the Universität zu Berlin in the early nineteenth century by Wilhelm von Humboldt and his contemporaries.

Today, the most interconnected and highly concentrated centers of international academic power—to take up Jacques Rancière's expression, our entire aesthetic regime of thinking (not just about art)—are characterized by an attitude of critical thinking and (self-)reflection, of original research, and of the academic institution's promise of unfettered education, training, and personal growth, which was the hallmark of the Prussian research university before it spread to other countries. On the historical development of the university and the triumph of the German model in the nineteenth century, the historian William Clark writes:

> The modern research university grew from the faculties of German Protestant professors. The North American system, for example, had been based on the model of the Oxbridge colleges. It began grafting the German professorial university onto itself in the second half of the nineteenth century. At American universities, the undergraduate

college remained essentially a descendant of the Oxbridge college, while the graduate schools emerged as a superstructure of German faculties or departments that were added on to the undergraduate college. After the 1870s, the new graduate schools cultivated research, while the college had a traditional pedagogical mission. Confronted with the German research university, Oxbridge itself began to change then, too; and, in the 1890s, so did the French.[2]

We are thus confronted with a paradoxical situation and a confusion that in Germany, and in Europe generally, often comes with an anti-American reflex. The complaint is that the economization of all aspects of neoliberal society has now encroached upon the universities as well, with the result that original research has become more difficult, the employment situation of more and more academics has become precarious, and the number of those suffering from mental-health problems (particularly depression and burnout) has gone up. The evidence commonly (and rightly!) cited includes the increasingly alienating function of administrative bodies—for instance, academics are confronted with administrators regarded as cut off from research and teaching as well as with excessive demands to participate in the university's bureaucracy. Literary theorist and professor Christopher Newfield writes: "Management obviously needs to be competent, but competence seems no longer to require either substantive expertise with the firm's products or meaningful contact with employees. The absence of contact with and substantive knowledge of core activities, in managerial culture, functions as an operational strength. In universities, faculty administrators lose effectiveness when they are seen as too close to the faculty to make tough decisions."[3]

Certainly not false, this empirical observation nonetheless fails to comprehend the (historical) reasons for what it describes. It thus remains helpless when it comes to devising countermeasures. From a historical or, more precisely,

[2] William Clark, *Academic Charisma and the Origins of the Research University* (Chicago: Chicago University Press, 2006), 28.
[3] Christopher Newfield, "Christensen's Disruptive Innovation after the Lepore Critique," *Remaking the University* (blog), June 22, 2014, http://utotherescueblogspot.co.uk/2014/06/christensens-disruptive-innovation.html.

from a genealogical perspective, bureaucratization and economization have their origin in an idealized model made in Germany that began with Wilhelm von Humboldt's university reform and spread internationally with great success. One reason why this shared point of departure is not recognized is that its symptoms are varied. Like the apparent takeover of academics' time by administrative duties unrelated to their work, the preference given to "excellence clusters" and prestigious large-scale projects, the quantification, by way of evaluation, of the humanities, and the crisis of (academic) publishing take different forms in the United States than they do in Germany. The Ivy League institutions, for instance, which were structured on the Humboldtian model as well, in the last few decades have become a point of reference for the propagation and institution in Germany of so-called elite universities (*Exzellenzuniversitäten*) with their mammoth projects (excellence clusters, special research units, graduate schools, all financed with external funds from third parties, which now make up 15 percent of funding for universities) that have rightly been reproached for nepotism—despite (or because of) constantly being evaluated.[4]

Both the politics of the revolving door (person A evaluates person B's application or institution with the knowledge that, in the near future, A and B will switch roles) and the Matthew effect—"that is, the tendency for resources to go to those who already have them"[5]—lead to an intellectual homogenization that is also, and by no means coincidentally, a social homogenization of students and faculty.

Academic publishing as well is facing its share of problems. Again, take the examples of Germany and the United States. In Germany, the "market" is clearly distorted. Horrendously high payments from authors or institutions to publishing companies, euphemistically called "printing-cost subsidies," make it possible to publish just about anything, often without any

[4] For a discussion of similar large-scale projects in England, see Gary Rolfe, *The University in Dissent: Scholarship in the Corporate University* (London: Routledge, 2013). "The pressure to compete for multi-million pound research grants has necessitated the formation of large multidisciplinary research teams that resemble Fordist production lines, where each member has a small, specialised job and rarely gets to see the big picture" (11).

[5] Michèle Lamont, *How Professors Think: Inside the Curious World of Academic Judgment* (Cambridge, MA: Harvard University Press, 2009), 8.

professional editing, as no one expects these academic publications to be read anyway. The more prestigious a publisher is, the higher the price (these exaggerated prices then go on to fund translations of famous authors). And although the symptoms are different, there is an analogous distortion in Anglo-American publishing. In his article entitled "Aaron Swartz Was Right," philosopher Peter Ludlow writes: "To put it bluntly, the current state of academic publishing is the result of a series of strong-arm tactics enabling publishers to pry copyrights from authors, and then charge exorbitant fees to university libraries for access to that work. The publishers have inverted their role as disseminators of knowledge and become bottlers of knowledge, releasing it exclusively to the highest bidders."[6] An all-pervasive logic of competition has allowed the law of the economically stronger to prevail. Why is that, and why is it so despite the apparently good, critical, leftist conscience of many in the humanities? The problem, it seems to me, lies in a misguided analysis that has countermeasures come up empty or even aggravate the conditions that are being criticized.

To illustrate this point, let us turn to a few contemporary statements. Writing on scholarship in the corporate university, Gary Rolfe provides a rough historical narrative of the decline of the university over the last two hundred years. It leads, he writes, from the "University of Reason" via the "University of Culture" to the misery of today's "University of Excellence," in which "'excellence' is in itself an empty signifier bereft of any ideological intent, a unit of measurement rather than something to be measured. The concept of excellence can therefore be applied to justify almost any aim."[7] Yet the alternative he proposes—independently of whether it would be feasible or desirable—seems to me to be more a symptom of the academy's status quo than a way

6 Peter Ludlow, "Aaron Swartz Was Right," *Chronicle of Higher Education*, February 25, 2013, http://chronicle.com/article/Aaron-Swartz-Was-Right/137425/.

7 Rolfe, *University in Dissent*, 4. Rolfe picks up on Bill Reading's *The University in Ruins* from 1996. Taking into account the already mentioned corollary funding issues, Rolfe writes: "The research agenda of the university has also become inextricably linked to finance and profit. Whereas external grants have always been important as a source of funding for research projects, the Research Assessment Exercise (RAE), introduced into the UK in the early 1990s, elevated grant income to one of the major indicators of quality. Along with the impact factor of the journals in which research papers are published, the quality of the research conducted by an academic department is measured by the amount of grant income awarded" (ibid., 11).

out of it. Rolfe suggests replacing the "idea of excellence" with an "idea of thought," something that "can only be achieved subversively through the development of a community of philosophers that is prepared to challenge and critique the mission statement of the 'University of Excellence' from within."[8] I have more to say about the systematic (because ideological) connection of critique, subversion fantasies, and philosophers' megalomania in this book. Here, I am more interested in a symptomatic historical blindness. Ignoring how the model of the university that dominates to this day was established—a university geared toward innovative research—is to ignore the central role philosophers like Hegel, Schleiermacher, and Fichte played in its establishment. Nostalgic critiques like Rolfe's are not just ineffective, they are actually counterproductive.

An inverse, positive assessment can be found in Michèle Lamont's 2009 book *How Professors Think*. Based on a conception of "widely shared institutionalized norms that regulate the system of national competition," she attributes objections against the peer-review ideology to disciplines "where post-structuralism has been influential and the 'theory wars' have been fought, [which] are more likely to take a relativistic stance toward evaluation."[9] This is ultimately motivated by a Habermasian faith in "ideal speech conditions" and a Weberian suggestion "that the production of rational-legal legitimacy requires belief in the use of impersonal, abstract, and consistent rules."[10] This is ideology in action: Lamont recognizes and thematizes the coproduction of sociological knowledge and academic evaluation, but renders it unproblematic by invoking the tendency of all involved to consciously acquiesce, as well as the allegedly obvious (social) progress that evaluation entails for (American) academia.[11]

By way of contrast to narratives of decline or progress, I would like to cite a third assessment of the humanities today. In an op-ed published in the prestigious German newspaper *Frankfurter Allgemeine Zeitung*, Hans Ulrich Gumbrecht,

8 Ibid., 1.
9 Lamont, *How Professors Think*, 52, 103–4.
10 Ibid., 247, 110.
11 Ibid., 11.

a literary scholar teaching at Stanford University, situates the current state of affairs and the changes taking place against the background of Humboldt's *Notes on Founding a University in Berlin*, which idealizes an "encounter between students and professors"— an exchange "of youthful and mature enthusiasm" to "bring forth new knowledge." The primary goal, therefore, is not the transmission of professional knowledge, but the often-invoked "unity of research and teaching." According to Gumbrecht, Humboldt's core ideal and spirit have become redundant: "The normalcy longed for by most renowned faculty is the transfer of cutting-edge research to institutions that no longer participate in teaching." Gumbrecht thus is not a follower of a logic of progress, nor does he think that we "live in an era of social decline"; he simply states, "The life span of the institutional form that has fed me well and entertained me even better is coming to an end—and that spirit probably already dwells somewhere else."[12] So far, so good for the old times (and for old men), but such an analysis remains apolitical, a swan song as much for the transformative power of the academy as for the significance of theory today.

Given this general impasse, it comes as no surprise that young(ish) academics who are actually in a (financially, intellectually, professionally) precarious situation cannot find a way out. Here too we find analogous phenomena in allegedly very different university systems. In Germany, as a political science professor writes, "nothing happens. There is no self-empowerment of junior faculty, no real self-organization."[13] And an American observer writes: "It baffles me why, in a higher [education] system that holds political but not ideological power over its workers, we don't object to our labor conditions en masse. There are several strong voices in the argument for adjunct labor reform, but the more widespread false consciousness that accepts, complies with, justifies, and administers exploited labor is shameful."[14] This, to be sure, is an effect of the mechanisms of dominance and

12　Hans Ulrich Gumbrecht, "Universität als melancholische Erinnerung," *FAZ Blogs: Digital/Pausen*, September 20, 2014, https://blogs.faz.net/digital/2014/09/20/universitaet-als-melancholische-erinnerung-697/; unless otherwise noted, all quotations from non-English texts were translated by Nils F. Schott.
13　Peter Grottian, "Das promovierte Prekariat," *Süddeutsche Zeitung*, October 7, 2014.
14　Tiffany Kraft, "From Ph.D. to Poverty," *Hybrid Pedagogy*, September 3, 2014, http://www.hybridpedagogy.com/journal/ph-d-poverty/.

fear implemented through evaluations—which, "of course, can be deeply flawed," as a reporter for the *Chronicle of Higher Education* writes. "For many adjuncts, fear of angry evaluations can quickly turn into fear of honest grading."[15]

In this book, however, I am more interested in a fundamentally systematic and historical—that is to say, genealogical—rereading or reconstruction of the status quo. Concretely, the questions I am asking are: How does a training in critical thinking link up with the idea of autonomous knowledge production? How does the production of knowledge articulate critique? What is the relationship between critical knowledge in general and dominant theories and practices of art in particular? And is there in poetics—understood as a different way of producing (texts, lives, institutions)—an alternative to the failures of aesthetics? Fundamentally, this book is concerned with an overwriting (an *Überschreiben* or *Überschrift*, as the German title suggests) of the subject by texts read or (over)written by the subject.

I originally wrote this book in German while I was still working in academia; in translation, it has been slightly shortened and adapted for an international audience. Many thanks to Caroline Schneider, Tatjana Günthner, and especially Max Bach at Sternberg Press for their interest in this book and for shepherding it to publication; to Till Wiedeck for his design; to Nils F. Schott for the swift translation and extremely helpful remarks concerning his own American academic experiences; and finally to Bernd Klöckener, my editor-collocutor, who edited both the German and the English manuscripts.

15 Max Lewontin, "For Adjuncts, a Lot Is Riding on Student Evaluations," *Vitae*, October 6, 2014, https://chroniclevitae.com/news/741-for-adjuncts-a-lot-is-riding-on-student-evaluations.

OVERWRITE

Ethics of Knowledge — Poetics of Existence

Introduction

> The important thing is not knowing whether man is good or bad in the beginning; the important thing is what will transpire once the book has been eaten. —Jacques Lacan, *The Ethics of Psychoanalysis*, 1960

We are all contemporaries of different presents. To write a contemporary book, to understand our contemporaneity—there is my present and there are other presents—we are forced to take a genealogical look back. Not to find the *one* correct past, but to bring to light something of the contingency of a past. Already in writing this book I began to live in another present, to settle in another present, to make another future livable for myself, beyond the confines of academia. Ethics is the question of the right life. And of how to be less afraid: not to yield to the blackmail of the future's contingency, but to imagine a better future in order to look (back) differently onto the present.

Like literature, philosophical writing aims for a conversion or for access to another world. I project myself into the future and look back onto the past—the present that, for me, has become contingent.

> This book will be a different one, and I want to become, with this book, different once more.

That everything could be entirely different is a speculative experience to be understood in wholly materialistic terms; it is, as it were, the opposite of the idealist notion that thinking could, from within itself, change the world or completely comprehend it.

Every place can become a scene of writing. For the one writing, the whole world is a possible background that moves to the foreground or enters the text itself. Everything then contributes to what is written without necessarily

showing up in the text. These two poles create a tension that all writing is caught up in: in writing, one is always thrown back onto oneself, but because of this, at the same time, one is as far away from one's self, one's ego, as possible. For when I write, I engage in a potential exchange with everyone else; I have something to say to everyone. Somehow every such isolation bears the strange fruit of a megalomania that consists not only in talking to others about everything, if possible, but also in immediately wanting to change everything.

This book, then, is also a book about the desire to write differently in order to situate oneself in the world differently. It is a book about the truth that is produced when a subject takes responsibility for its thinking, its experiences, its conflicts—all of which rewrite, or overwrite, the subject. Knowledge thus understood becomes true knowledge only when what is known transforms me and the world (the ontological triad *thinking—subject—world*). Only then has the changed ego become part of a new world (the deictic triad *I—here—now*). To situate oneself anew within the whole is to switch from *reference* to *inference* (Robert Brandom). True knowledge does not picture the present; it pulls us into an as yet unknown future to which we (will) need to justify our present actions. The question, then, is no longer what the world was like, but whether it is true *now*, as I take responsibility through writing for my existence within it. When I situate myself anew in the world, when I know how to localize myself in a (changed) world, when the recursive circle of knowledge has closed to form a different whole, an entirely different knowledge—mere (abstract) knowledge—will (ethically) come true.

This book argues that a transformation of knowledge into truth is primarily located in writing, in an overwriting of the subject that becomes an other, a different subject, in the process. My ego becomes an alter ego not when I write about myself but when I overwrite myself; the ethical component of knowledge cannot be conceived of independently of a poetics of existence. (This is precisely what distinguishes such a poetics from an aesthetic self-fashioning and its inconsequential innovations.) I can situate myself differently in the world only when I actively find my way to a truth; when, in writing, I produce my truth from the nameless knowledge about the world at my disposal.

This poetic production—*poiesis*, taken in its original sense of producing a truth—means less that I place something before myself than that I place something within the world, place myself in an *other* world.

When I (actively) situate myself in a global context, the question of the location of thinking imposes itself: *Where am I speaking from? What is the place of my speaking?* Rather than *Who am I?* the question is: *Who must I be to be able to write?* Or, *What do I have to do to be read differently?* That which is at stake in (philosophical) writing—the transformation of one's own world and of the thinking of others—always already lies beyond the site of my laboring. Hence the necessity of subjecting oneself and one's surroundings to a constant manipulation, the ongoing attempt to construct "cognitive niches" (Lorenzo Magnani) that urge a reconfiguration of the universal.

> My desk, my office, my career, and the institutions whose protection I seek are only traps I'm caught in. I can understand them only by turning them against themselves.

The much-invoked will to knowledge—the desire for truth—has always been a motor for experiments with writing differently. We can only control or navigate the constant stream of thought because we are always already ahead of ourselves—and, as in a game of chess, we are all the better at it the further we think ahead as we make our next move. Unlike, say, attempts at unearthing the unconscious id by way of automatic writing, for me, writing differently—"writing another way"—means, for example, "writing with the other," with another ego that ought to be smarter than me. It can also mean writing with the superego, which doesn't simply demand more texts or better texts. It forces an encounter with the truth, which obviously also implies confronting one's failure. Writing with the superego—encountering the truth—doesn't mean liberating myself from the superego, but rather conforming to its irrepressible demands while not relenting in my desire and holding on to a production of truth that the state institutions for the (re)production of knowledge so successfully prevent.

OVERWRITE

The discourse of the university gives free reign to hatred. This discourse suppresses speaking in one's own name; it turns servants into representatives of (absent) masters and hardly ever produces a book. Instead, it produces heaps of theses and dissertations that constantly violate the spirit of a categorical imperative of academic work: *You shall only write in the spirit of the books you admire, not stick to their letter!* This sheds light not only on an elevated potential for aggressiveness among those working and studying in academia but also on the fact that so many of them suffer from depression.[16] It would be too easy to ascribe this merely to the fact that universities increasingly work according to the rules of the free market. Yet that is what many of the afflicted do, as they seek to externalize the evil that afflicts them in order to then demand of universities that they protect them from the so-called evil of the free market. But the opposite polemic reproach that those suffering from depression are merely "victims" of a self-incurred immaturity does not help either.

> I write about things that lie ahead of me; at the same time, my writing is always ahead of myself.

The insidious truth about (the misery of) modern research universities is not simply located halfway between these two views. It is best approached by way of a genealogy of academic morality and of the rules articulated by it (because morality, unlike ethics, aims for general laws). This genealogy examines how the central categories of an ethics of knowledge (knowledge, subjectivity, innovation, reflection, critique, aesthetics, humanist self-education, etc.) are selected and constituted. The current aesthetic regime of thinking produces and reproduces the academic-artist, the *Wissenschaftskünstler*,

16 To quote from just one of many sources: "About one-third of U.S. college students had difficulty functioning in the last 12 months due to depression, and almost half said they felt overwhelming anxiety in the last year, according to the 2013 National College Health Assessment, which examined data from 125,000 students from more than 150 colleges and universities." Amy Novotney, "Students under Pressure," *Monitor on Psychology*, September 2014, http://www.apa.org/monitor/2014/09/cover-pressure.aspx.

whom Johann Gottlieb Fichte once called for,[17] a figure that is still responsible for the ideological implementation of concrete aesthetic-critical settings on both the level of content and the administrative level.

What is largely forgotten today is that this model seemed highly suspect to its contemporaries (from Vienna Jesuits via Sorbonne professors to the fellows of the English colleges) who immediately recognized, behind the increasing bureaucratization, a creeping economization geared at ever more efficient professional training. What strikes me as even stranger is the historical blindness that continues to nostalgically hold on to an ideology that gave us the aesthetic spirit of contemporary capitalism long before all "artistic critique."[18] Despite, or precisely because of, the cachet of leftist radical rhetoric in the humanities, academics remain blind to the political conditions of their own work—as if the concrete settings of seminars and working groups as well as the speaking and writing they produce were endowed with timelessness or necessity.

The critically burnished spaces of contemporary higher education are governed by a peculiarly constraining casualness. They seem to presuppose the idea that where there are no masters, there can be no repression. Everything is allowed, nothing prohibited, everyone is called to flexibly continue their education and authentically come into their own. This results in depressed personalities incapable of representation or triggering conflicts, or of living up to the (self-imposed) demand to be original.[19] It is an irony of the history of the university that its inmates today suffer from the massive side effects of an analeptic drug developed more than two hundred years ago in the exact same seminar rooms: the drug of "auto-formation," or education of the self (*Selbstbildung*).

17 Johann Gottlieb Fichte, "Deduzierter Plan einer zu Berlin zu errichtenden höheren Lehranstalt, die in gehöriger Verbindung mit einer Akademie der Wissenschaften stehe" (1807), in *Idee und Wirklichkeit einer Universität: Dokumente zur Geschichte der Friedrich-Wilhelms-Universität zu Berlin*, ed. Wilhelm Weischedel (Berlin: De Gruyter, 1960), 44.

18 For the term "artistic critique," see Luc Boltanski and Ève Chiapello, *The New Spirit of Capitalism*, trans. Gregory Elliott (London: Verso Books, 2005).

19 See Alain Ehrenberg, *The Weariness of the Self: Diagnosing the History of Depression in the Contemporary Age,* trans. Enrico Caouette et al. (Montreal: McGill-Queen's University Press, 2010).

As an antidote, this book suggests bringing a bit of fetishism into the mix. By fetishism I mean above all endowing the Other with all the insignia of beauty and success —completing and enjoying the Other. The fetishistic dimension of text production in general, and the motivation to write a book (and another one, and yet another one) in particular, feed on the phantasm that my textual signifiers assemble to form an object. The ethical desire of the subject of academic knowledge can be gauged according to whether this metanoetic qua life-changing self-transgression, this writing over and beyond the self, succeeds.[20]

> Everything I live through, everything I read, must be written down and rewritten.

The focus of this book is thus on the ethical dimension of knowledge. It does not set out to prove that the results of such a knowledge production are more fruitful (Anke Hennig and I wrote about that already in *Present Tense* and *Metanoia*) or to articulate general doctrines for academia. This also is not a book about the methodological and epistemological implications of focusing on the poiesis of (true) knowledge. It is, however, about the ethical implications of such a poiesis. And in this regard I attempt to develop conceptual alternatives to the pillars of aesthetic thinking on the levels of content ("reflection"), discourse politics ("contemplation"), and organization ("communication"). In the *ethopoiesis* (Foucault) of knowledge, as I conceive of it, speculation replaces contemplation. I also count on the transformative dimension of recursion to supplant paralyzing and ineffective (self-) reflection. And instead of approaching dialogic communication, I outline the alternative setting of a writing-with-the-other that confuses fixed psychological entities (egos).

This book is not another (meta-) critical undertaking. On the contrary, I emphasize the astonishing achievements of the university's aesthetic regime. These include,

20 See Armen Avanessian and Anke Hennig, *Metanoia: A Speculative Ontology of Language, Thinking, and the Brain*, trans. Nils F. Schott (New York: Bloomsbury, forthcoming 2017).

for example, the (re)production of a new self-educating academic subject, a surprisingly long-lived practical resolution of the paradoxical double demand for producing new knowledge while preserving tradition in research and teaching—a double demand that still enthralls subjects eager for knowledge (although students and scholars today have fewer and fewer illusions that the existing institutions could come close to living up to such promises).

Central to my whole endeavor is the assumption that actually transformative elements must first be salvaged from the usurpation of critique, rescued from a critical attitude that compensates for its daily failures by brazenly laying claim to past transformations. A truly transformative or accelerationist attitude allows us to go beyond critique, which, as Bruno Latour has famously claimed, has long "run out of steam."[21] Critique is a veritable machinery for legitimizing the capitalist status quo—actual rethinking never results from critical (self-)reflection, it is only ever produced by manipulating one's surroundings, recursively appropriating its parts, and assembling them to form a new whole. Only in this recursive transfiguration does the world become an other—indicating that in writing and overwriting, a transformation takes place as a knowledge comes true (*knowledge* comes into and goes through the *world* and the *subject*, so to speak, and all three are transformed in the process). I want to distinguish this knowledge produced through writing from a mere accumulation of innovative knowledge. It is a speculative overwriting—materialist, not deconstructionist, as we will see—in the sense that reading is speculatively transposed into living, into writing, and so on.

21 Bruno Latour, "Why Has Critique Run Out of Steam? From Matters of Fact to Matters of Concern," *Critical Inquiry* 30, no. 2 (Winter 2004): 225–48.

PART I

Genealogy of
Academic Morality

Critical Legitimacy

Legitimate Crisis

> Critique has been the tool of choice for so long, and our students find themselves so well-trained in critique that they can spit out a critique with the push of a button. [...] Reading and writing are ethical practices, and critique misses the mark.
> —Karen Barad, interview with Rick Dolphijn and Iris van der Tuin, 2009

Immanuel Kant's influential order reads as follows: "*Enlightenment is the human being's emergence from his self-incurred minority. Minority* is inability to make use of one's own understanding without direction from another. This minority is *self-incurred* when its cause lies not in lack of understanding but in lack of resolution and courage to use it without direction from another. *Sapere aude!* Have courage to make use of your *own* understanding! is thus the motto of enlightenment."[22]

Think for yourself—be critical! This two-part formula still captures the ideal of education today. The first part contributed to the foundation of the Universität zu Berlin (now Humboldt-Universität zu Berlin) on the orders of the Prussian *Policeyminister* (today's minister of the interior); the second is a demand of critically enlightened discourse we are still confronted with every day. For two hundred years, thinking has absorbed the principle of critique as a matter of course, to the point that, like all functional ideologies, critical thinking appears entirely "natural" and without alternative. Who would deny being critical? Who would want

22 Immanuel Kant, "An Answer to the Question: What Is Enlightenment?," in *Practical Philosophy*, trans. and ed. Mary J. Gregor (Cambridge: Cambridge University Press, 1996), 17 (italics in original).

to be seen as uncritical? Critical thinking is a bit like Descartes's *bon sens*: the critical faculty "is the best distributed thing in the world: for everyone thinks himself so well endowed with it."[23]

> "Can we be postcritical—as distinct from uncritical?" (Rita Felski)

Today, now that such "common sense" has been discredited both politically and psychologically, critique and art—as "key terms of modernity"[24]—have become hegemonic normative authorities. But without a poetic, productive, or, in Reza Negarestani's terms, "constructive vector, the project of evaluation—critique—is transformed into a merely consumerist attitude toward norms,"[25] instead of, as it claims, changing things *for the better*, or even *transforming the existent*. In the *Nicomachean Ethics*, to counter Plato's doctrine of virtue, Aristotle distinguishes between knowing (*noesis*), acting (*dianoesis*), and making (*poiesis*); but I am rather interested in the connections of knowledge and ethics between these activities such as they arise, for example, in abductive thought.[26]

Reading François Jullien's *A Treatise on Efficacy* in German translation, I at first made a mistake (misreading "dianoetic" as "dianoe*thical*") that brought home the ethical relevance of Jullien's question concerning an "ability" that is "at once intellectual ('dianoetic') and

23 René Descartes, *Discourse on the Method*, in *The Philosophical Writings of Descartes*, vol. 1, trans. John Cottingham, Robert Stoothoff, and Dugald Murdoch (Cambridge: Cambridge University Press, 1984), 111.
24 Helmut Draxler, *Gefährliche Substanzen: Zum Verhältnis von Kritik und Kunst* (Berlin: b_books, 2007), 7.
25 Reza Negarestani "The Labor of the Inhuman," in *#Accelerate: The Accelerationist Reader*, ed. Robin Mackay and Armen Avanessian (Falmouth: Urbanomic, 2014), 440.
26 "Action plays an epistemic and not merely performatory role, for example relevant to abductive reasoning. [...] We define cognitive manipulating as any manipulation of the environment devoted to construct external configurations that can count as representations." Lorenzo Magnani, *Abductive Cognition: The Epistemological and Eco-cognitive Dimensions of Hypothetical Reasoning* (Berlin: Springer, 2009), 176. We will see how "critique" is ultimately incapable of attaining the kind of transformation that manipulates the environment.

directly linked with action."[27] The Greeks called this ability *phronesis*, a kind of situated intelligence. A "state of capacity to make,"[28] understood in ethical terms, cannot of course designate anything like an autonomy or sovereignty of our actions or our subjectivity. This is what distinguishes a philosophy that is more than self-sufficient academic praxis and that is also capable of accessing its poietic dimension from *theoria*, understood as the contemplation of a given, handed-down, and mediated knowledge. The abductive triad *knowing—acting—making* refers to a philosophical ethos, a labor on ourselves that includes a transformation. Our conflicts indicate the extent to which we change (ourselves), and it seems to me that shedding light on objective contexts is necessarily tied to an active modification, an othering of ourselves.[29]

For a conflict to emerge—be it directed against hegemonic powers or social exploitation—it must be named. The claim to transformation thus includes courage and action. Only action sets the scene for an objective conflict. Conflicts become manifest, reach (critical) limits, and then overstep (overwrite) them.[30] In a society that seems to consist only of (de facto entirely conformist) individualists, it is important to recall that a violation of unwritten or latent rules provokes a conflict. Vice versa, where there is no conflict, talk of resistance is cheap.

> For a conflict to emerge from a state of latency, it must be named.

27 François Jullien, *A Treatise on Efficacy: Between Western and Chinese Thinking*, trans. Janet Lloyd (Honolulu: University of Hawai'i Press, 2004), 5. For my misreading of *dia-noethisch* as *diano-ethisch*, see François Jullien, *Über die Wirksamkeit*, trans. Gabriele Ricke and Ronald Voullié (Berlin: Merve, 1999), 17.
28 Aristotle, *Nicomachean Ethics*, trans. W. D. Ross, rev. J. O. Urmson, in *The Complete Works of Aristotle: The Revised Oxford Translation*, vol. 2, ed. Jonathan Barnes (Princeton, NJ: Princeton University Press, 1984), 1140a.
29 On the concept of othering, see Avanessian and Hennig, *Metanoia*.
30 The political debates surrounding undocumented immigrants in France, the so-called *sans-papiers*, develop such an objective form of conflict, which introduces a new political subject into reality.

Every progressive act, every act directed at a future norm (at an *ought*) thus has to entail a conflict or risk of being suspected of conformism (no matter how "critical") to the given state of affairs (to what *is*).[31] There will be trouble because the powers that be think they cannot let anything pass, not the slightest contravention, not the slightest confusion of the usual course of things. This is how I understand Foucault's notion of a "philosophical ethos appropriate to the critical ontology of ourselves as a historico-practical test of the limits we may go beyond and thus as work carried out by ourselves upon ourselves as free beings."[32]

How, by contrast, does the kind of critique that is hegemonic today (and is fully backed institutionally and financially) work? Why is it so difficult to shed the mystical belief that thinking for oneself—making use, in Kant's words, of one's own reason—is first and above all predicated on becoming critical or, rather, on having been schooled in the art of enlightened critique?

To critique is always also to draw boundaries that must not be overstepped. Critique mainly makes assumptions about morals and does not trigger any ethical overwriting (of oneself). In this book I am trying to shed light on this function of critique by way of a genealogy of academic morality. In other words, I outline something like the genesis of critical thinking from the spirit of the university that has subsequently affected many adjoining fields such as art, literature, and journalism. Its effects can be spelled out in the terms of the ontological triad *thinking—subject—world*.

"Could it not be that critique is that revolution at the level of procedure without which we cannot secure rights of dissent and processes of legitimation?"[33] We owe this crucial insight into the

31 Dirk Baecker makes this point from a sociological perspective in reference to the strained relations between the constitution, personnel, and norms of a cultural order. It turns out "that the personnel invokes the constitution with equal right as the norms, but unlike the norms it does so directly. It is only thanks to this *right* that the personnel can seek to come into conflict with the norms, provided it does not *have to* seek it, given the dispute with the environment, the material apparatus, the activities and ensuing restlessness of the personnel itself." Dirk Baecker, *Kulturkalkül* (Berlin: Merve, 2014), 69.
32 Michel Foucault, "What Is Enlightenment?," trans. Catherine Porter, in *Ethics: Subjectivity and Truth*, ed. Paul Rabinow, vol. 1, *The Essential Works of Foucault, 1954–1984* (New York: New Press, 1997), 316.
33 Judith Butler, "Critique, Dissent, Disciplinarity," *Critical Inquiry* 35 (Summer 2009): 795.

relationship between critical thinking and the political legitimacy of the modern order to Judith Butler. If she is right, we have to say (and this is paradoxical only on the surface): critique legitimizes. Critique would then be a revolution (and indeed a betrayed one) that has been shifted to the level of procedure, a revolution whose potential for transformation remains tied to the status quo and its norms.

Critical non-force thus goes even deeper than what Jean-François Lyotard described as early as 1972, when he wrote that "critique makes itself the object of its object, establishes itself in the field of the other, accepting the dimensions, directions and space of the other even as it contests them."[34] Critique shifts levels: the object criticized moves from being merely an empirical given to being a phenomenon that exists because it is legitimate (presumptuous as this legitimacy might be).

Let's take the example of established institutions whose powers are rarely founded democratically and are much more likely to be the result of an originary usurpation. When, for instance, university personnel criticize the norms of the university, this critique inevitably leads both parties to a common (juridical) discourse in a zone of regulated conflict (no matter what the actual result of their negotiations turns out to be). On a discursive level this ennobles both parties, even when the critical party is suppressed as dissident (which is a rare case in Western societies anyway). Such a shift is unavoidable, and every critique is marked by this displacement of reflection (of whatever is reflected as well as whoever is reflecting) into the sphere of law. What is lost in this transfer into given normative structures is the potential for change that only becomes effective in conflicts.

When confronted with a given it cannot accept, critique posits itself as lawful by declaring itself to be the only possible agent of change. All too often, however, critique merely buries critics' heads in the sand or directs their gaze at "what we've already achieved," at achievements that critique seeks to preserve by adapting to a changing present. In the academy we see this in the helplessness to which proponents of

34 Jean-François Lyotard, "Energumen Capitalism," in Mackay and Avanessian, *#Accelerate*, 168.

(ultimately conservative) anti-austerity policies are reduced: all they can do to oppose the diktat of economic usefulness and efficiency is to make nostalgic declarations about, for example, "the death of universities as centres of critique."[35] We're dealing with a two-fold misunderstanding here that is particular to critique. Critique deludes itself about the reasons for changes actually taking place (which it projects into the past as effects of its own self-reflexive practice) and it ignores the fact that the economization dominating all areas of life in (academic) thinking under the headings "personal responsibility" and "privatization" was and is being produced and kept alive by critique itself.

"We can only criticize something," the philosopher Rahel Jaeggi writes, "if a rule has been broken and if there is a party that can be held responsible." For her, critical analysis is never only an "instrumental precondition but part of the critical process itself."[36] However, critique, which is always only reflexive-aesthetic, is incapable of exploiting the existing transformative (poietic) potential, which always works via recursion. The problem, moreover, is not just that critique does not manage to bring about a transformation, but that its norms, too, are not subject to any transformation either—whether they like it or not, critics are always already in the know.

Three problems are connected here: 1) A fundamental methodological (self-)misunderstanding is found, for example, in Jaeggi's strict delineation of "immanent critique," which refers to an "always already" dynamic of forms of life (yet to be discovered) and thus to an innovative potential (thought along aesthetic lines) to produce continuity (instead of contributing

[35] Diane Reay, "From Academic Freedom to Academic Capitalism," *Discover Society* (blog), February 15, 2014, http://www.discoversociety.org/2014/02/15/on-the-frontline-from-academic-freedom-to-academic-capitalism/. On anti-austerity politics and the accelerationist view that such a politics is helpless (because it usually remains without a concrete perspective for the future), see Nick Srnicek, Alex Williams, and Armen Avanessian, "Zukunft—was war das noch?," *taz: die tageszeitung*, February 4, 2014; online as "Aus der Kapitalismus-Falle befreien!," http://www.taz.de/!5049418/; translated as "Remembering the Future," https://syntheticedifice.files.wordpress.com/2014/02/srnicek-williams-and-avanessian-2014-remembering-the-future1.pdf.

[36] Rahel Jaeggi, *Kritik von Lebensformen* (Berlin: Suhrkamp, 1987), 139, 280.

to a conflictual break with the given).[37] That is why there is 2) no critical comprehension of the fact that critique does not *itself* create norms but merely helps latent norms become effective. This has a correlate in a sugar-coated view of the past, which here means, above all, critique's own achievements. The fact that norms can become apparent (and thus effective) for the critic only when they have already changed explains that 3) faced with its current lack of efficacy, critique claims for itself to have brought about (all) historical transformations.

> As if mere reflection ever led to political events, as if anyone achieved success by just a little more self-reflection, as if thinking—Hegel's speculative thinking like any other—weren't the result of materially grounded practices, concrete settings of reading, writing, and speaking.

"But what would be the alternative?" is a phrase critique has copied from its favorite opponent, capitalism. There shall be no gods beside critique. The insight into its obvious implication in the given (power) conditions, which critique has in recent years celebrated as a great epistemological advance, thus becomes a blank check to go on as before, undisturbed and uncontested. This is another reason why critique is the procedure of legitimization that is the least likely to be attacked. Critique endows its object with necessity—of whatever kind, be it the necessity of power itself. At the same time, of course, this has a stabilizing effect for the critical subject: things go on and on and on—and things will surely be no different tomorrow.

37 Symptoms of this misunderstanding are Jaeggi's sidelining of the speculative dimension of Hegel's thought (all that remains of the *Phenomenology of Spirit* is a "reflexive form of life" or a "dialectic progressive movement," which she sees as supplemented and driven by a "critical self-assessment of consciousness") and her interpretation of the psychoanalyst self-consciously making connections (the "'dialectic process' corresponds to the psychoanalytic process of working through") (ibid., 281–88). Jaeggi's conception betrays a reduction of both Hegel and psychoanalysis to a wholesome degree of reflexively differentiating what is already known.

Critique, in most cases, already appears in existing discourse. Yet its basic principle or functioning is particularly apparent in the less frequent case of an originary accumulation of critical legitimation; in cases, that is, in which an object or discourse is established as a criticized one in the first place. For something to be recognized by critique as an object of the law, and thus as lawful, also means: critique legitimizes (and thus ennobles) the criticized as well as the criticizing. The critic is involved in a new contract and, strictly speaking, is the one who initiates it.

> Critique legitimizes both the critic and the object criticized.

The legitimacy produced by critique is thus different from earlier forms of legitimation by affiliation (by belonging to an ethnicity, language group, culture, by nationality, by institutional or corporate membership, and so on, which includes obtaining university diplomas). It makes critique complicit in contemporary forms of establishing power by means of "governance" and "compliance." This is what I understand to be an "ontology of critique": everything exists on the basis of a legitimacy that is no longer natural or quasi-natural but has been produced by a practice of critique. Today, every institution or authority is able to legitimize itself critically, calibrated on critical discourse, and wherever critique does not come to the rescue by itself, institutions have to find within themselves a critical instance or produce one. (How many examples of transformations due to institutional critique have there been since Hans Haacke's terrific Guggenheim piece from 1971 or John Knight's extraordinary work from the 1970s, which since then have had to serve as legitimization for entire art institutions specializing in institutional critique?)

It is not by chance that this affirmative logic of aesthetic critique is most obvious in the field of art. "Value does not increase on its own, but only through constant critique, evaluation, and attention," writes Michael Hutter in "Balanced Investments," which appeared in an issue of *Texte zur Kunst* dedicated to the other of critique—namely,

"speculation."[38] Suhail Malik (in the same issue) has given this assessment a further philosophical (contemporary speculative) as well as economic turn (by means of a comparison with trading in derivatives). According to Malik, contemporary art, in its evaluation of anyone and anything, forms the condition of possibility of "the pricing of everything" in the first place, a pricing that is the condition of capitalism and ubiquitous in its neoliberal variant. It is precisely because contemporary art has a critical value that can never be determined with accuracy that it serves as a matrix for price formation in society at large, "for universal financialization." For Malik, contemporary art's "speculative survaluation paves the way for untrammeled speculative marketization not only across CA [i.e., contemporary art] itself but also across and into everything."[39]

Thanks to a fundamentally folkloric attitude and entirely idiosyncratic divisions (on the one hand, the few exceptional critical artists who, by mere coincidence, are all good friends; on the other, superficial curators, institutions that don't get it, malevolent collectors who don't care about *art* as such, etc.), aesthetic art theory is able to constantly evade the fact of its fundamental complicity. In their analysis of art and the global market, Markus Metz and Georg Seeßlen write, "The majority of 'art criticism' is, sometimes unwittingly, sometimes knowingly, a propaganda tool for a 'market-compliant' discourse."[40] Moreover, as sociologist Andreas Reckwitz has shown, "the economization of the social does not contradict the logic of the aesthetic; it is structurally homologous."[41] Never mind: fawning aestheticists (academics or freelancers, no matter) keep on churning out a mass of critical catalogue pieces that are in most cases exercises in navel-gazing and, incidentally, produce a whole lot of symbolic capital.

38 Michael Hutter, "Balanced Investments: On Speculation in the Art Market," trans. Karl Hoffmann, *Texte zur Kunst*, no. 93 (March 2014): 84. I was involved in editing this issue.
39 Suhail Malik, "The Value of Everything," *Texte zur Kunst*, no. 93 (March 2014): 78.
40 Markus Metz and Georg Seeßlen, *Geld frisst Kunst – Kunst frisst Geld: Ein Pamphlet* (Berlin: Suhrkamp, 2014), 338.
41 Andreas Reckwitz, *Die Erfindung der Kreativität: Zum Prozess gesellschaftlicher Ästhetisierung* (Berlin: Suhrkamp, 2012), 48.

The question of how every critical discourse is implicated or embedded in a consensus with power is particularly acute in the context of contemporary art criticism. It is a popular occasion to fight for distinction by means of ever more subtle differentiations of the already quite hollow concept of critique. In her essay "'Smuggling': An Embodied Criticality," curator and theorist Irit Rogoff tries to capture the development of the function of critical observation and participation from analysis to performance by distinguishing between, among other terms, "critique" and "criticality": "It seems to me that within the space of a relatively short period we have been able to move from criticism to critique, and to what I am calling at present criticality. That is that we have moved from criticism which is a form of finding fault and of exercising judgement according to a consensus of values, to critique which is examining the underlying assumptions that might allow something to appear as a convincing logic, to criticality which is operating from an uncertain ground of actual embeddedness."[42] There is thus, on the one hand, a revisionist "critique" that remains beholden to the system it criticizes. On the other hand, there is "criticality," which is aware of its "embeddedness." It, too, criticizes within the system, but it does so without assenting to the system as such, aware that an absolute position outside the system is impossible, and that even the most radical criticism has a legitimizing effect. The "smuggling" of embedded criticism thus names a strategy of sidestepping or going behind an order and of hollowing out legitimacy from the inside. Immanent criticality takes pleasure in the self-reflexive paradox of holding on to a subversive behavior it knows to be unsustainable.

> My critique is the most critical—yours is quite uncritical, really.

Later in this chapter I will juxtapose the most advanced positions of Rogoff's criticality and Jaeggi's immanent critique with a speculative and poietic othering whose recursive procedures *do* practice an abductive thinking-through-doing and a transformative integration of parts into a

[42] Irit Rogoff, "'Smuggling': An Embodied Criticality," *Transversal*, August 2006, 2; available at http://eipcp.net/dlfiles/rogoff-smuggling.

(new) whole.[43] To do so, however, there are a number of obstacles to be overcome, not least because critique absorbs the recursive operations of all biographical or social change into its own reflexive operations. On a strictly philological level, this absorption becomes evident as a blind spot. Orthodox critics tend not to take into account the reflections—by the very theorists they most often invoke: Hegel, Marx, Freud—that are more inscrutable and cannot be accounted for by a simplistic model of enlightening discourse. And even though its literary executors have done their best to sideline it, the Frankfurt School contains a speculative expansion of the concept of critique. In blunt terms: critical theory, too, is based on a speculative practice, a transformative power (transformative of discourse) that institutional power has done its utmost to exorcize in the course of the last decades. This is as true of Adorno's essayistic "over-interpretations" as it is of Benjamin's poetic experiments in writing and research. Howard Caygill has pointed out that the transformative or manipulative mode of what Benjamin, in his academic disciplinary transgressions (on the Baroque, Baudelaire, Surrealism, etc.), calls "immanent critique" may indeed be qualified as speculative. Benjamin's philosophical practice, whose methodology is laid out, for example, in his dissertation on the notion of critique in early German Romanticism, continues the speculative and poetic resistance of immanent critique against philosophical aesthetics as it is being established at that time. Caygill writes, "Immanent critique is speculative in acknowledging that both it and the work or object being judged are transformed by their encounter."[44] In Benjamin, this process of transformation is tied in and allied with poetic procedures. The immanent art criticism he develops is in fact a speculative critique: it implies a speculative view on an absolute within a limited realm—and going beyond its critical limits saves it from the fate of all other critiques that make a big show of exposing the scandal of power while at the same time subterraneously toughening the laws of power.

43 Linguists have recognized that recursion is a formal property that allows for the production of an infinite set of meanings from a finite inventory of elements and rules, both on the levels of morphology (*walk/walks/walking*) and syntax (*I write. You read what I write. I hope you read what I write.*).
44 Howard Caygill, *Walter Benjamin: The Colour of Experience* (London: Routledge, 1998), 35.

Self-legitimization through critique can also take place when the criticizing subject pursues the hidden revisionist goal of assuming the position of power. In the everyday life of the academy or the arts, this move is readily apparent in the allegedly substantial debates between different generations. This explains what I would like to call *critical disasters*, a rule that applies to a very high percentage of critically upset minds: young radicals display incredible critical verve and yet do nothing more than perform a spectacle of real subsumption that is about little more than getting their hands on the levers of power. Critique, in this case, is part and parcel of the scramble of those in power and of those they have trained for more prominent exhibition sites or of attempts at a quicker takeover of departments, schools, and universities. Such a logic of substitution, in my view, is at work on pretty much every level: when a subject assumes a respectable position by criticizing a given state of affairs, when a subject criticizes a department and still endeavors to get a job within it, or when a young art journal presents itself as the enterprise whose critique will surpass that of an older, established journal.

What interests me most in this familiar picture is a performative dimension that is usually overlooked and that is probably most easily visible in the field of realpolitik. The everyday life of democratic politics has accustomed us to the kind of party-based opposition whose critique is geared toward (nothing more than) the next election. It never amounts to real resistance. And generally, as Franco "Bifo" Berardi tells us, "critical consciousness is not the problem any more. The problem is autonomy—the actual ability to withdraw from the automatisms that are supporting power."[45] What is needed instead is an *acceleration of critique* (Gilles Lipovetsky), a manipulation of the critical impulse: starting from an insight into the given structures (and not by making an attempt, doomed in advance, to nostalgically bethink oneself of the better days) and without slowing down the present dynamics, new solutions have to be sought.

The search for a path that leads beyond or emancipates from the status quo always also implies a poetic labor on oneself. In the absence of such labor, changes are

45 Franco "Bifo" Berardi and Mark Fisher, "Give Me Shelter," *frieze*, January/February 2013, 152.

just cosmetic changes and problems appear as merely external crises without any (ethical) relation to the subject. It then also remains incomprehensible why critique fails in its very objective success or, more precisely, why it cannot perceive its own (legitimizing) success any other way than as a degeneration of its (initial and pure) intention.

In this context, an acceleration of critique means giving up a supposed external ideal in favor of accepting an originary alienation. But it also means using the position of embeddedness to create an opening toward the future.[46] One's own imperfections will then point the way to changed and future norms (*ought* rather than *is*). All too often, however, the only criterion employed is the empirically contingent (or always existing) possibility that a critical position is either not adopted or eventually worn down, and all involved succumb to an inexplicable nostalgia.

Jacques Rancière provides a telling example: the Situationist avant-garde. Its evolution highlights the consequences of objective success: artistic or aesthetic critique functions as the mirror of a criticized reality—for example, subjects' desire for a creative existence and aesthetic satisfaction paves the way for a post-democratic transformation—which is misunderstood by subsequent critique as having objectively failed. "The trajectory of Situationist discourse—stemming from an avant-garde artistic movement in the post-war period, developing into a radical critique of politics in the 1960s, and absorbed today into the routine of the disenchanted discourse that acts as the 'critical' stand-in for the existing order—is undoubtedly symptomatic of the contemporary ebb and flow of aesthetics and politics, and of the transformations of avant-garde thinking into nostalgia."[47]

The legitimizing function of critique—the exact opposite of what critique sees itself as doing—is apparent in the domain of politics as well. First of all, critique is evidently the preferred reflex response to acute crises within the

[46] Alex Williams and Nick Srnicek, "#Accelerate: Manifesto for an Accelerationist Politics," in *#Accelerate: The Accelerationist Reader*, ed. Robin Mackay and Armen Avanessian (Falmouth: Urbanomic, 2014), 347–62.

[47] Jacques Rancière, *The Politics of Aesthetics: The Distribution of the Sensible*, trans. Gabriel Rockhill (London: Continuum, 2006), 3–4.

neoliberal order.[48] Permanently declaring a state of crisis is a strategy (easily unmasked by the critical Left as a pretense) for legitimatizing constant "reforms" whose sole purpose is to ramp up international competition and further dismantle the welfare state. Declaring a state of crisis is an expression by the deceptive or deceived consciousness of a change that sees what is present as objectively given, considers the current order to be in danger, and seizes every opportunity (or produces such crisis opportunities on purpose) to expand economic power by ever more (governmental) control. Yet the critical reflex reacting to declarations of crisis is counterproductive in that it merely contributes to stabilizing the crisis discourse: the shady "managers" of the financial crisis are no less dedicated to criticizing the current state of affairs than are those who criticize them, who already see late capitalism as being in crisis (for centuries at that). Each side is transparent to the other, but not to itself.

> Within the neoliberal order, critique is the preferred reflex response to acute crises.

Since "crisis" is obviously an ideologically charged term, I am less interested in giving a global definition, or in how and where this phantasm runs amok, than I am in the question of why there seems to be no remedy against the crisis discourse. After all, what is the usual reaction (of the Left) to put a stop to this discourse and its disastrous effects? The name of the preferred mode of reaction to all acute *crises* of neoliberalism is *critique*. Crisis and critique are a perfect team; the former does not simply give rise to the latter (as Reinhart Koselleck would have us believe).[49] Each implies the other, each depends on the other. It is almost as if both misunderstand each other just as much as they

48 "Crises being 'the means immanent to the capitalist mode of production.'" Gilles Deleuze and Félix Guattari, *Anti-Oedipus: Capitalism and Schizophrenia*, trans. Robert Hurley, Mark Seem, and Helen R. Lane (Minneapolis: University of Minnesota Press, 1983), 230. On the relationship between critique and crisis, see my chapter, "Krise — Kritik — Akzeleration," in *#Akzeleration*, ed. Armen Avanessian (Berlin: Merve, 2013), 71–77.
49 Reinhart Koselleck, *Critique and Crisis: Enlightenment and the Pathogenesis of Modern Society* (Cambridge, MA: MIT Press, 1988).

understand each other's strategy (i.e., that "crisis" is an excuse and that "critique" is compromised).

A closer look reveals once more the schema analyzed earlier: 1) critique legitimizes crisis, and vice versa; 2) even neoliberal aficionados of crisis are eager to critique; 3) leftist critics remain under the spell of the crisis, danger, and decline they constantly try to ward off; and 4) critics legitimize themselves as the only possible "critical" authority at the same time as they legitimize the crisis and those who declare it.

Before turning to the aesthetic and economic aspects of critique, I'd like to take another look at its function of (political) legitimization, this time in the domain of knowledge—the main focus of this book. What we find here is the structural schizophrenia that, drawing on Pierre Bourdieu and others, I will show to be the hallmark of the university's self-conception.[50] The polarization of the academic domain Bourdieu describes results from academics' delusions about their own position and their future. The ideology of the university as possible site of both unfettered research and the subject's auto-education remains alive and well today—what is not faring well is "merely" the illusion that the actually existing institutions could even come close to living up to this promise.

Were we to assign a date to the general realization that the options for social and professional advancement—which the bourgeoisie had previously regarded as a matter of course (as reward for disciplined autonomous education)—were illusory, it would have to be 1968. Without meaning to sideline the progressive achievements of the student movement (especially in social policy), we cannot but note that in our context, the critique articulated by this generation has to be understood first of all as a reaction to this "crisis." Such a schema, however, has long been operative in the German research university (and in its wake, in the American research university); we might call it the *irony of the Romantic university*. It brings out what only appears to be a paradox: critical self-knowledge asserted itself at the latest by 1968, at a point when the educated classes' usual mechanism of advancement was no longer running smoothly. Yet the

50 See Pierre Bourdieu, *Homo Academicus*, trans. Peter Collier (Stanford, CA: Stanford University Press, 1988).

critique of the mechanisms of power and reproduction responsible for this failure consolidates the very logic that eventually led to the dismantling of those achievements that were intended to broaden access to higher education and make academic knowledge less exclusive.

The academic university, Reckwitz tells us, is one of the apparatuses that critically regulate today's "aesthetic capitalism";[51] in other words, the university works according to a neoliberal aesthetic critique. According to Brian Holmes, "By co-opting the aesthetic critique of alienation, the culture of the networked enterprise was able to legitimate the gradual exclusion of the workers' movement and the destruction of social programs. Thus [...] a selective, tendentious version of artistic critique emerged as one of the linchpins of the new hegemony invented in the early 1980s by Reagan and Thatcher, and perfected in the 1990s by Clinton and the inimitable Tony Blair."[52]

This sheds light on another effect of critique: its application—in politics, art, or academia—not only reveals its purely negative character (constant innovation concurrent with the impossibility of transforming norms), it also establishes a permanent dialectics of negation. This is what Bourdieu describes as developing an awareness of the power of powerlessness, the particularity of the total, the professionalism of dilettantism, etc. This resembles what takes place in the art field when artists conceive of themselves as anti-artists and thereby define the concept of art in a dialectic relation to the concept of anti-art. This results in an "expanded field" ("expanded cinema," "expanded academia") in which boundaries are constantly displaced and transgressed. In turn, this expanded field is based on a negative dialectics: critique collaborates in fixing the (new) boundaries of each field by reflecting upon it. Part and parcel of this inverted Mephistophelism (which, unlike Goethe's figure, always wants the good but causes the bad) is an automatic increase in abstraction and knowledge that comes with dialectic thinking: in

51 Reckwitz, *Die Erfindung der Kreativität*, 11.
52 Brian Holmes, "The Flexible Personality: For a New Cultural Critique," *Transversal*, January 2002, http://eipcp.net/transversal/1106/holmes/en. Citing Thomas Frank's *The Conquest of Cool*, he continues: "The result was a change in 'the ideology by which business explained its domination of the national life'—a change he [Frank] relates, but only in passing, to David Harvey's concept of 'flexible accumulation.'"

being transgressed, the boundary appears to withdraw from an ever more abstract knowledge or distance itself from it, like an unattainable horizon. It is not by chance that this hyper-reflexive dialectics produces a genuinely aesthetic effect: like the critical corruption of art objects, such epistemological unattainability lends itself to aesthetic-contemplative consumption. Self-reflexive immanent criticality is rewarded for its efforts in stabilizing the system with an aesthetic surplus pleasure: with the pure form of aesthetic pleasure of the subject reveling in itself, delighting in the unison of its critical-reflexive faculty with the nature of the social totality.

This points to one more reading of Kant's definition of enlightenment quoted at the beginning, which has a result (as so often in Kant) as unsettling as it is amusing: the true sign of enlightened societies is the high number of errors. Kant's enlightenment program posits unreason as primary. The progress of reason thus takes place only in a critique of unreason and the discovery of its errors. This means that progress or becoming enlightened is not measured by the amount of knowledge accumulated but by an insight into (one's own) ignorance. This structural schizophrenia has a correlate in the impossibility of using "one's own reason" as one's own. (It results from the illusory humanist definition of an essence of the human that precedes oneself. The alternative model of a future-oriented inhumanism or Prometheanism has "reason" constantly re- and overwrite the definition of the human.) Taken to its logical conclusion, this means that the most enlightened society is not the one that knows the most but the one that presents the most errors. Accordingly, the constant demand for critique exposes an inhuman truth about our critical society: the more reasons it offers for critique, the more progressive it is.

Knowledge, Desire, Economy

> I wanted to be a physician, not a small business owner, says the doctor with a sigh. I wanted to be a scientist, not a writer of grant proposals, adds his colleague. I wanted to be a journalist, says a third, not chase after ratings. And I, says the mountaineer, wanted to climb mountains, not advertise energy drinks. I wanted to write novels, not stare at bestseller lists, says the author. I wanted to tend my garden, adds someone, but to pay for its upkeep I had to have it photographed for *Better Homes and Gardens*. And I, says the artist, really wanted to make art. Hearing this, the others have a good laugh.
> —Markus Metz and Georg Seeßlen, *Geld frisst Kunst–Kunst frisst Geld*, 2014

The blind spot of critique is its legitimizing dimension. Every suspicion that this blind spot exists is driven away by a differentiation of the concept of critique, which always aims to be (and sometimes unfortunately is) even more critical. The parallel observation that modernism's critical impulse (however radical it may be in theory) fails to attain its goal (instead of transforming the given, it merely brings out what is already latently present) has frequently caused frustration and astonishment. For two hundred years now, critical impulses have not only been integrated into the structures of capitalism but have even become—especially since the second half of the twentieth century—a driving force of the capitalist economy. And as Markus Metz and Georg Seeßlen write in *Geld frisst Kunst–Kunst frisst Geld* (Money eats art—Art eats money), "A society of economic and cultural subjectivity is best controlled, horizontally, by means of aesthetics (taste, fashion, signs) and, hierarchically, by means of art."[53] Artistic critique is the matrix of present-day neoliberalism.

53 Metz and Seeßlen, *Geld frisst Kunst*, 364.

Luc Boltanski and Ève Chiapello provide a lucid analysis and differentiation of (late) capitalist society's aesthetic structure and the artistic critique that determines it. They distinguish between a first spirit of capitalism, of the (Protestant) Manchester variety; a second spirit that drives the technological progress of modernity; and a third, the *new spirit* of capitalism of the last few decades. The three spirits of capitalism form part of the discourses necessary for the "accumulation of capital." This accumulation requires the integration of large groups, if not masses of people. To motivate them to participate, it takes a promise of liberation, the promise of a "common good." In the case of the first spirit of capitalism, this promise was the liberation from feudal forms of domination; the second hoped for a liberation, driven by technological progress, from the constraints of class society.[54] The third spirit of capitalism, roughly characterized by the transition from a focus on production to a focus on consumption, is based on critique, especially the form that Boltanski and Chiapello—"to express its origin in the Parisian Bohème"—call artistic critique. Boltanski writes, "While social critique [which continues the tradition of the labor movement] aims primarily at solving socio-economic problems by means of nationalization and redistribution, artistic critique is centered on an ideal of individual autonomy, self-realization, and creativity, an ideal that contradicts all forms of hierarchical power relations and social control."[55]

54 See Boltanski and Chiapello, *New Spirit of Capitalism*, 433–48. They note a "confusion between two interpretations of the meaning of the term 'liberation'. Liberation can be understood as *deliverance* from a condition of *oppression* suffered by a people, or as *emancipation* from any form of *determination* liable to restrict the self-definition and self-fulfilment of *individuals*" (ibid., 433; italics in original). Brian Holmes, in "The Flexible Personality," writes on this point: "Each age or 'spirit' of capitalism must justify its irrational compulsion for accumulation by at least partially integrating or 'recuperating' the critique of the previous era, so that the system can become tolerable again—at least for its own managers. They identify two main challenges to capitalism: the critique of exploitation, or what they call 'social critique,' developed traditionally by the worker's movement, and the critique of alienation, or what they call 'artistic critique.' The latter, they say, was traditionally a minor, literary affair; but it became vastly more important with the mass cultural education carried out by the welfare-state universities. Boltanski and Chiapello trace the destinies of the major social groups in France after the turmoil of '68, when critique sociale joined hands with critique artiste."
55 Luc Boltanski, "Leben als Projekt: Prekarität in der schönen neuen Netzwerkwelt," trans. Robin Celikates, "Ökonomisierung," special issue, *Polar*, no. 2 (2007), http://www.polar-zeitschrift.de/polar_02.php?id=69.

Artistic critique offers answers to the ever more urgent question of the ontological status of the artificial.[56] What is the nature of everything produced in the last few centuries by a capitalism with no relation to nature that is unable, despite a large number of (ideological) attempts, to base its existence on an ontology? Artistic critique thus usefully derives the status quo from an artificial origin. We will see in detail that producing a model of subjectivity that corresponds to this *aesthetic justification of the world* (to use Nietzsche's terms) is the central achievement of the Romantic research university: the artistic-creative subject.

Several centuries of capitalist development (and the political catastrophes of the twentieth century that unfolded alongside it) raise the question of how we are to deal with the historical contingency just mentioned. Here, too, artistic critique has provided answers and succeeded in allaying the fears many of today's lifestyles inspire. Contingency and arbitrariness as well as spontaneity and idiosyncrasy have become, at the latest since Baudelaire's dandyistic aesthetics, an inherent part of the kind of heroic-modern morality that seeks to capture something permanent or eternal in every fleeting moment, albeit not in any classicist sense but according to the "model of an aesthetic existence"—that is, in the form of a "continually affective fascination" with aesthetic experiences.[57]

Another aspect concerns the possibility of perceiving and describing difference(s). Critique (specifically that of the various avant-gardes) has made important contributions in this domain in the way it determines the ontological status of things; above all, as we have seen, their negativity. And this negativity, precisely, is what the third spirit of capitalism shares with artistic critique (in critical theory, the relevant keyword is "aesthetic negativity").

Given these achievements, there is no point in criticizing the effects of artistic critique or the art market as artificial, contingent, and thus merely negative. Artistic critique and the art market generated a new model of productivity, a de facto noncritical poiesis. Rather than criticizing critique, we need first of all to understand how exactly artistic critique is complicit

56 This can be seen even in residual, folkloric forms, such as green consumerism.
57 Reckwitz, *Die Erfindung der Kreativität*, 314.

with capitalist practices and to what extent we have to attribute necessity to the "rampant exploitation" we find in the art world and its labor relations, which serves as the matrix of economic exploitation in society as a whole.[58]

> In capitalist competition, success results from a radical critique of competition and its criteria.

To get a better sense of the specific economics of critique, let's take a quick look at the caste of critical intellectuals "who have one foot in the bohemian world of creativity and another foot in the bourgeois realm of ambition and worldly success," as David Brooks describes in his book *Bobos in Paradise*.[59] From an economic point of view, the thesis put forward by the *New York Times* columnist—that countercultural values have permeated the business world, the only sphere of American life in which people can still talk of starting a revolution and be taken seriously[60]—means that the ascending artistic class did not end up on top in capitalist competition by trying to win.[61] Perfidiously, its economic success instead is owed to its constant radical critique of the criteria of competition.

Critique legitimizes, and the more self-confidently it is pronounced, the more successful the critic will be in the competition for attention, resources, and status. Competitions, however, are not a given; rather, the frameworks they institute are always already distorted. That is why the critique of such frameworks always comes with half-hearted alliances and maneuvering. Such evasive displacement

58 Hito Steyerl writes: "I'd guess that—apart from domestic and care work—art is the industry with the most unpaid labor around. It sustains itself on the time and energy of unpaid interns and self-exploiting actors on pretty much every level and in almost every function. Free labor and rampant exploitation are the invisible dark matter that keeps the cultural sector going." Hito Steyerl, "Politics of Art: Contemporary Art and the Transition to Post-Democracy," *e-flux journal*, no. 21 (December 2010), http://www.e-flux.com/journal/politics-of-art-contemporary-art-and-the-transition-to-post-democracy.
59 David Brooks, *Bobos in Paradise: The New Upper Class and How They Got There* (New York: Simon & Schuster, 2000), 11.
60 Ibid., 110–11.
61 See also Sharon Zukin, *Loft Living: Culture and Capital in Urban Change* (Baltimore: Johns Hopkins University Press, 1982).

of competition thus not only helps in legalizing competition but also in renewing it by way of a constant dialogue with its critics. These are the two effects of the critical procedure I have already described. The exploited in this process are the artists; the acquired means of production is critique; the product is the dynamics of competition—and the profiteers are the critics themselves.

This schema, or small-scale drama, is easily discerned in an example that offers itself for spelling out the particular logic of desire (better, the peculiar cycle of desire) of an ascending middle class, especially with a view to what has happened in Berlin over the last two decades. (There are parallels, of course, with developments in major cities worldwide, especially in New York City's past and present.) Upper-middle-class kids from places like the United States and Denmark move to Berlin and put their bourgeois existence at risk by letting themselves be exploited by some art-world institution or another, or by one of the small publishers who function according to the principles of neoliberal start-ups, or … or … the creative possibilities are endless. As artists and intellectuals, as participants, generally, in the cultural spectacle, they are the vanguard of a gentrification that will push them out a few years later. For a short time, "artists can regard themselves as scouts of fortune who win, often by incurring great losses (bourgeois existence, future), a few years of excesses, opportunities, and coincidences. They then assist in furnishing the neighborhood with the image of an artists' quarter, which is then sold to the kind of affluent renters who, during the lifetime others devoted to excess, completed their education and now seek to use the high price they pay for rent to buy back some of the life they missed as well."[62]

The scenario described here by Diedrich Diederichsen isn't the only possible scenario. We might think of situations that function more on a family model and thereby highlight the capitalist zero-sum game all the more. It might just as well be that once the German or American middle-class scion has contributed to gentrifying the neighborhood, it is her uncle

[62] Diedrich Diederichsen, *Der lange Weg nach Mitte: Der Sound und die Stadt* (Cologne: Kiepenheuer & Witsch, 1999), 235.

who buys one of its apartment buildings and turns it into condos. (In another variant that occurs more and more often as the baby boomers die off, the adult children of doctors and lawyers do this themselves—with the money they inherited from their parents or grandparents.) Increasingly, too, foreign-born artists, initially attracted by low studio rents, succeed in turning a condo into their artistic base. This second scenario is not simply a cynical exposition of the failure on the part of both the artists and the children of the bourgeoisie. Instead, it juxtaposes two parties who have achieved a synthesis and critical success in the creation of a new artistic upper class.

There is, therefore, no need to come to a decision about whether artistic critique is positive or not and for whom. The interesting point is whether and how it has effected political and social change.[63] Its achievement is in no way diminished by its stark contrast with the norms championed by art and critique. This contrast, however, might explain why, in Boltanski and Chiapello's view, "artistic critique is currently paralysed by what, depending on one's view-point, may be regarded as its success or its failure. It was successful in the sense that [...] from the end of the 1960s it coincided with the aspirations of an enormous audience. [...] It failed inasmuch as the liberation of desire has not sounded the death knell of capitalism, as heralded by Freudo-Marxism between the 1930s and the 1970s. Moreover, that belief entailed ignoring freedom's implication in the regime of capital and its profound complicity with desire, on which its dynamic to a great extent rests."[64]

I mentioned earlier the ontological questions of capitalism that artistic critique was able to respond to in terms of concrete experiences in modernity, questions concerning our relation to artificiality, contingency, and negativity. This opens up an additional dimension—namely, Foucault's critical ontology of subjects—as well as the possibility of articulating an ethics of the subject starting from the desire of the subject. In what sense is capitalism

[63] See Tom Holert, "Something Other than Administrated 'Quality': Art Education and Protest 2009/1979," trans. Erika Doucette, *Transversal*, October 2010, http://eipcp.net/transversal/1210/holert/en.

[64] Boltanski and Chiapello, *New Spirit of Capitalism*, 466–67.

in league with our desire? At which points do we hook up with capitalism? And what if, as accelerationists have argued in recent decades, capitalism has a perfidious knack for finding a way to satisfy people's needs instead of frustrating or suppressing them (as the canon of leftist critique claims)?

Picking up on these questions allows us to give a more detailed analysis of the relation between economic and symbolic capital in the academy, a relation that has received much scrutiny in the wake of Bourdieu's sociological analyses. Within the aesthetic paradigm or regime, symbolic capital has also been thought of as critical capital. Both views, however, are insufficient. Viewing the symbolic capital of the dominant cultural faction exclusively as a subcategory of capital runs the danger of viewing it only from the perspective of (the economically dominant) power. It obscures an economy (of desire) proper to symbolic capital, an order of dominance with its own forms of production (producing critical subjects), reproduction (in teaching, for example), and products (innovative research results).

That is why a Lacanian reading of "symbolic capital" is helpful in understanding the economy of the symbolic as (also) an economy of desire. The production and appropriation of symbolic capital is guided by a surplus enjoyment and can be judged in terms of an orientation toward desire. Only if we add this perspective to the terms of power and politics can we understand the pertinence of inquiring into the economy (of desire) of research and how it relates to a morality and ethics of knowledge production. Neither a lack of interest (autonomy) nor political involvement (critique) provides sufficient criteria.

> Which economic desire is the production of symbolic capital based on?

Bourdieu's analyses extrapolate from two fields that the French university system tends to keep separate: research (the production of innovative knowledge) and teaching (the reproduction of the canon). In Germany, as we have seen, a different academic tradition has been dominant since Romanticism—at a later date, it takes over in other countries as

well, the United States among them. In the next chapter, I would like to lay out the ironic solution arrived at by idealistically *and* romantically developing the research policies initiated by Prussian administrators and Berlin idealists.

As I have stated, the production of symbolic capital is not exclusively a matter of power and politics. An analysis of the economic dimension of the will to (innovative) knowledge takes us further. The innovative appeal of Humboldt's university model rests, above all, on the promise of connecting the two poles—free research and the reproduction of the canon in teaching. This system is deceitful if only because it pretends to be entirely geared toward research and originality to give free rein to a voluptuous desire for truth, while actually it primarily serves the purpose of reproduction: the reproduction of a structure (of the subject and of knowledge) understood as dynamic and oriented toward innovation. The canon of knowledge and objects worth knowing is being reproduced; not simply copied but (gently) modified and thereby made to fit an ever-evolving state of research. The pole of teaching, put bluntly, establishes a framework in which the pole of critical research may "freely unfold." This loop abolishes the paradox and ensures that even in the humanities, the hope for discovering ever-new novelties never dies. Ironically, the modern university, geared as it is by nature toward innovation, hardly leaves any room for the truth to unfold, but instead vociferously demands of the subjects caught up in it critically to fathom boundaries and to respect them: *Think for yourself! Be critical!*

The Art(s) of Academic Knowledge

On the Promise of Critical Research

> The researcher as modern hero of knowledge, the civil servant as work of art (*der Staats-Beamte als Kunstwerk*). As absolute inversion, it was a work of Germanic irony. —William Clark, *Academic Charisma and the Origins of the Research University*, 2006

Confronted with the modern research university's high-minded promise of free and therefore pleasurable research and with the ensuing production of a critical mind, an immanent critique of the university as it actually exists is insufficient and powerless. Critique or critical knowledge has its origin in Germany, where the Romantic university was its first home. Its main achievement lies in having produced an actually new (and still effective) relation between subject (researcher), world (institution), and (critical) thinking, and having endowed it with a universally valid currency: symbolic capital.

A genealogical look back at the history of the German research university and the concept of "critical knowledge" it established shows that this new paradigm could become dominant only under the auspices of the aesthetic. To counter utilitarian and commercial interests, Fichte already proclaimed the university to be "*a school of the art of the scientific employment of reason*" and of "the practical employment of the art of science in life," from which "*artists* in life" are to emerge.[65]

[65] Fichte, "Deduzierter Plan," 34 (emphases in original); see also Clark, *Academic Charisma*, 443.

For Fichte, the connection of art and science—art and academic knowledge—takes the following form: the essence of academic teaching "is the art of training the academic artist himself. This art presupposes a science of the art of academia, which, to be possible, presupposes that one possesses this art. In this union and synthesis thus consists the essence of a teacher in an art school of the scientific employment of reason. The principle thanks to which the art of academia raises itself to this level is the love of art."[66]

The implicit recourse to the medieval tradition of the *artes liberales*, embodied in the university professor, tends to obscure the fundamental oxymoron of modern or innovative research, the combination of (innovative) research and (canonical) teaching. Yet it comes out all the more clearly when we recall that it represents the apotheosis of a cultivation of the academic as artist that delineates itself, on the one hand, from medieval knowledge (by making the canon more dynamic) and, on the other, from the ideal objectivity of empirical natural science (by focusing on the researcher's personality).

The exceptional nature of this new ideal university is evident in the ideas concerning the training of students that German idealists and Romantics propagated, especially a new conception of academic qualification. In this case, the modern research university begins with a bona fide archaism—namely, the rehabilitation of the medieval doctoral degree, which had lost its significance over the course of several centuries. In addition, there is a telling shift in the respective valuation of *dissertatio* and *disputatio*—the written and oral parts of qualifying examinations. Up to around 1800, the dissertation was more of a list of theses on which to base the disputation. William Clark writes: "The disputation was an oral event. It aimed not at the production of new knowledge but rather at the rehearsal of established doctrines. What was produced—oral argument—was consumed on the premises. The disputation did not accumulate and circulate truth."[67] The purpose of the disputation was for the candidate to prove that he was familiar with the canon, that he embodied the knowledge handed down by tradition, and that he was able to hand it down himself by teaching. In Humboldt's

66 Fichte, "Deduzierter Plan," 44.
67 Clark, *Academic Charisma*, 79.

university, on the contrary, doctoral candidates were expected to make an innovative, original research contribution in their dissertation.

The thrust of innovation that does in fact come with the invention of the German research university is based on an institutional innovation: an elegant (because innocuous) fusion of two opposing endeavors. It combines the production of new knowledge with the conservation of tradition; in short, research and teaching. Research now finds itself tied in with tradition in a new way. It is a "living tradition" that cannot simply be regarded (and handed down) as given; it must be nurtured hermeneutically and interpretatively. That is why it is perceived as both changeable and unavoidable. In the modern research university—as it sees itself and becomes so attractive for a critical economy of desire—new knowledge and tradition, innovative research and teaching, are not played off against each other but enter into a symbiotic relationship. The "ideology" (using the term non-pejoratively) of the modern university states that it freely allows its subjects, which strive for the truth, to undertake their research and develop their personality according to the principle of self-formation.[68] Here, and in what follows, I follow Foucault's supposition:

> The will to truth had its own history, which is not that of constraining truths: the history of the range of objects to be known, of the functions and positions of the knowing subject, of the material, technical, and instrumental investments of knowledge. This will to truth, like the other systems of exclusion, rests on an institutional support: it is both reinforced and renewed by whole strata of practices, such as pedagogy, of course; and the system of books, publishing, libraries; learned societies in the past and laboratories now. But it is also renewed, no doubt more profoundly, by the way in which knowledge is put to work, valorised, distributed, and in a sense attributed, in a society.[69]

68 This promise of free research and university autonomy goes beyond financial security but was, from very early on, tied to standardization measures: "The promise of a scholarship, even if dim, coupled with the threat of its removal, facilitated the recasting of seminarists into the standardized shapes sanctioned by the ministry and directorate" (ibid., 171).

69 Michel Foucault, "The Order of Discourse," trans. Ian McLeod, *Untying the Text: A Post-structuralist Reader*, ed. Robert Young (Boston: Routledge & Kegan Paul, 1981), 55.

But, unlike Foucault, I am concerned less with questions of the valorization, control, selection, organization, or channeling of discourses than with the evasive maneuvers tied in with academic discursive strategies—with strategies of evading truth, evading a desire for absolute knowledge that, in spite of a basic will to knowledge, tends to be excluded. Making this distinction is crucial for an ethics of knowledge that emphatically thinks truth in conjunction with a transformation of the subject tied to truth. Today, such an ethics of knowledge can only emerge in a poetic engagement and manipulative confrontation with the critical self-conception of the research university, whose ideological success is predicated on suppressing its truth. Lacan's sly comment that "knowledge has, for centuries, been used as a defense against the truth" is thus right on the mark.[70] To justify the provocative thesis that academic knowledge serves primarily to evade the truth, we have to look at, among other things, the difference between an absolute desire for truth and the state-sponsored will to knowledge. In terms of the current state of affairs, the question is: How does the hegemony of the contemporary aesthetic regime of thinking organize our (knowledge) society, and how does it control and evaluate the materiality of academic writing?

In stark contrast to the tradition of French or English universities, Fichte assigned a new significance to the written qualifying paper (*Qualifikationsschrift*). "This dissertation," writes William Clark, "put novel demands on the doctor of philosophy. The medieval master of arts had been obliged only to prove himself able to enact an—albeit heroic—disputational role, as good as everyone else. […] The doctor of philosophy, as authorial persona, exhibited the qualities of the Romantic artist, 'originality' and 'personality.'"[71]

This originality, which seems to come from out of nowhere around 1800, is obviously conceived of aesthetically and comes into being via critique. Today, still, researchers accordingly define "research" as "a process in which new perspectives and reflections are introduced. Critique is an

[70] Jacques Lacan, *Seminar XIII: L'objet de la psychanalyse* (lecture, January 19, 1966), http://staferla.free.fr/S13/S13%20L'OBJET.pdf, page 92.
[71] Clark, *Academic Charisma*, 211.

indispensible element of research."[72] Philological research or attempts at unearthing an originary meaning obscured by history (an activity still very much in vogue) are not to be an impediment to the Romantic academic-artist but, on the contrary, spur on his original research. The originality Fichte speaks of is fundamental for a new economic order and the accumulation and production of innovative knowledge, which revivifies the past and thus allows it to be communicated through teaching in the first place.

The order of knowledge laid out in Humboldt's ideal of education has a social dimension that (in opposition to the nostalgia concerning it) is not without (dialectical) conflict with civil society. As Clark writes: "Humboldt contrasted the pernicious special interests of civil society with the necessary solitude and freedom that should be guaranteed by the state to the university. On this view, state and university worked together."[73] To this day, our innovation-oriented universities try to come to terms with such (mis)conceptions of their bureaucratic identity. "The solution from 1806 to 1810 via Fichte, Schleiermacher, Humboldt, and others was simply to move away from the theory-less enlightened revolutionary to the artistically charismatic Romantic bureaucrat. The rapid bureaucratization of German academic life in the wake of the so-called Humboldtian reforms would be, then, not a sign of their failure, as the great minister and his epigones may have read them. It would be, rather, a mark of their singular success."[74]

Much derided though it is, bureaucratization remains an indispensible condition of professional training that is based on disciplinary competence and authority, just as Max Weber described it.[75] The Prussian state was not just the model for the bureaucratization of the university, nor was the economy of Prussian state power simply an application of the principles of reorganizing and evaluating academics—in fact, the Prussian *Policeyministerium* was a partner in the foundation of the new university. Clark describes how the enlightened *Policeystaat* thus lays out the modern space of negotiating knowledge: "Policies

72 Michael Ochsner, Sven E. Hug, and Hans-Dieter Henschel, "Four Types of Research in the Humanities: Setting the Stage for Research Quality Criteria in the Humanities," *Research Evaluation* 22, no. 2 (June 2013): 80.
73 Clark, *Academic Charisma*, 446.
74 Ibid.
75 See Matti Klinge, "Die Universitätslehrer," in *Geschichte der Universität in Europa*, vol. 3, ed. Walter Rüegg (Munich: C. H. Beck, 2004), 116.

of the German police state served to extract the category of labor from that of academic life. Such policies helped to dissolve the traditional, juridico-ecclesiastical space of academic charisma, embodied in the catalogue of professors, and to replace it with the new rationalized, politico-economic regime displayed in the catalogue of disciplines, a list of labors."[76]

Such a tight interweaving of bureaucracy, knowledge, and economics can be traced even in the newly conceived course schedules that serve to control and evaluate the faculty.[77] The Prussian doctor of philosophy, with his well-documented curriculum vitae, with registered character witnesses who evaluate him, with all sorts of bureaucratic paperwork, is indeed an invention of Romantic irony.

The fact that autonomous thinking goes back to an order issued by a government department charged with matters of education should not, however, lead us to a simplistic criticism of the institutions as they exist today or of the critical knowledge they produce. Citing Frederick the Great's order to think for oneself is not the same as saying that political power has defiled critical knowledge. Instead, we have to appraise the invention, the effects, and the productivity of the new model of knowledge. Also, that ingenious order is but a concise interpretation of Kant's commandment to make use of one's own understanding, as well as a (philologically impeccable) translation of the Latin motto *Sapere aude!*

Kant's essay "What Is Enlightenment?" famously ends with an appeal to Prussian state power, personified by Frederick the Great, to recognize (and respect) boundaries. The enlightened ruler is to draw the boundaries for his

76 Clark, *Academic Charisma*, 58.
77 Assessments by David Francis Mihalyfy regarding the economy of the university in the journal *Jacobin* need to be nuanced. It is indeed true that "the ideal of administrative public service has been gradually replaced with that of maximizing short-term self-interest, despite debatable benefits to the institutions and the populations that they claim to serve," but only insofar as it fulfills a kind of inner truth of our academic system or ideals. With this in mind we can understand this statement even better: "Rather than being institutions that prioritize free inquiry, research, and high-quality education, universities are increasingly acting like the worst of Wall Street, where anything goes in order make a buck for the people at the top." David Francis Mihalyfy, "Higher Ed's For-Profit Future," *Jacobin*, June 7, 2014, https://www.jacobinmag.com/2014/06/higher-eds-for-profit-future/; "Higher Education's Aristocrats," *Jacobin*, September 27, 2014, https://www.jacobinmag.com/2014/09/higher-educations-aristocrats/.

subjects' knowledge within which they may develop their reason critically. When the Prussian police minister turns the maxim *Sapere aude!* into an order for precisely these subjects, he displays a refined sense of rhetoric, which proves him to be faithful to Kant, who himself appeals to Prussian politics: "Here a strange, unexpected course is revealed in human affairs, as happens elsewhere too if it is considered in the large, where almost everything is paradoxical. A greater degree of civil freedom seems advantageous to a people's freedom of spirit and nevertheless puts up insurmountable barriers to it; a lesser degree of the former, on the other hand, provides a space for the latter to expand to its full capacity."[78]

These historical observations show that critical knowledge does not merely enter into political contexts and is not merely tied in with economic practices; from a genealogical perspective, critical knowledge is a central, active instigator of the political-economic order (of a whole aesthetic regime). Hence it is important to understand the reciprocal effects exercised by (objective) discourse and those subjected to it. As Foucault says in his 1970 lecture "The Order of Discourse": "Doctrinal allegiance puts in question both the statement and the speaking subject, the one by the other. It puts the speaking subject in question through and on the basis of the statement, as is proved by the procedures of exclusion and the mechanisms of rejection which come into action when a speaking subject has formulated one or several unassimilable statements. [...] Doctrine brings about a double subjection: of the speaking subjects to discourses, and of discourses to the (at least virtual) group of speaking individuals."[79]

The Berlin model has been adopted throughout Germany and beyond. Long before the market expansion of the universities,[80] or their alleged fall from grace in hooking up with industry under neoliberalism, this model turned out to be a popular export. Its sales pitch is simple, economical, easy to grasp: "You know it yourself."

78 Kant, "What Is Enlightenment?," 21.
79 Foucault, "Order of Discourse," 63–64.
80 On the "university" business model (its growth and endowment models, tax avoidance, property investment, systematic increase of student debts, etc.) see, for example, John Cochrane, "University Debt," *The Grumpy Economist* (blog), March 20, 2014, http://johnhcochrane.blogspot.de/2014/03/university-debt.html.

It is hard to come up with a marketing ploy more insidious than the prompt to "think for oneself," which promises the subject nothing short of becoming itself in independent research—nothing short of attaining freedom. This is the crucial point of the economy of desire, of the amalgamation of the subjects of critical knowledge and symbolic capital as it has been produced in the universities. Since around 1800, a type of knowledge has been in vogue in Berlin (and soon afterward in other European countries and the United States) that is a product of immaterial labor and can be consumed by students. But students of course are not merely passive consumers. They do not become immaterial laborers producing such knowledge only after completing their studies; their enrollment is already an inscription in this recursive cycle. It is obvious that, for many, such a practice of knowledge is an addiction. The profound dependence the "self-thinking subject" thus enters into cannot be ascribed to contingent situations alone; the alliance between the economics of symbolic capital and the desire of the critically thinking subject is manifest long before the pervasive triumph of "cognitive capitalism."[81]

The promise to "think for oneself" has not only turned out to be a bestseller that, like all successful brands, works beyond its content. It is necessarily also at the source of an irremediable frustration for the interpellated subjects that are hopelessly addicted to their (will to) knowledge. The competitive neoliberal (academic) subject thus described is promised that it will gain hold of itself. To understand this promise, I would like to turn to the psychoanalytic discourse that has explicitly described the discourse of the university. Jacques-Alain Miller writes that there is "but one ideology Lacan theorizes: that of the 'modern ego,' that is, the paranoiac subject of scientific civilization, whose imaginary is theorized by a warped psychology in the service of free enterprise."[82] For the moment, I have to resign myself to merely sketching the bitter ethical consequences or tragedy easily entailed by a claim to an "absolute truth." A way out of this dilemma is suggested by a Lacanian ethics that not only determines the subject as a product of the discourse of the university

81 See Yann Moulier Boutang, *Cognitive Capitalism*, trans. Ed Emery (Cambridge: Polity Press, 2011).
82 Jacques-Alain Miller, "Clarification," in *Écrits*, by Jacques Lacan, trans. Bruce Fink, Héloïse Fink, and Russell Grigg (New York: W. W. Norton & Co., 2005), 852.

but also sees "truth" as an effect produced in the subject. This runs counter to the "production" of innovative knowledge sanctioned by the university. Such knowledge is *to be discovered* — that is, it is thought to be contained in the objects under investigation. The originality of the researcher, in turn, would consist in finding just this (as yet concealed) knowledge. In Lacanian psychoanalysis, in which the subject's knowledge is not supposed to play a decisive role, the production of truth is entirely different: it is, precisely, about the production of something. In Lacanian terminology, the subject has to transform its symptom into a *sinthome* — it has to transform the object of its desire into a thing and try to change itself. If the desire for truth can be distinguished from contemporary self-interested knowledge — and this is what makes Lacan's approach so helpful in the context of these historical and sociological reflections on the origin of today's production of knowledge — this distinction must be possible on all levels. It has to thwart the (institutional) strategies of knowledge and imply a different productive way of dealing with its objects — a real transformation (not just one merely *claimed* by critique) in which even the subject of truth will not remain unaffected.

> The promise of "thinking for oneself" has turned out to be a bestseller.

Before we turn to a detailed analysis of this poietic truth — a truth to be produced that is completely different from an aesthetic obsession with innovation — we have to take a closer look at the field where critical knowledge was erected, and where Fichte, in the wake of Kant, set up the paradoxical figure of the academic artist as central figure. The field of knowledge I am talking about is one of aesthetics, its boundaries defined by critique; the system, at its basis, is an aesthetic theory or science. Since the foundation of the German Romantic research university, this newly conceived aesthetic theory or philosophy has been defining the relationship between art and knowledge on which the aesthetic regime of thinking is based. Operated by an aesthetic critique influenced by the prospects of economic gain or loss, this regime achieved hegemony in the neoliberalism of the

late twentieth century. Thus, Andreas Reckwitz writes, a "creativity dispositif" (*Kreativitätsdispositiv*) has become effective in all social domains, constituting "an interface between a process of aestheticization *and* a social regime of the new."[83]

83 "The decisive point is this: within the creativity dispositif, the new is not conceived of as progress or quantitative increase but as an aesthetic *stimulation*, i.e. a stimulus perceived as perceptive-affective and positive" (Reckwitz, *Die Erfindung der Kreativität*, 40).

Inventing the Good Old Days

The Nostalgia of the Contemporary University

> What Rancière labels political philosophy [...] continues the work of the police [...] to establish the stable essence of the political. And the same could be said about the policing effects of the philosophy of art or of aesthetic theory.
> — Bruno Bosteels, *Some Highly Speculative Remarks on Art and Ideology*, 2012

We have seen that the complaints the economization and bureaucracy of the university give rise to today express a nostalgic mystification of Humboldt and his contemporaries. From a historical perspective, we are dealing with an outsourcing of the German model to American graduate schools—something usually forgotten in tirades against the twin terms of "economization" and "Americanization." "After the 1870s," William Clark writes, "the new graduate schools cultivated research, while the college had a traditional pedagogical mission. Confronted with the German research university, Oxford and Cambridge also began to change then too and, in the 1890s, so did the French."[84] If it is an import at all, the economic imperative—that is, the demand for originality and innovation—is a *re*import from America of a Humboldtian university model. Yet how is it possible that universities today do not recognize themselves in their original model but indulge in

84 Clark, *Academic Charisma*, 28.

a rhetoric that views the university as a "public sphere in which the use of reason is practiced for its own sake," as educational researchers Jan Masschelein and Maarten Simons write?[85] How is it possible that the invocation of Humboldt's ideal of education goes hand in hand with an almost inexplicable forgetfulness and nostalgic mystification?

This kind of approach works with a conception of knowledge that also mystifies the realities faced by students trained for the job market. Oriented toward "aesthetic production" (Fredric Jameson), obeying the regime of "the new" or of "aesthetic innovation" (Reckwitz), and outlined by the Romantic university, the concept of knowledge has been refined ever since Humboldt.[86] The university allowed the symbolic or intellectual economy, which Steven Shaviro sees as the matrix of the "relentless innovation" on which political economy is based, to come into existence.[87]

> "In today's capitalism everything is aestheticized, and all values are ultimately aesthetic ones." (Steven Shaviro)

The historical background I've sketched so far, the genealogical insight into the morality of the critical-aesthetic university, reveals how shortsighted criticisms of economization often are. Critiques of an alleged betrayal of Humboldt's ideal are rampant in current discourse.[88] This type of nostalgia is governed by a partial amnesia that particularly

85 Jan Masschelein and Maarten Simons, *Jenseits der Exzellenz: Eine kleine Morphologie der Welt-Universität*, trans. Florian Oppermann (Zurich: diaphanes, 2010), 46.
86 Fredric Jameson, *The Cultural Turn: Selected Writings on the Postmodern, 1983–1998* (New York: Verso Books, 1998), esp. 4–6; Reckwitz, *Die Erfindung der Kreativität*, 337.
87 "But we also live in an age of astonishing invention and relentless innovation, when, as Fredric Jameson puts it, 'aesthetic production' has become the 'dominant cultural logic or hegemonic norm.' Even positivistic science finds itself approaching ever closer to the condition of aesthetics." Steven Shaviro, *Without Criteria: Kant, Whitehead, Deleuze, and Aesthetics* (Cambridge, MA: MIT Press, 2009), 14.
88 Masschelein and Simons, for example, consider the public reason of the university to be endangered by an "innovation race associated with academic entrepreneurship." Jan Masschelein and Maarten Simons, "The University: A Public Issue," in *The Future University: Ideas and Possibilities*, ed. Ronald Barnett (New York: Routledge, 2012), 165.

concerns the economic backdrop of the "humanist ideal of education," whose preserve, the university, is thought to be endangered. Just as the great humanist universities, at the time of their founding, marginalized the colonial framework that made them possible, among other things, so today's universities ignore the social framework. What remains is the humanist phantasm of a free, self-educating individual.

The specificity of humanities research since the establishment of the modern research university—its critical economy proper—consists, as I've said, in the peculiar dialectic of research and teaching, production and reproduction. Up until then, teaching was devoted to an older ideal of knowledge, tasked with preserving and reproducing the canon. And the quality of teachers was measured by their ability to embody this canon. The Romantic doctrine of originality, on the contrary, calls on researchers to endow the canon with new life, time and again, and thereby to resolve the tension between tradition and innovation in the name of continual progress of academic knowledge.

There is a tension that derives from the dialectical relation between innovation and the philological preservation of past achievements. On the one hand, there is a call for socially relevant, up-to-date research, made manifest in the increasing importance of adjoining fields like journalism or the visual arts, which answer to the same critical-aesthetic imperatives as the humanities. On the other hand, the preferred discipline of the knowledge to be passed on is philology, which has time and again been reproached with marginalizing truly innovative research in the academy. One prominent example of such a marginalization is the discussion triggered by Nietzsche's *Birth of Tragedy*, which had a profound impact on the evolution of the discipline. Typical here is Richard Wagner's dictum that philology produces "nothing but more philologists" and is good for no other purpose.[89] The media theorist Friedrich Kittler, who has examined the theory of the university underpinning Nietzsche's case in great detail, generalizes this conception in the following

[89] Richard Wagner, "An Friedrich Nietzsche, ordentl. Professor der klassischen Philologie an der Universität Basel: Offener Brief (Sonntagsbeilage der *Norddeutschen Allgemeinen Zeitung* vom 23.6.1872)," in *Rezensionen und Reaktionen zu Nietzsches Werken, 1872–1889*, ed. Hauke Reich (Berlin: DeGruyter, 2013), 83.

terms: "The philosophical faculty and, specifically, the revalorized discipline of philology are pure systems of self-reproduction in the service of the university and the gymnasium,"[90] which at the time was the only type of secondary school in Germany whose diploma granted access to higher education.

Yet this omnipresent lachrymose critique of the humanities—referencing the obvious fact that most of the time the humanities don't even begin to live up to their claims and goals—overlooks their actual achievements. After all, research in the universities is "innovative." This innovativeness, moreover, serves a "humanist" (self-)education that does indeed aim for "progress" and even for an improvement of "humanity"—which is why the reproach that research in the humanities serves only to reproduce itself does not end up affecting it. And yet the reproach is justified insofar as it thinks the (dynamic) field of possibilities as given (or even fixed) within a space always already limited by the capacities of the subjects populating the university. Rather than deplore such humanist fixations, however, I want to explore the kind of inhuman procedures of (ethically true) knowledge whose "product," as Reza Negarestani writes, "does not correspond with what the human anticipates or with the image it has of itself."[91]

Kittler describes how the Romantic idea of original research was scaled down to the routine of teaching. Thanks to the articulation of an ideal of humanist self-education, in which education was no longer conceived of as the exclusive property of the educated,[92] this process also reproduced a certain ideal of productivity. It took place step by step: "Thus emerged, in strict correlation with the professorial interpreters of poets in the new philosophy department, teachers of language and literature in the gymnasium. The feedback loop of the gymnasium and higher education, from which philologies, until about 1960, derived all their legitimacy, started functioning."[93] Once the philological disciplines have been valorized as self-reproducing systems in secondary and higher education,

90 Friedrich Kittler, *Philosophien der Literatur: Berliner Vorlesung 2002* (Berlin: Merve, 2013), 229–30.
91 Negarestani, "Labor of the Inhuman," 436.
92 Which had characterized premodern concepts of education; see Baecker, *Kulturkalkül*, 19.
93 Kittler, *Philosophien der Literatur*, 152.

the loop is definitively completed: in the twentieth century, at the latest, masses of teachers' children become professors again. Put in polemical terms, "teachers' children" (*Lehrerkinder*) are a historically specific German version of the way the educated and well-off white middle class in Europe and North America, until recently, reproduced itself.

> What might a curriculum in the *inhumanities* look like?

Often deplored in debates about the reproduction of elites, the reproduction of parental status is not only evident in the increasing exclusion of students from immigrant and lower-middle-class families from universities.[94] It is manifest as well in the difficulties faced by students from less well-off families in eastern Germany or in American elite institutions' "diversity," which, as a *New York Times* op-ed piece stated, is "mostly cosmetic, designed to flatter multicultural sensibilities without threatening existing hierarchies all that much." The academic offspring has a cultural advantage: "They don't need to be told—that's how the system already works! The 'holistic' approach to admissions [...] privileges résumé-padding and extracurriculars over raw test scores or G.P.A.'s. [...] The result is an upper class that looks superficially like America, but mostly reproduces the previous generation's elite."[95]

Whether or not the frequently voiced impression is true that nonconformist behavior and thinking (political, academic, ethical) is given less and less room in the

[94] In an interview about German universities, Green Party politician Cem Özdemir said: "In Germany, what is reproduced is the status of the parents. Seventy-one percent of children whose parents have gone to university will do so too, but only 24 percent of children of those who have not will go. This has nothing to do with talent or intelligence. It is a social problem. Youth from socially disadvantaged areas do not receive the support they need. [...] Financial worries discourage many young adults from poorer families from taking up university study. And scholarships are addressed to the best, not to those in need." See "Cem Özdemir über Uni-Gerechtigkeit: 'Auswahl im Kreißsaal,'" *UniSpiegel*, June 28, 2012, http://www.spiegel.de/unispiegel/studium/gruene-chef-cem-oezdemir-warum-migranten-an-der-uni-fehlen-a-841345.html.

[95] Ross Douthat, "The Secrets of Princeton," *New York Times*, April 6, 2013, http://www.nytimes.com/2013/04/07/opinion/sunday/douthat-the-secrets-of-princeton.html?_r=0.

university—despite ritualized dissidence in lifestyle matters—this cannot be attributed to a failure of the university's ideals. On the contrary, it is precisely a consequence of the success of the academy's real historical mission. Nonetheless, the university's role as a generator of progress (i.e., increasing the productivity of symbolic or economic capital) becomes less and less significant the more the creativity dispositif coupled with the logic of innovation becomes omnipresent in the third spirit of capitalism. The more dominant that art (including its academies) becomes, the more that capitalist logic tends to be reproduced without having to funnel its subjects through traditional universities. The modern fusion of the reciprocal poles "innovative research" and "humanist teaching" begins to crack, and it becomes questionable whether, in the age of expanded academia, the capitalist machinery still needs the humanities (i.e., the academic-artists groomed in the university) to increase society's potential for innovation and creativity.

The social sciences have been very critical of the recruitment of the professoriate from the children of professors or teachers, regarded as a reproduction of social strata and power structures through paternalism and nepotism. Knowing what to do with what is learned in the research university—what Althusser calls "know-how-to-do" (*savoir-faire*)—applies above all to one's own career. "Theory is being used as a basis for social action and less as a tool for acquiring knowledge," writes cultural scholar Klaus Schönberger.[96] For instance, while the precarization critically lamented on the theoretical level may, as economic pressure increases, indeed lead to self-reflection, it hardly ever results in conflicts aimed at social liberation. Instead, what is unconsciously reproduced when teachers' children turn into professors is the superego. Graduate students hardly stand a chance against the full force of a professorial authority that may not be inherited genetically but is passed on and amplified by a patriarchal pedagogy.

96 Klaus Schönberger, "Studying Theory/Theories at Art School? On the Cultural and Social Analysis of Cognitive Capitalism," trans. Erika Doucette, *Transversal*, October 2010, http://eipcp.net/transversal/1210/schoenberger/en.

Yet what's so depressing about the current situation is not that young researchers might fail to live up to the Romantic demands for originality and authenticity the way earlier generations did. The general dejection is rather due to the fact that, to reproduce its aesthetic spirit, the critical capitalism (unconsciously) implemented by their forefathers has less and less need of this academic form of "innovativeness" and "originality." That task is increasingly taken over by other aesthetic practices, such as art itself. This is made obvious by the decay of the illusory unification of research and teaching, which is nonetheless still ideologically projected onto Humboldt. In fact, "research" today is increasingly reduced to being only *one* of the aspects that have been central for over two hundred years: gaining distinction within the scientific community.

The Humboldt model assigned a systematic position to the "original personality of the researcher" within the frameworks of a teleological philosophy of history and of the "humanist ideal" of education. This was the source of the esteem the academic-artist felt for himself—the feeling of making (i.e., producing) a difference and being socially relevant (be it in order to keep progress going, be it to satisfy capitalism's need for innovation—two aspects that, far from being exclusive, condition and amplify one another). As soon as academic-artists no longer labor under the illusion that their actions are always already embedded in a "natural" teleology (an illusion they have been losing since 1968, increasingly so in the new millennium), the realization that they are in a situation in which their achievements are rewarded (or even just recognized) only by success within the academic system creates an imbalance, and results in today's pervasive sense of dejection.

> Back then, original thinkers were still able to ... If the institution only let me ... I simply don't get around to writing under these circumstances ...

One decisive difference between the (idealist) Romantics and their successors, today's (neoliberal) late Romantics, so to speak, is that the former did not yet have to

operate under the omnipresence of the creativity dispositif. From this perspective, the nostalgia with which the latter yearn for the good old times or good old academic system is to be seen as a longing for a setting in which academic-artistic creativity (at least where the subject practicing it is concerned) could still make itself believe that it lived up to the demand for originality. This is no longer possible today, as the difficulties one encounters in trying to develop objective criteria for idealized (and idolized) "innovative research" show quite well. New methodologies are desperately repudiated by hordes of what might best be called "innovative philologists" until a new generation adopts them (to further their own careers).[97] The good old ideal of "paradigm-shattering" research still applies, but today's researchers associate it with academic working conditions that are a thing of the past.[98]

[97] A research group has empirically investigated these phenomena with particular reference to art history, English literature studies, and German literature studies: "Two criteria are not consensual in any of the three disciplines: *productivity* (i.e. continually or periodically generating research output) and *relation to and impact on society* (i.e. responding to societal concerns, studying topics relevant to society from the scholars' perspective, conveying findings to a non-academic audience, affecting local/regional/national culture). One possible reason why *productivity* does not reach consensus might be that scholars are not striving for continual or periodical output but rather for a few big intellectual achievements." Sven E. Hug, Michael Ochsner, and Hans-Dieter Daniel, "Criteria for Assessing Research Quality in the Humanities: A Delphi Study among Scholars of English literature, German Literature and Art History," *Research Evaluation* 22, no. 5 (December 2013): 376.

[98] "The factor and cluster analyses of the scholars' constructs, which were captured and rated using the Repertory Grid method, show that two conceptions of humanities research can be distinguished: 'modern' and 'traditional' research. They can each have a positive or negative connotation. This results in four types of humanities research: (1) positively connoted 'traditional' research, which describes the individual researcher working with one discipline, who as a lateral thinker can trigger new ideas; (2) positively connoted 'modern' research characterized by internationality, interdisciplinarity, and societal orientation; (3) negatively connoted 'traditional' research that, due to strong introversion, can be described as monotheistic, too narrow, and uncritical; and finally (4) negatively connoted 'modern' research that is characterized by pragmatism, career aspirations, economization, and pre-structuring." Ochsner et al., "Four Types of Research in the Humanities," 87.

Universal Depression

Research on the Verge of a Nervous Breakdown

> I think that throughout this historical period the desire of man, which has been felt, anesthetized, put to sleep by moralists, domesticated by educators, betrayed by the academies, has quite simply taken refuge or been repressed in that most subtle and blindest of passions, as the story of Oedipus shows, the passion for knowledge. That's the passion that is currently going great guns and is far from having said its last word.
> —Lacan, *Ethics of Psychoanalysis*

The logic of production in the humanities differs surprisingly little from the general neoliberal conditions of reproduction. In his analysis of the latter, Maurizio Lazzarato writes: "If production today is directly the production of a social relation, then the 'raw material' of immaterial labor is subjectivity and the 'ideological' environment in which this subjectivity lives and reproduces. The production of subjectivity ceases to be only an instrument of social control (for the reproduction of mercantile relationships) and becomes directly productive, because the goal of our postindustrial society is to construct the consumer/communicator—and to construct it as 'active.'"[99] Not surprisingly, academia is characterized by both a general depression and a high level of aggression that derive from

[99] Maurizio Lazzarato, "Immaterial Labor," in *Radical Thought in Italy: A Potential Politics*, ed. Paolo Virno and Michael Hardt (Minneapolis: University of Minnesota Press, 1996), 143.

the discrepancy between how one's creativity is seen by others and by oneself. Many academics remain imprisoned by this obsession with originality. When critical capitalism and, especially, fully aestheticized neoliberalism triumph, every nostalgic mystification of the university as a bulwark against a reality it has itself created has to be opposed with Luc Boltanski's lucid insight into the fact that "today, the anxiety-charged demand to be oneself is a moral imperative drummed into us from childhood onward."[100]

In his 2012 book *Die Erfindung der Kreativität* (The invention of creativity), Andreas Reckwitz describes the effects of this "creativity dispositif" on contemporary society. With a view to the concept of the academic-artist, I would like to nuance his general statement that in the eighteenth and nineteenth centuries the invention of creativity is modeled on the ideal of the artist (and, more widely, of art as compensation), which "since the 1970s has become independent of the countercultures and generalizes itself such that the 'creative industries' advance to become the leading sectors of aesthetic capitalism."[101]

A general turn toward aesthetics characterizes what Mark Fisher calls "capitalist realism." He names several central depressing aspects of the state of contemporary higher education: first, the pathologies of late capitalism ("the 'mental health plague' in capitalist societies"—i.e., hyperactivity, attention deficits, depression); second, the bureaucratic administration and framework specific to the educational system; and third, the "privatization of stress," or the inability to understand the local work situation within a comprehensive political context.[102] It comes as no surprise, then, that findings of a 2012 survey conducted in Britain of twenty thousand academics "indicate that levels of perceived stress remain high in the higher education sector."[103] From the point of view of the egotistical (professorial) potentates, the subaltern egos are responsible for their own suffering. That is why

100 Boltanski, "Leben als Projekt."
101 Reckwitz, *Die Erfindung der Kreativität*, 165.
102 Mark Fisher, *Capitalist Realism: Is There No Alternative?* (Winchester: Zero Books, 2009), 19.
103 Gail Kinman and Siobhan Wray, *Higher Stress: A Survey of Stress and Well-Being among Staff in Higher Education* (University and College Union, 2013), http://www.ucu.org.uk/media/5911/Higher-stress-a-survey-of-stress-and-well-being-among-staff-in-higher-education-Jul-13/pdf/HE_stress_report_July_2013.pdf.

self-hatred and aggressiveness are not irregular and isolated but are, like shame and depression, typical consequences of structurally excessive demands. It also explains, to Fisher's mind, the contemporary "craving for familiar cultural forms"[104] — for example, why "young women scientists leave academia in far greater numbers than men,"[105] and thus fall back into traditional gendered domestic roles. Moreover, "capitalism requires the family (as an essential means of reproducing and caring for labor power; as a salve for the psychic wounds inflicted by anarchic social-economic conditions), even as it undermines it."[106] For, as Boltanski writes, at the center of it all is

> a project that is more robust, has a longer life, and will be less easy to resolve than the affective and professional project one has previously participated in: the project "child." In a connectionist world, this project becomes a bulwark against fragmentation and represents a promising path in the search for a more "authentic" life. Such an "unfounded" and "non-strategic" decision to change one's life, which is indeed "unpredictable," stands in opposition to the usual, short-lived, self-interested decisions that, even if they cannot be immediately translated into monetary terms, and even if they concern people instead of things, are all approximations of our societies' exemplary decision, the decision to consume. The decision to have a child is meant to oppose the everyday decisions that are prone to being reproached for being impersonal, calculating, standardized, unnatural: that is, inauthentic.[107]

Accordingly, the real collaboration of academics' children in the elite research university finds a contrast in their vocal complaints about discrimination as academic-parents. In this discourse of victimization and discrimination, children are the only reason these egomaniacs (for that's what most of them are) give for not getting around to finishing their dissertation or that second book. It does

[104] Fisher, *Capitalist Realism*, 59.
[105] Curt Rice, "Why Women Leave Academia and Why Universities Should Be Worried," *Guardian Higher Education Network* (blog), May 24, 2012, http://gu.com/p/37zjm/sbl.
[106] Fisher, *Capitalist Realism*, 33.
[107] Boltanski, "Leben als Projekt."

not occur to them that it might be all their side projects or lack of talent or the simple fact that, in fleeing from themselves, they cannot give enough talks, organize enough conferences, publish enough book chapters, and seize enough career-boosting networking opportunities they discern in another committee membership or administrative responsibility.

It would be taking the easy way out to blame these phenomena on the deployment of precarization as an "instrument of government"[108] — especially in those models of neoliberal self-exploitation that are academia and the art world. This failure of writing, I want to argue, is instead an ethical failure. The price to pay for smoothly fitting into the bureaucratic mechanism of academia is the internalization of potential conflicts; the absence of friction on the outside results in depression on the inside and produces a hysterical subject on the verge of a nervous breakdown.

> **The failure to write is an ethical failure.**

Given the Romantic and economic origins of the humanities, it is no surprise that contemporary researchers in the field are part of the capitalist production cycle. The ideological promise of free research, subject only to the desire for the truth and to no external entity, is losing credibility and is being recognized as illusory. At the same time, the pressure on the immaterial producers rises.[109]

[108] "Precarization means more than insecure jobs, more than the lack of security given by waged employment. By way of insecurity and danger it embraces the whole of existence, the body, modes of subjectivation." Isabell Lorey, *State of Insecurity: Government of the Precarious*, trans. Aileen Derieg (London: Verso Books, 2014), 1.

[109] Of particular relevance here is the aspect of immaterial labor described by Lazzarato: "As regards the activity that produces the 'cultural content' of the commodity, immaterial labor involves a series of activities that are not normally recognized as 'work' — in other words, the kinds of activities involved in defining and fixing cultural and artistic standards, fashions, tastes, consumer norms, and, more strategically, public opinion. Once the privileged domain of the bourgeoisie and its children, these activities have since the end of the 1970s become the domain of what we have come to define as 'mass intellectuality'. The profound changes in these strategic sectors have radically modified not only the composition, management, and regulation of the workforce — the organization of production — but also, and more deeply, the role and function of intellectuals and their activities within society." Lazzarato, "Immaterial Labor," 133–34.

There seems to be no way out of this situation since the coproducers of this neoliberal status quo ignore their own complicity. Accordingly, a "government of insecurity," a precarization due to "the crisis," destroys even the least impulse that could, as Isabell Lorey also writes, "tend to prevent individuals from playing the game of competition."[110]

The modus operandi in the modern research university is keenly aware of the patriarchal protection the institution affords. It's rather convenient for most academics that all the talks and meetings and so on keep them from working; a conformist adaptation to the routine renders any further insight superfluous. To speak of a protection afforded by the institution is not to say that the institution makes it possible to work freely. Quite the contrary: it insidiously protects academic-artists from realizing how much their efforts at living up to their *ideal artistic egos* are caught up in enabling and preserving the status quo (and its ideals of creativity and originality or, increasingly, of self-fulfillment and flexibility).[111] To put it in slightly provocative terms, the real (protective) function of the university is this: it enables its inmates to consider themselves innocent victims of the general situation.

> The institution protects us from insight into our own failure.

To avoid any misunderstanding: we witness a hypertrophy of university administrations, but this is not simply an outgrowth of neoliberal governance. Nor can there be any expectation for real resistance from minds dulled by critical (self-)reflection. But how can it be so difficult to understand that, in practice, ideological interpellation always works through compliance? Mark Fisher illustrates the point with the example of the academic manager: "The preservation of his 60s liberal self-image depended on his 'not really believing' in the auditing processes he so assiduously enforced. What this disavowal depends upon

110 Isabell Lorey, "Governmental Precarization," trans. Aileen Derieg, *Transversal*, January 2011, http://eipcp.net/transversal/0811/lorey/en.
111 "Over the course of the twentieth century, the auratic artist's inimitable ideal ego undergoes a reversal to become an imitable ideal ego, that of the creative self" (Reckwitz, *Die Erfindung der Kreativität*, 89).

is the distinction between inner subjective attitude and outward behavior." It is, however, "precisely workers' subjective disinvestment from auditing tasks which enables them to continue to perform"—with a depressing lack of conflict, we may add—"labor that is pointless and demoralizing."[112]

The never-ending complaints—especially those about qualifying papers and strategic publications precluding the "real work" of writing—and accusations leveled at an (absolutely onerous) administration indicate a fundamental misunderstanding or ignorance concerning the practical conditions of thinking. Thinking, however, requires a practice of overwriting. It's not simply in one's head, nor does thinking simply develop as such. What, then, if new forms of thinking—and overwriting what has been thought and written before—were linked to effective strategies against the impositions of neoliberal university managers?

[112] Fisher, *Capitalist Realism*, 55.

Resistance and Minority

The Outer Face of Power

> Blasphemy protects one from the moral majority within, while still insisting on the need for community. —Donna Haraway, "A Manifesto for Cyborgs," 1991

One thing we most certainly don't lack are critics of the current miserable state of the educational system, especially among its inmates. Innumerable are those who conceive of themselves as victims of adverse conditions and, despite their numbers, fancy themselves a militant minority whose only obstacle on the path to that liberating little bit of power and freedom is that their career is not advancing steadily enough.

But do the current conditions (in the university) even allow for any forms of resistance? After all, as I've tried to show, critique is a two-faced operation that always ends up on the side of power. For an order to legitimize itself, it needs a religious or metaphysical construct—or, in modernity, critique. No critique can escape this shift from the procedural level of objectivity (the level of conflicts) to the level of legitimacy (the level of order). Critique legitimizes its object—always. The most probable outcome, therefore, is that the struggle for subjectivity expressed in the form of a critique of power and economics leads to a preponderance of precisely the kind of economy of the self that is embodied by contemporary critics. Their political identification as a subversive critical minority is thus an anesthetic, a self-delusion of the elite (and not just the academic elite).

How do these alleged victims conceive of themselves? And given its inflationary use, how has the meaning of the concept of an academic minority changed? To begin with, we have to clear up a misunderstanding that the dominated part of the ruling class (as Bourdieu would call them) likes to cling to. Artists and intellectuals dispose of a decent amount of capital—cultural capital, at least—which contributes to them not grasping their own status as *ruled rulers*. What they usually don't want to see (besides the fact that the current aesthetic regime is a condition for neoliberal governance) is that minority positions can easily become majority positions. This is the case whenever a minority is able to articulate its claim as one to which everyone should subscribe.[113] Any elite can serve as an example of the fact that being in a quantitative minority by no means implies being without power. Isabelle Stengers writes, "A position may well be affirmed by a qualitatively minority group and will be a majority position if it presents itself as what should be accepted by everyone, i.e., as a potentially consensual claim," and follows Deleuze and Guattari in positively defining "a minority as that which does not dream of becoming a majority."[114]

> "On the side of the critic or theorist, do we not participate in a redoubling of the effect of recognition, insofar as we gladly assume that art is different from all other forms of ideology? Are we not too giddy to recognize the effect of recognition as symptomatic of ideology, whereas art would somehow escape this predicament by showing us the inner workings of the ideology effect as such?" (Bruno Bosteels)

113 The often aggressive attempt at appropriation is *aesthetic* insofar as its structure resembles (and by no means incidentally) that of the aesthetic judgment described by Kant. In making an aesthetic judgment, we cannot but impute—with all the discursive power at our disposal, if necessary—this judgment to everyone else.

114 Isabelle Stengers, "Deleuze and Guattari's Last Enigmatic Message," *Angelaki* 10, no. 2 (August 2005): 166n10, 158.

Of course it is by no means wrong to hope that counter- or subcultures conceal a potential for ethical or political resistance, or both. Yet wherever self-proclaimed minorities aim not for divergence but for security and proliferation, their mini-cultures deteriorate into what Diedrich Diederichsen calls "isolationist islands, milieus and combat zones with a fanatically asserted privileged relation to reality." Their inhabitants no longer seek to be "representatives of a position but bearers of a cognitive privilege."[115] Not unlike the propensity of "political art" to offer "exotic self-ethnicization, pithy gestures, and militant nostalgia,"[116] the consequences these processes have in academia are not only comical, they can also be tragic.

Particularly significant is the connection between ethics and knowledge in social groups and their conceptions of alternative models of the "right life." In the everyday routines of academic career advancement, however, political utopias have mutated into tools for climbing the career ladder—tools used egotistically that ignore the societal context, like the abuses of "feminism" examined by Nina Power, and are thus rendered politically ineffective and even counterproductive.[117] Picking up on Stengers's concept of "objecting minorities," we might speak of *assenting majorities*. They form wherever a truth claim is abandoned in favor of asserting a cognitive privilege or advantage. It is not hard to think of subcultures that rehearse their folkloric slogans with all the violence required for regression—and that are even more brutal (and not by chance) in dealing with dissent. Unfortunately, as Deleuze and Guattari write, "leftist organizations will not be the last to secrete microfascisms. It's too easy to be antifascist on the molar level, and not even see the fascist inside you, the fascist you yourself sustain and nourish and cherish with molecules both personal and collective."[118]

I see an additional feature: a cult of victimhood, an unconditional will to position oneself as a victim, a compulsion to think all relations in the renegade categories of

115 Diederichsen, *Der lange Weg nach Mitte*, 19, 21.
116 Steyerl, "Politics of Art."
117 See Nina Power, *One-Dimensional Woman* (Winchester: Zero Books, 2009).
118 Gilles Deleuze and Félix Guattari, *A Thousand Plateaus: Capitalism and Schizophrenia*, trans. Brian Massumi (Minneapolis: University of Minnesota Press, 1987), 215.

perpetrator and victim. This psychocultural habit affects political debates about gender and other cultural questions as well—and not for the better.[119] A compulsive separation from the alter ego maintains the difference between ego and other, victim and perpetrator. The famous creed, *I am an other*, is thus taken to mean: I am completely different from the other even if the other acts no differently from me.

Niklas Luhmann succinctly describes the polarization of *alter* and *ego*: "As has been established by empirical research, this gradual division between acting and observing tends to create a discrepancy in the attributes the partners ascribe to each other and ultimately can become a conflict of attribution. In other words, the actor judges his acting to have been called for by the particular circumstances of the situation, whereas the observer in contrast tends to attribute the acting to the characteristics of the actor's personality. Accordingly, both parties start from different points of departure when searching for the causes of action, and this in itself leads to conflict."[120] This explains how, without the slightest inkling of guilt and unperturbed by any (conscious) shame, scores of academics are able to reproach others for scheming as they justify their own ruthlessness as a legitimate defense or acknowledge profiting from patriarchal structures (that are thereby reinforced and ultimately enjoyed) only in terms of an imagined victimization. As Dirk Baecker, following Luhmann, puts it: "We only grasp what we ourselves participate in—but we are

119 As I was writing this book, Anke Hennig wrote to me in an e-mail: "Feminism is a symptom, as innocent as the unconscious. The problem is that it hardly ever rises above an oedipal conflictual behavior, at the expense of the transformative potential of conflicts. That is true of both participants. On the side of the supposed winners: the insight, simple enough in itself but difficult to grasp, that men who had trouble with their fathers' tyranny are no feminists but, in taking up the struggle, are on track to reproduce gender relations. Of course feminism still plays a role as the synonym for the search for better gender relations. On the side of women, things look at least a little better. But they certainly don't where the current forms of the battle of the sexes are concerned, which are highly problematic, to put it mildly (and which are increasingly reduced to a mere rhetorical fig leaf or worse, albeit common: abused as a discursive vehicle for power). Conflicts with the patriarchate have an oedipal character for both sexes, to be sure; yet in reference to feminist studies and their home, the university, women's critique of the patriarchate has the distinction of having challenged the evil normality of the university's master discourse with an 'abnormal' discourse of truth."
120 Niklas Luhmann, *Love as Passion: The Codification of Intimacy*, trans. Jeremy Gaines and Doris L. Jones (Stanford, CA: Stanford University Press, 1998), 34–35.

unbelievably skilled in obstructing our view of the situation and in hiding from ourselves the extent to which we participate in it."[121]

Foucault's genealogical readings provide a model for how we might comprehend not just these psychocultural mechanisms but the historical background of self-declared victims or minorities as well. He describes a hegemony of elite struggles: the future bourgeoisie fighting against feudal society, the exploited fighting their exploitation in modern capitalism, and, today, the tendency of individuals to declare themselves singularities worth protecting. Critical discourses—in particular, discourses of power and dominance claiming to speak for artistic practices of subjectivity—delude themselves about their true character. Egos express conflicts only as a critique of alter egos, of other subjects. The objective truth of conflicts thereby remains excluded, the conflicts are transferred symptomatically to the ego. Instead of triggering and accelerating conflicts, multiplying and letting them play out, what we find is mostly criticism (sometimes even of ourselves). Yet both "resisting the present" (Deleuze) and genealogically accounting for the knowledge we presently possess are necessarily tied to a production of *objecting minorities* predicated on an ethical transformation and "the power to object and to intervene in matters which they discover concern them."[122]

Perhaps we should abandon the concept of minority, used and abused as it is, in favor of the concept of outsiderness. Minorities may express critique—but they do not necessarily put up resistance or force conflictual debate of what would otherwise remain unspoken. Outsiders remain excluded without declaring themselves a minority. What is decisive is not whether they live up to demands addressed to them; what is decisive is what I will discuss, with reference to Deleuze, as a humorous trespass (of the self). Only a witty confusion of claims and demands can hope to question the taboos concerning the mention of upper-class backgrounds and discrimination in the everyday routines of academia. Beckett's *besoin d'être mal armé* (need to be ill-equipped) does not exclude resistance. (This applies as well to the *démence*

121 Dirk Baecker, *Postheroisches Management: Ein Vademecum* (Berlin: Merve, 1994), 43.
122 Stengers, "Deleuze and Guattari's Last Enigmatic Message," 160.

universitaire [university madness] of which Beckett too, it seems, was keenly aware.) Quite the contrary: it is precisely when we are caught in the middle that we are able to lash out (the liberating effect of intelligent violence!) and make the bureaucrats of the mind feel queasy.

In producing "unexpected effects" thanks to "an art of being in between" Michel de Certeau sees a poetic art of acting.[123] But the simple shameful attempt to no longer be caught in the middle, to occupy a stable position, to take care of oneself and one's interests, is a political betrayal and an ethical lapse. That is why it so often entails an intellectual failure. The spread of precarious labor is a good example: when a subject considers itself to belong to a minority due to its precarious situation, it does so because it myopically conceives of this situation as a lack of an institutionally secure position. An outsider conceiving of herself *from out of* the local conflict zone, however, is engaged in something completely different—namely, in transforming the frontiers she is traversing.

Only in acting from outside a zone that is taboo does a subject's precarious status express a truth. The goal in this case is no longer an accumulation of innovative knowledge; the goal is a poiesis, a productive transformation. What is written under these changed conditions has a political dimension not in the sense that it voices a critique but in the sense that it expresses the subject holding on to a truth that has absolute validity for the one subjected to it. This might sound like the heroic fidelity oaths that have been popularized by Badiou's acolytes and have caused all kinds of adolescent euphoria. Yet Badiou's intention of making the "existential consistency of philosophy" visible and of "demoralizing philosophy" is not the same as an ethics of knowledge that aims for poiesis and draws on plenitude instead of betting on emptiness.[124] The only way to orient ourselves in a given whole is to manipulate the parts we analyze. Such a transformative navigation of the whole has an emancipatory potential, if only because every conflict-provoking move procures further insights.

123 Michel de Certeau, *The Practice of Everyday Life*, trans. Steven Rendall (Berkeley: University of California Press, 1984), 30.
124 See Alain Badiou, *Second manifeste pour la philosophie* (Paris: Flammarion, 2010), 15, 68.

> *Demoralizing philosophy* (Badiou) must be supplemented by poeticizing ethics.

Knowledge becomes ethically true for a subject only when it constitutes the subject anew: "In the experience of ethics, the issue is that an individual must become a subject."[125] Unfortunately, for Badiou the "neo-classicist" (as Peter Osborne calls him) the event so venerated by his followers is modeled on aesthetic experience as well. In the words of Grant Kester, "the 'event' [...] like the aesthetic object itself, must be pure, autonomous, and non-referential."[126] The question this raises for an ethics (of knowledge) then becomes: How is it possible to hold on to this moment of absolute desire (for truth), a desire that confronts, in the recursive rewriting of the given, the partiality of all knowledge? Ethical truth is a process in which the subject is overwritten by "its" knowledge, a process that is radically different from pseudo-revolutionary dismissals of the totality of the given.

But what can be ethically opposed to the aesthetic pressure of capitalism? What lines of flight are available if it's true that "oscillating between depression and perversion, neo-subjects are condemned to a double life: a master of performances to be admired and an object of enjoyment to be disposed of"?[127] Yet given Pierre Dardot and Christian Laval's

125 Alain Badiou, "On Simon Critchley's *Infinitely Demanding: Ethics of Commitment, Politics of Resistance*," *Critical Horizons* 10, no. 2 (August 2009): 157. He continues: "In particular, a truth is a set of consequences of the fact that something that exists before the event in the world, understood in the minimal sense of existence, becomes existence in the strongest sense" (ibid., 158).

126 Grant H. Kester, *The One and the Many: Contemporary Art in a Global Context* (Durham, NC: Duke University Press, 2011), 50. On Badiou, see Peter Osborne, "Neo-classic: Alain Badiou's *Being and Event*," *Radical Philosophy* 142 (March/April 2007): 19–29.

127 Pierre Dardot and Christian Laval, "The New Way of the World, Part II: The Performance/Pleasure Apparatus," trans. Gregory Elliott, *e-flux journal*, no. 52 (2014), http://www.e-flux.com/journal/the-new-way-of-the-world-part-ii-the-performancepleasure-apparatus/. The task is to understand how "the 'psy' discourse, with its power of expertise and scientific legitimacy, made a major contribution to defining the modern governable individual. [...] It is thus utterly pointless to deplore the crisis of supervisory institutions like the family, schools, trade unions, and political organizations, or to lament the waning of culture and knowledge or the decline of democratic life."

subsequent discussion of largely psychotic phenomena, we have to wonder whether perversions (fetishism, for example) might not after all contain perspectives within which tactics could be developed to evade the depressive state of the neoliberal aesthetic subject. To do so is simply to take seriously the question Lyotard asks: "Isn't fetishism an opportunity for intensities? Doesn't it attest to an admirable force of invention, adding events which could not be more improbable to the libidinal band? From where would you *criticize* fetishism, when you know that one cannot criticize homosexuality or masochism without becoming a crude bastard of the moral order?"[128] This (universal) order always already corrupts the ethical subject, and it can, as Deleuze (in his book on Sacher-Masoch) and Kafka (in "In the Penal Colony") have shown, only be understood via irony and humor. (We'll return to this point.)

Is there a fetishistic disposition —i.e., a perverse and nonhysterical way—to relate to the law that might provide an alternative to the oedipal fixations and critique of minority positions? The law, after all, is never neat, and the blight of lethargy clings even to the smooth solutions that (male?) academic discourse loves to free-associate about (martially heroic fantasies about tough decisions, clean cuts, empty "events," and so on). A good example of the kind of alibi politics practiced in humanities departments is widespread political verbal radicalism (already condemned by Walter Benjamin in 1931 as a "left-wing radicalism [...] to which there is no longer in general any corresponding political action").[129] It only seems to be a challenge to authority. What it actually inherits is Kant's strange compromise (the public use of one's reason as a scholar must always be free, the private use of one's reason as a civil subject may be restricted),[130] but under current conditions it is difficult to distinguish this compromise from conformist cowardice.

The task of a speculative and poietic ethics must be, on the contrary, to replace the oedipal confrontation with the ironic research university with a witty perversion and, ultimately, with an ethics of speculative transformation. The

128 Jean-François Lyotard, *Libidinal Economy*, trans. Iain Hamilton Grant (London: Continuum, 2004), 108.
129 Walter Benjamin, "Left-Wing Melancholy (On Erich Kästner's New Book of Poems)," trans. Ben Brewster, *Screen* 15, no. 2 (1974): 30.
130 Kant, "What Is Enlightenment?," 18.

question that needs to be addressed is thus: What forms of transgressing the law, of defying the omnipresent aesthetic-critical cosmos, are conceivable and practicable? In this neurotic cosmos, there can only be victims and perpetrators, just as everyone cannot but live in guilt and atone by being critical. Critique thus refers less to the law than it does to guilt, which it acknowledges (as the violence of the law). In de Certeau's terms, "An ideological criticism does not change its functioning in any way; the criticism merely creates the appearance of a distance for scientists who are members of the institution." Instead of discerning heterogeneous practices or its own power potential, it only engages in an "elucidation of the apparatus by itself."[131]

[131] De Certeau, *Practice of Everyday Life*, 41.

Critical Aesthetics

The Triumph of an Academic Discipline

> One of the most amusing features of the history of science is to be found in the propaganda scientists and alchemists have addressed to the powers that be at a time when they were beginning to run out of steam. It went as follows: "Give us money; you don't realize that if you gave us a little money, we would be able to put all kinds of machines, gadgets and contraptions at your service." —Lacan, *Ethics of Psychoanalysis*

We have seen how successful the Berlin model of the research university has become. In fact, once the critical thinking based on this model spread, contemporary observers quickly recognized it to be an economic factor. Ultimately, this was and is possible only because, as Reckwitz writes, "the form of the aesthetic […] structurally corresponds to"—or can at least be adapted to—a general "economization" and "rationalization."[132] But there are other forms of thinking in the humanities besides the dominant aesthetic regime. My investigation of this disciplinary regime and its discursive regulations is of course not to be construed as a call for a return to a different ethical (representative) or poetic (mimesis-based) regime (to use Rancière's schema). Instead, I am concerned with outlining a different constellation of the ethical and the poetic that has been obscured by the enormous force of the aesthetic.

Friedrich Kittler's Berlin lectures on "philosophies of literature," and especially the significance Kittler assigns to poetry in the genesis of the modern research

[132] Reckwitz, *Die Erfindung der Kreativität*, 343.

university, make it possible to detail the reasons for the tremendous productivity of the Romantic academic-artists. The effect of poetry is "that one always has to 'think more' than can be said by all the words of a language; [poetry] is thus not a textbook for philosophers but a kind of surplus going beyond all textbooks; it is the perfect stimulation for philosophers."[133] Such a dynamic of escalation entails an immediate shift. No language contains enough words to fully express the thoughts of the literarily stimulated philosopher. Even the most rapid development of a language of philosophy will always lag behind the dynamism of what is to be thought. No matter how far philosophical discourse seeks to extend its conceptual language, it will never catch up. This is the point at which Kittler sees a parallel shift that divests literature, and poetry in particular, of its existence on paper and elevates it to the status of a "medium of philosophy," aestheticized around 1800. This "philosophy has appointed and legitimized itself as the address of poetry. With poetry, philosophy thinks through what it itself can no longer write down."[134] This is particularly obvious in the literary-philosophical attitude of Hegel's speculative idealism. According to *Phenomenology of Spirit*, poetry's affinity to philosophy is conditioned by the presence of the absolute in poetry.

Let's take a closer look at the dynamic shift prompted by the embedding (and sublation) of the artistic in the philosophy doctoral degree. I suspect it is not merely an economic surplus; rather, it arises from "the necessity of poetry for a certain historical kind of philosophy" that Kittler speaks of.[135] In the history of the academy, we see this embedding becoming "the core of the modern university" and turning philosophers into the nineteenth century's "celebrated princes of knowledge," as Matti Klinge writes.[136] But where did literary philosophy find its

133 Kittler, *Philosophien der Literatur*, 130.
134 Ibid., 131.
135 Ibid.
136 "Thanks to its orientation toward research, the philosophy department, which outside German-speaking countries split into humanities and science departments almost everywhere in the nineteenth century, became the core of the modern university; this was reflected in the status of its professors as well. From being mere university teachers who were in close contact with school and high school teachers [...] they moved to being, especially in the large cities, the celebrated princes of knowledge." Klinge, "Die Universitätslehrer," 120.

resources? The Romantic origin of the modern research university suggests that we should look for corresponding shifts in the domains of aesthetics and poetics.

I have already mentioned the shifting dynamic produced by every critique. This same dynamic operates to valorize and devalorize fields of research, differentiate disciplines, and redraw their boundaries. A new discipline never emerges in isolation; rather, it emerges as part of a new paradigm, a new foundation of the field of knowledge to which it pertains. We can distinguish two movements here: first, a nondiscursive incursion, and second, attempts at discursively reembracing such disruptive events. The *Critique of Judgment*, as Nick Land has argued, may be called "the site where art irrupts into European philosophy with the force of trauma," because Kant's "aesthetics" is an attempt to reintegrate this artistic trauma discursively.[137] It is in this sense that aesthetics, as Christoph Menke has pointed out, means nothing less than a refoundation of philosophy. In linguistics we find another example of such a claim to shifting the field of knowledge in its entirety. From Saussure to Derrida, linguistics has claimed to refound not merely the field of what can be said but also the field of what can be thought. Engagement with such radical critiques usually led to an integration of their critical discourse into the field of research—aesthetics, for example, finds a place beside ethics and epistemology—and to a new repartition within the field. The result, of course, was a shift of the boundaries between disciplines.

In his "retelling of the 'birth' of aesthetics in the eighteenth century," Menke points out that "the introduction of the category of the 'aesthetic' required nothing less than a transformation of the fundamental terms of philosophy. The beginning of aesthetics is, in fact, the beginning of modern philosophy."[138]

137 Nick Land, "Art as an Insurrection: The Question of Aesthetics in Kant, Schopenhauer, and Nietzsche," in *Fanged Noumena: Collected Writings, 1987–2007*, ed. Robin Mackay and Ray Brassier (Falmouth: Urbanomic, 2011), 145. The third critique is thus more than the aesthetic bridge between epistemology and moral philosophy; see also Jacques Derrida, *The Truth in Painting*, trans. Geoff Bennington and Ian McLeod (Chicago: University of Chicago Press, 1987), 38–39.
138 Christoph Menke, preface to *Force: A Fundamental Concept of Aesthetic Anthropology*, trans. Gerrit Jackson (New York: Fordham University Press, 2013), x.

And Jacques Rancière, for his part, has come to fame by delineating the aesthetic regime of art from two earlier ones, the ethical and the representational. According to Rancière:

> The word aesthetics does not refer to a theory of sensibility, taste, and pleasure for art amateurs. It strictly refers to the specific mode of being of whatever falls within the domain of art, to the mode of being of the objects of art. In the aesthetic regime, artistic phenomena are identified by their adherence to a specific regime of the sensible, which is extricated from its ordinary connections and is inhabited by a heterogeneous power, the power of a form of thought that has become foreign to itself: a product identical with something not produced, knowledge transformed into non-knowledge.[139]

We could add any number of examples to this list of phenomena that are determined, in the aesthetic regime, by their opposites and constitute a signature of "critical thinking." Fichte, one of the fathers of copyright law, for example, conceived of a program of original research that expressed an analogous relation of the academic-artist to his knowledge, a relation whose inconsistency Kittler points out: "Since Fichte, intellectual property [*Eigentum*] thus possesses a peculiar basic trait: no author can avoid possessing it as his own feature [*Eigentümlichkeit*]; it is thus much less than a property. [...] Since Fichte, all of us, as long as we write, own something that does not at all belong to us, in the sense that we cannot dispose of it."[140] But of course this inconsistency is strictly in keeping with the logic of the aesthetic regime. An anti-constructivist dualism operates on every level of this regime; it suspends the venerable discipline of poetics because it is no longer able to establish a connection between the truth of a work and the procedures of production. From this perspective, the old poetics merely seems to follow an abstract making (whose model Rancière calls *mimesis*, Hegel *equivalence*) whereas the aesthetic regime obeys a dialectical logic.[141]

139 Rancière, *Politics of Art*, 18.
140 Kittler, *Philosophien der Literatur*, 149.
141 We will see later how a poeticization of philosophy that opposes this aestheticization operates via a speculative dialectics.

One other disciplinary constellation within the aestheticized discourse of modernity is relevant in this context: the structure of reciprocal support between aesthetics and art history (or the academic study of art in general). The emergence of salons and their culture of taste didn't only change the conditions of art's reception: in modernity, the space within which art is negotiated changes completely. Taste plays less and less of a role in the evaluation and cognition of art. Instead, art is increasingly determined by a concept of art that is always renegotiated anew. In this process, art's thinking begins to give voice to critique.[142] In conformity with the epistemological conditions of the aesthetic regime, the concept of art, too, becomes one of critique, permanently negotiated on the limits of nonart.

> The field of art is constituted by a concept of art elaborated by academic-artists.

In writing about the development of art since the nineteenth century, Thierry de Duve traces the loss of prestige of the profession of painting in the wake of industrialized production. This loss concerns everything fabricated (by hand), but it affects art in particular from the moment that material discoveries, such as the oil-based paints invented by the Van Eyck brothers, are no longer made by artists but by the innovations of industrial technology. In the end, it is no longer clear what the work of art really consists of when all its material components are industrially produced—when, in short, art becomes ready-made. The result, roughly speaking, is the transformation of art as making into art as concept. This has also led to the increasing academization of the art world in recent years (at least in Germany and anglophone

142 On the historical shift of critique and criticism, see John Rajchman, "The Contemporary: A New Idea?," in *Aesthetics and Contemporary Art*, ed. Armen Avanessian and Luke Skrebowski (Berlin: Sternberg Press, 2011), 125–44. "The practice of criticism, the role of the critic, and the frameworks of history, would all themselves change accordingly, as the old boundaries between art and criticism themselves shifted places—criticism as a kind of art, and art as a kind of criticism, even of institutions, discovering in the process fresh points of contact and relay with European critical theories or philosophies" (ibid., 133–34).

THE TRIUMPH OF AN ACADEMIC DISCIPLINE

countries). Ever since the triumph of aesthetics in modernity, the art field no longer features professions but is constituted by a *concept* of art. Yet whichever concept of art is current at a given point is then elaborated in the (expanding) university by academic-artists or artist-academics. This entails a systematic overlap of art and academic discourse that serves as the matrix that links academia and other discursive fields.

This connection also explains the interest art takes in theory. Ever since the radical avant-gardes, the fine arts—maybe even more so than literature—have known that it is the concept of art that determines what art is. Theory thus appears to immediately create reality—even if an aesthetic regime geared toward (changes of) visibility, perception, and experience is incapable of discerning a poietic potential and at most recognizes a critical potential. (This is another instance of how critique misunderstands itself—its powerlessness is compounded by the fact that it avidly attributes past transformations to itself.) Artists see theorists as making distinctions the artists themselves do not see—decisive ones, especially the distinction between art and nonart.

Contemporary art's struggle for recognition and assertion has been profiting from a substantive concept of art canonized by the university. What sanctions contemporary art as art, at a given point in time, is its ability to conceptually articulate itself as such (aided by an academic discourse and the critics schooled in it). Academic theory provides art with the concept it needs in order to be art, a concept that allows the observer to perceive the artwork in such a way that what is artistic about the work becomes apparent. This is also why contemporary art necessarily accompanies the kind of capitalism it criticizes with such devotion.

> "Art serves capital in three ways: in the cycle of debts and profits (and in the redistribution from the bottom to the top), in the real estate business's raids of the cities, and finally as a reservoir and motor of the resource that is creativity." (Markus Metz and Georg Seeßlen)

The new rules governing the relationship between art and knowledge also apply to the study of fine arts. Art academies, which used to transmit the skills needed by the painter to master his trade, become art universities. Under the auspices of the Romantic research university, the task of aesthetics is to furnish art with the concepts it needs, even with, as some have recently claimed, a hegemonic elite language of its own (for instance, so-called IAE, or International Art English).[143] Like art itself, academic art history is no longer able to legitimize itself by describing historic styles, techniques, and materials.

The transformation of the academic discipline of art history (*Kunstgeschichte*) into art studies (*Kunstwissenschaft*) is tied to a focus on the present. Previously, historical competence was a prerequisite: in order to not only establish the canon but, at the same time, guarantee the value of masterpieces, one needed to distinguish old originals from copies, if this somewhat crudely Marxist way of breaking it down to material interests be allowed. This aristocratic principle of taste has had to yield to critique. Under the auspices of aesthetics, even art journalism is tasked with finding out which art is being the most critical (to allow for its objective success and, subsequently, to transform its symbolic capital into economic capital).[144] The problem for art studies, increasingly interested in contemporary art, is to develop its concept of art philosophically (i.e., to become an applied aesthetics) instead of borrowing it from history, which has canonized a specific concept of art.

143 The syntactic, stylistic, and semantic characteristics of IAE have been described in an amusing polemic by Alix Rule and David Levine: "*October* sounded seriously translated from its first issue onward. A decade later, much of the middlebrow *Artforum* sounded similar. Soon after, so did artists' statements, exhibition guides, grant proposals, and wall texts. The reasons for this rapid adoption are not so different from those which have lately caused people all over the world to opt for a global language in their writing about art. Whatever the content, the aim is to sound to the art world like someone worth listening to, by adopting an approximation of its elite language." Alix Rule and David Levine, "International Art English," *Triple Canopy* 16 (July 2012), http://www.canopycanopycanopy.com/contents/international_art_english.

144 "Vis-à-vis the overexcited contemporary art market, there are calmer, indeed almost cooled-off market segments (the market for classical art, for example). This is reflected in discourse, as a comparison of publications will show. While well into the 1980s classical and modern art were treated about equally in reporting and reflection on art, art historical topics today seem to be of interest only in the context of 're-evaluations.'" Metz and Seeßlen, *Geld frisst Kunst*, 215.

As such, aesthetic art studies has to ask itself whether it is able to recognize true art and to distinguish art from nonart in the present (i.e., when it lacks distance and cannot rely on history's selection). Ever since the dynamic of criticism started the constant renegotiation of the boundary between art and nonart, art historians can no longer come to a noncontradictory concept of art via art history alone.

This leads us to the already familiar "critical" characteristics of the concept of art within the aesthetic regime: nonart becomes art, and art that has no relation to nonart has no chance of being or becoming art. For art historians, this means that their concept of contemporary art has to be a critical and dialectical concept subject to constant revision. Either the academic concept of art, in seeking to legitimize itself, constantly engages with what is not art (or what cannot, yet, be art), or it runs the danger of falling prey to a nominalism without substance. In the latter case, it would no longer be subject to any determination; art would merely be whatever someone calls art. Such nominalism would strip the academic discourse of art of the cognitive privilege and critical supremacy it is working so hard to maintain. Engaging with contemporary art, however, does not break this circle. What we are confronted with here, rather, is an ideological form of real subsumption—namely, an economic system that defines what it produces as art (to sell it on the art market). The university recognizes as art what the art journals dominating theoretical discourse declare to be art. This completes the aesthetic-nominalist circle, which can be summarized as: valuable contemporary art is that which is declared to be art by the authorities of art studies and art criticism. Is it possible to step out of this cycle of the aesthetic regime, the cycle of critical nominalism?

Speculative Poetics and the Poeticization of Philosophy

Contemporary Forms of Temporality

> All the objects of our senses become ours only to the extent that we *become aware* of them; that is, we designate them, in a more or less clear and vivid fashion, with the stamp *of our consciousness*. […] Our whole life, then, is to a certain extent *poetics*. — Johann Gottfried Herder, "On Image, Poetry, and Fable," 1787

In this book, I argue from the perspective of an ethics of knowledge and a poetics of existence *against* the dominance of aesthetic philosophy and, given the impasse of "critical" aesthetic thinking, *for* its overwriting by way of two strategies: poetics and speculation. Let us recall two points mentioned in the previous chapter: on the one hand, Christoph Menke's statement that philosophy was relaunched as "aesthetics" around 1800 and, on the other, Friedrich Kittler's contention that philosophy since then has kept itself alive by making literature its medium.

Although it has gone largely unnoticed, poetics, since early Romanticism, has never ceased providing important insights (not least because it also managed to remain largely unaffected by the success of aesthetics). How can these insights be developed without discarding the achievements of critical thinking? Poetics qua poetology is not simply equivalent to the (critical) concept of poetry or the (aesthetic) analysis of a novel: it is supposed to express a poietic thinking. A speculative poetics,

accordingly, can have an ontological basis, provided we understand poiesis both as *creation* and as *practice*. And an ethics of knowledge informed by this approach refers to poiesis as the production of truth that concerns three fundamental levels: transformation of the object being addressed, transformation of the world as a whole, and transformation of the subject tasked with an action.

> The poiesis of truth concerns the transformation of the object investigated, of the investigator, and of the world as a whole.

Poetic truth is fundamental for a speculative ethics. It affects not only the subject of knowledge but its object as well (be it a scientific thesis, literary text, work of art) and determines its (conflictual) role in the routine of academia. Exploiting power strategies always concerns a given configuration and implies its manipulation. According to François Jullien, manipulation is hardly discussed by Western thinkers—and when it is, it is not conceived of as something positive. In Chinese thought, which has "no qualms about conceiving of manipulation upstream," at the beginning of every development, it is a central category.[145] To what extent does it take place on all three levels—subject, object, and the world as a whole? The tactical potential for manipulating the context (or power strategies) within which one works "is produced," Jullien writes, "by my opponent. Or, rather, it is not in me (it would exhaust me), nor is it exactly in him, but *I draw it from him*. [...] The potential lies *in the situation*."[146] The task is to exploit this potential; not for oneself, but for the sake of what one is drawn toward. The exploitation of the opponent, however, not only serves the "transformation" of the self, it also serves the "deconstruction" of the opponent.[147] The two cannot be separated. At the beginning is the insight that we are trapped. In the accelerationist language of Benedict Singleton and Reza Negarestani: only a precise localization of a given

[145] Jullien, *Treatise on Efficacy*, 137.
[146] Ibid., 176 (italics in original).
[147] Ibid., 48.

problem or situation (the local) can, in reference to the future and to a greater whole (the global), produce new delocalizations.[148]

Joseph Vogl has demonstrated that objects constitute themselves through their "dense" form.[149] An object of science is a result of the tensions it accumulates as the object of diverging methods and epistemic discourses. Its constitution is never independent of a methodic (and thus institutional) conflict whose differences allow it to emerge in the first place. This insight reveals an eminently ethical dimension of academic research. The transformation of scientific material into an autonomous object of research always implies a change, through manipulation, of highly encoded and fixed language games between institution and individual. In Giorgio Agamben's terms, as we will see in a moment, poetics does not merely participate in the things that open up truth, it creates them.

The demand to act tied to the production of academic truth is a language act, in the sense of an "ability to *commit* oneself, the *authority* to make oneself *responsible*,"[150] to speak for oneself. For Robert Brandom, inference is always tied to a discursive commitment.[151] But the function of creating paradigms already operates on the most basic level of language. From a transcendental perspective, the human is a poietic being that—from a strictly aesthetic (i.e., humanist) point of view—seems to be genuinely "in-human" and overrides the idea of a creative potential that needs to be actualized or tasks that are, supposedly, always already given. This poietic dimension of human language is continually productive, even if traditional language theory, never mind aesthetics, doesn't recognize it as such.

148 That is why breaking down structures in the (academic) environment is the correlate of abductive manipulation on the part of the objects of academic research.
149 "Every designation of an object is, at the same time, a discursive accomplishment of the same object." Joseph Vogl, *Kalkül und Leidenschaft: Poetik des ökonomischen Menschen* (Zurich: diaphanes, 2004), 13–14.
150 Robert Brandom, *Reason in Philosophy: Animating Ideas* (Cambridge, MA: Belknap Press of Harvard University Press, 2009), 59–60.
151 As Ray Brassier has stated: "The meanings of our claims regularly outstrip what we currently intend or are aware of. This is because the *implications* of our claims regularly outstrip what we are currently aware of. To be rational is to keep track of those entailments and thereby to track what we become committed to when we commit ourselves to a belief or claim." Ray Brassier, "Wandering Abstraction" (lecture at "Accelerationism: A Symposium on Tendencies in Capitalism," Berlin, December 2013).

Perhaps even more frequently, however, the poietic dimension of language (literary language in particular) is philosophically suffocated with a vague concept of "aesthetic experience" and integrated into an edifying critical-humanist discourse. Generally, poetic effects (to take up Kittler again) in literary theory or philosophy are turned into attempts to aesthetically suspend literature or poetics:[152] "We may thus not be wrong to suspect that in Kant, poetry becomes essential to philosophy for the simple and dramatic reason that the human being as such (not empirically, of course, but transcendentally) is always already a poet. When the categories no longer float in Plato's heaven of ideas but are products of a human—categories that the same human first needs to draw from objects of his experience—we versify as we schematize in the depths of our human soul; that is, without noticing."[153]

My suggestion is to rewrite Kant's transcendental aesthetics as a transcendental poetics in which concept and reality transform one another. In other words, I propose a radical revision of Kant's critical concept of experience (his critique of what can and cannot be experienced), a revision of the kind pursued, for example, by early Romanticism and, a century later, by Walter Benjamin. What is required is an alternative to the aesthetic regime's fatal reduction to two dimensions of aesthetic experience, which David Joselit describes as "the *perceptual*, which focuses on optical sensation as a form of knowledge, and the *psychological*, which attends to how works of art create dynamics of identification between persons and images."[154]

It's especially the more advanced proponents of contemporary art theory that are beginning to see the necessity of a poetics that leaves critical aesthetics behind. Peter Osborne, for example, draws on Benjamin and the early Romantics to show that Conceptual art has proven the impossibility of moving beyond the realm of *aisthesis*, of totalizing an

152 The perennial accusations the two parties level at one another are, respectively, a "lack of academic rigor" and a "lack of conceptual acuity." I think both parties are right.
153 Kittler, *Philosophien der Literatur*, 133.
154 David Joselit, *After Art* (Princeton, NJ: Princeton University Press, 2013), 60. Also see my essay, "The Speculative End of the Aesthetic Regime," trans. Gerrit Jackson, *Texte zur Kunst*, no. 93 (March 2014): 52–65.

anti-aesthetic. He thus traces the boundary beyond which aesthetics becomes a post-conceptual or post-aesthetic poetics.[155] And Howard Caygill, as mentioned above, highlights a double thrust of Benjamin's speculation: to defend speculation against Kant's concept of experience and to position a poetic concept of speculation against the idealist-aesthetic version developed by Hegel.[156]

Hegel developed three facets of the idea of the *concept*: abstract, dialectical, and speculative.[157] Starting with a speculative "actuality of the concept" allows us to see why a speculative poetics can never be exhausted by a fabrication identical to itself. Accordingly, I understand poetics to be a transformative practice, a symbolic doing—a speculative production of reality. At this point, we can name three characteristics of a speculative poetics beyond Hegel's speculative idealism.

First, poiesis should not be considered an idealist reconciliation that cannot ultimately be separated from Hegel's speculative thinking (despite all attempts in recent decades to salvage his dialectics). Speculatively idealistic thinking, as Hegel denotes in various texts and contexts, is "the unity of what is distinguished"; it is "grasping opposites in their unity, or the positive in the negative"; and it remains tied to a "might of union" that I consider to be distinct from a transformative speculative dialectics.[158] Later on, I will delineate a recursive concept of

155 Peter Osborne, *Anywhere or Not at All: Philosophy of Contemporary Art* (London: Verso Books, 2013), 33.
156 See Caygill, *Walter Benjamin*, 2–3.
157 "In terms of form, the logical domain has three sides: (a) the *abstract* side or that of the *understanding*, (b) the *dialectical* or *negatively rational* side, (c) the *speculative* or *positively rational* side." Georg Wilhelm Friedrich Hegel, *Encyclopedia of the Philosophical Sciences in Basic Outline, Part 1: Science of Logic*, ed. and trans. Klaus Brinkmann and Daniel O. Dahlstrom (Cambridge: Cambridge University Press, 2010), 125. See also Alexandre Kojève, *Introduction to the Reading of Hegel: Lectures on the Phenomenology of Spirit*, trans. James H. Nichols Jr., ed. Allan Bloom and Raymond Queneau (Ithaca, NY: Cornell University Press, 1969), 169.
158 Georg Wilhelm Friedrich Hegel, *Lectures on the Philosophy of Religion*, trans. R. F. Brown, Peter Crafts Hodgson, J. M. Stewart, and H. S. Harris, vol. 1 (Berkeley: University of California Press, 1984), 206; *The Science of Logic*, ed. and trans. George Di Giovanni (Cambridge: Cambridge University Press, 2010), 35; and *The Difference between Fichte's and Schelling's System of Philosophy*, trans. H. S. Harris and Walter Cerf (Albany: State University of New York Press, 1977), 91. On these definitions of the speculative, see also Wilfried Dickhoff and Marcus Steinweg, "What Is Speculation?," introduction to "Money," special issue, *Inaesthetics*, no. 3 (2012), http://inaesthetics.org/index.php/main/issue/3/0.

othering from "reflexive innovation," which is tied to an aesthetic notion of the imagination.[159]

Second, in the wake of Schelling's and Fichte's absolute positing of $I = I$, Hegel had attempted a speculative transformation of Kant's transcendental philosophy. He too begins with an examination of the nature of reason and the antinomy of its desire to overcome the boundaries of its own critique. But what does the speculative dimension of such an idealism really consist in? Is its logic simply determined by Hegel's compulsive will to sublation, and is his system driven by a constant identification of what cannot or should not be identified (the so-called non-identical)?

If we read Hegel's speculative proposition (speculative because there is an identity of subject and object) as actually a *proposition*—a linguistic-syntactic construct—we see that it is not as if subject and object *are identical* but that they *become (each) other*. Entirely in keeping with Hegel's distinction between a logic of being and a logic of essence, the proposition's original subject is negated, in the dialectic movement of the proposition, by a predicate that turns out to be a substance: "Thus the content is, in fact, no longer a Predicate of the Subject, but is the Substance, the essence and the Notion of what is under discussion. [...] Starting from the Subject as though this were a permanent ground, it finds that, since the Predicate is really the Substance, the Subject has passed over into the Predicate, and, by this very fact, has been sublated."[160]

There is, finally, the possibility to account differently for the affinity of speculative and poetic logos claimed by Hegel—namely, via a "production" of reality. Since the advent of capitalist modernity, everyday reality has been characterized by an unstoppable productivity. Yet it is symptomatic

159 Once more, it is Fichte who gives a precise description of such an exhausted reflection: "This interplay [...] that consists, as it were, in self-conflict [...] in that the self endeavors to unite the irreconcilable, no attempting to receive the infinite in the form of the finite, now, baffled, positing it again outside the latter, and in that very moment seeking once more to entertain it under the form of finitude—this is the power of the *imagination*." J. G. Fichte, "Foundations of the Entire Science of Knowledge," in *Science of Knowledge with the "First" and "Second" Introductions*, ed. and trans. Peter Heath and John Lachs (Cambridge: Cambridge University Press, 1991), 193.

160 Georg Wilhelm Friedrich Hegel, *Phenomenology of Spirit*, trans. A. V. Miller (Oxford: Oxford University Press, 1977), § 60, p. 37.

that in today's hegemonic aesthetics and the contemporary art that conforms to it (like everything late capitalism produces, this art is *only* product), the decisive dimension has been lost. Poiesis maintains a relation with truth; as Giorgio Agamben writes, it lets something pass from nonbeing into being. This aspect cannot but remain invisible to an aesthetics fixated on the imagination that thinks production in terms of an economics of innovation. Agamben reminds us of an originary distinction, abandoned in modernity and, systematically, by modernism, of three categories: action, production (production of a truth), and labor. Already in pre-aesthetic metaphysics, the "central experience of poiesis, production into presence, is replaced by the question of the 'how,' that is, of the process through which the object has been produced. In terms of the work of art, this means that the emphasis shifts away from what the Greeks considered the essence of the work—the fact that in it something passed from nonbeing into being, thus opening a space of truth."[161]

> Aesthetics conceives of production within an economy of innovation.

The productive moment of poetics tends to be excluded from the aesthetic regime. All in all, Agamben tells us, the capitalist dominance of labor obscured the distinct properties of the three categories. Yet it is particularly since the end of the eighteenth century—since the invention of aesthetics and its focus on subjective experience and (artistic) objects as the results of labor, and since the establishment of an aesthetic regime of thinking (not just about art)—that poiesis and praxis have merged to become indistinguishable. Accordingly, the capitalist aesthetic regime constructs our reality in such a way "that in it, the subject can execute creative activities, have aesthetic experiences, and develop as a creative self."[162]

161 Giorgio Agamben, *The Man without Content*, trans. Georgia Albert (Stanford, CA: Stanford University Press, 1999), 70.
162 Reckwitz, *Die Erfindung der Kreativität*, 329.

Poiesis does not fall back behind a critical ontology. Quite the contrary: it develops the power to change the face of the world. This power has not sufficiently been thought about in terms of its implications for an ontology. This would require it to be delineated, on the most fundamental level, as separate from aesthetic innovation that characterizes capitalist production. This innovation emphasizes continuity insofar as the given is not rigid but accessible to change, even dependent on change. Yet innovations merely fill in the blanks that (pre)exist in the given in order to drive a development traced out in advance. The poietic activity I oppose to innovation, however, takes as its starting point something that is not, or not yet, and immediately comes across as demiurgic. This moment of autonomous creativity is also responsible for the primacy of poetics over any access to the world mediated by our senses and faculties (i.e., aesthetics and epistemology).

Yet in what respect does a speculative poetics go beyond a critical ontology? It must aim to show how speculation changes the relationship between dialectic negation and the originally positive materiality or sensibility it negates. As briefly indicated earlier in this chapter, Peter Osborne's discussion of (Post-)Conceptual art shows that negativity itself cannot be totalized. In the "supra-aesthetic artistic regime of truth" he describes, there is only a dialectic reflexivity that aestheticizes the nonartistic. A speculative poetics, on the contrary, always insists on how, in every recursion to an other, something emphatically other emerges—an othering, not just a continual process of innovation. Speculation does not simply sublate negation; its negation of negation precisely does not lead to a dialectical synthesis. What it leads to is a difference. Positively, this difference appears as something new. The new belongs to an order of time. Within time, the new not only relates dialectically to the old, it *cofounds this old* because it operates the speculative production of time itself.

> Recursive dialectics is speculative and leads to a difference.

Subject and other relate to one another temporally. The temporal relation of the subject becomes objective in being; the temporal relation of an object (which can also be another subject or assume a subject position) gives the object an existential character. Connected and transitioning from one to the other through time, subject and object form a circle, which in turn relates to a structure of meaning.[163] From an ethical (not a moral) perspective, the question then becomes: To what extent does the circle of a different understanding of the past transform the present as well? To what extent does a different understanding of the present necessarily come about via a transformation of our many possible pasts?[164]

Such a transformation is obviously marked by a paradoxical temporality: it is a recursive othering, a circular self-production of a subject that did not previously exist. The ontological dimension of this ethical figure is an object of speculative poetics: in speculation, the negation of negation results in a change, not in a sublation, and the new does not emerge as a knowledge of something already given. The development of something that is new is not an organic or genetic emergence; it is an experimental production in the subject. The truth unfolds in a dimension different from a knowledge produced by propositions, formulas, or objects.

Against Hegel's reflexive dialectic of sublation, the distinctive feature of a recursive dialectic is its temporal distancing. It understands time not in terms of speculative idealism but rather in terms of the speculative materealism developed by Quentin Meillassoux. The starting point of Meillassoux's speculative philosophy of time is his concept of ancestrality: a present that was never present to itself and that neither we nor any other subject attended or experienced. Ancestrality attributes objective existence to the past (independent of any present). This

[163] "The 'circle' in understanding belongs to the structure of meaning." Martin Heidegger, *Being and Time*, trans. John Macquarrie and Edward Robinson (New York: Harper, 1962), ¶ 32, p. 195.

[164] Pierre Macherey's distinction between ethics and morality shows that this temporal circle concerns the ethical core of subjectivity as well. The difference lies in that "the form of the relation to the self considered by ethics is not defined with reference to a law, and therefore to a universal. [...] The subject is thus not given as such at the origin, already completely constituted; it is the outcome of a procedure of transformation which constitutes it. Ethics is interested precisely in this production of the subject." Pierre Macherey, "Foucault: Ethics and Subjectivity," in *In a Materialist Way: Selected Essays*, ed. Warren Montag, trans. Ted Stolze (London: Verso Books, 1998), 96–97.

changes the status and the direction of time as a whole. When we correlate the temporal space of ancestral events with a transcendental subject, the ancestral past, in opposition to a subjectivized past (my own or the past lived by past human beings), is a past *that has never been a present*—i.e., an *originary past*. The ancestral thus conceived of is a past *for us*, a past that has never been a present in itself or for another. In a transcendental interpretation (which Meillassoux for various reasons doesn't provide), the ancestral was not a present before it was a past for the subjects: "On the contrary, it has been *its own future*—i.e. our present which reconstitutes it on the other side—*before* being a past: because as past it is completely *constituted*—and not *re*constituted—by our current projection towards it."[165]

In that sense, Meillassoux also allows us to concretize the newly popular, albeit under-determined concept of speculation. The idea of a non-metaphysical speculation would be to turn the ultimate absence of a basis to all things, their radical contingency, into a principle, an absolute. This could result in a discourse that does not abstain from giving reasons or speaking nonsense (*déraisonner*), as Meillassoux claims, but rather consists of precise arguments capable of reengaging with inherited philosophical and literary problems—the question of the temporal syntheses in Deleuze, for example, or the switch of tenses, from past to present, in the twentieth-century novel, the fundamental asynchrony in contemporary narration, and so on. A *speculative poetics*.

What is important to understand is that the ancestral past, unlike the subjectivized past, has no other meaning than our going back to it—that is, it has no other meaning than the reversal of today's time toward a time without humans. In this sense, Meillassoux's thinking accords with theses put forward in linguistics or the philosophy of tenses:[166] *without*

165 Quentin Meillassoux, "Metaphysics, Speculation, Correlation," trans. Taylor Adkins, *Pli: The Warwick Journal of Philosophy*, no. 22 (Spring 2011): 8.
166 The ancestral past indeed becomes a past that never has happened, that never has been present, that returns from the future to itself instead of proceeding to the future by itself. Gustave Guillaume provides a concrete linguistic foundation for this speculative figure of time. As in Meillassoux, the openness of the future is directed at the form of the past; the connection of future and past is indeed temporal and has a direction; and the present has no other function than the reversal of time. On this point, see my postface in Gustave Guillaume, *Zeit und Verb: Theorie der Aspekte, der Modi und der Tempora*, trans. Esther von der Osten and Bernd Klöckener (Zurich: diaphanes, 2014).

being inconsistent, we can think what there is when there is no thinking—i.e., think a certain form of the *absolute* that is not tied in with our mental categories because it exists whether we exist to perceive it or not.

> Everything my entire academic training was to protect me from, the reason I acquired all this methodological heft—wasn't it to keep me away from just these kinds of inhuman ideas?

Following Meillassoux, then, *le passé est imprévisible*—the past is unpredictable. For an ethics of knowledge, this implies that the production of subjects, too, is prone to different genealogical descriptions and overwriting. The circle of a different understanding of the present runs through a transformation of my past; I have to write a past according to my present. And "I am writing my past for my present" means, at the same time, "I am writing a different history for my *con-temporaries*," and "I am (over)writing a new present for myself." It is hard to think of anything more unlike the philological idealism that characterizes historical work as it is performed in the university.

From Hegel's idealism to Meillassoux's materialism, speculative philosophies are fascinated by such a form of temporality. Even Negarestani's inhuman distortion of humanism works with it: "Inhumanism as a force that travels back from the future to alter, if not completely discontinue, the command of its origin—that is as a future that writes its own past."[167] The truth does not lie in the past but in the future. Truth is not always already given; it is to be produced. I do not mean that in any relativistic sense, but only to suggest that production (poiesis) and thinking (noesis) have to be conceived of differently (and most certainly not, as in aestheticized philosophy, via a primacy of aisthesis qua sensibility). What I am looking for is a poetic "model of an art of acting." De Certeau speaks of the "poetic activity of readers," a poetics that precedes every theory, as well as "that *mētis* which, in seizing

167 Negarestani, "Labor of the Inhuman," 444.

occasions, constantly restores the unexpected pertinence of time in places where powers are distributed."[168] Accordingly, a speculative poetics—a poetics that does not impose a chronology or hierarchy on theory and practice, thinking and acting—operates with a concept of an asynchronous temporality.

"Self-designing processes are anastrophic."[169] The formula summarizes the cyber-nihilistic doctrine of Sadie Plant and Nick Land, but it might well be the sort of thing Hegel had in mind when he spoke of the speculative essence of retroactivity. The reality of a thinking that has undergone dialectical negation is a speculative reality; its facts have changed or transformed. In this respect, speculative poetics goes beyond and overwrites traditional poetics (and its focus on genres). Thanks to its poietic core, it obstructs the aesthetic regime, which is based on imagination and oriented by the paradigm of experience. It has much to say about the way this aesthetics deals with actual changes that transgress the boundaries of certain developments—for instance, the problem it seems to have with a certain kind of art, with the Romantics at the beginning of the nineteenth century, or a hundred years later with the artistic and philosophical avant-gardes, or today with speculative attempts to go beyond the way contemporary art is produced and received.

This problem is evident as early as Hegel's critique of Romanticism in the *Lectures on Aesthetics* or in Gustav Shpet's critique of Futurism in *Aesthetic Fragments* (1922–23). These works demonstrate that contemporary aesthetics—the term "contemporary," in the sense of sharing the same time, has to be used with caution—opposes what it cannot but see,

168 De Certeau, *Practice of Everyday Life*, 172, 88–89. François Jullien diagnoses a fundamental fixation of our Western thinking that resists all attempts at overcoming abstract separations of theory and practice. He contrasts it with the way Chinese thinking conceives of time: "This is time that is oblivious to the distinction between theory and practice; it is neither the time of *chronos* nor that of *kairos* (neither regularly periodic nor chancy). It never repeats itself, yet you can count on it" (Jullien, *Treatise on Efficacy*, 72). Although Jullien calls it "strategic time," he describes what I, like de Certeau, would call "tactical time." Although the Greeks thematized *mētis* (wisdom, skill, craft) they did not succeed in thinking it, so that the concept itself fell into oblivion. The central text in the background of this discussion is Marcel Detienne and Jean-Pierre Vernant, *Cunning Intelligence in Greek Culture and Society*, trans. Janet Lloyd (Atlantic Highlands, NJ: Humanities Press, 1978).

169 Sadie Plant and Nick Land, "Cyberpositive," in Mackay and Avanessian, *#Accelerate*, 308.

given its concept of art, as art theory without art. The reason for such incomprehension on the part of the German idealist and the Russian phenomenologist, but the reason also for the confusion of today's critics when confronted with "reason to destroy contemporary art" (Suhail Malik), is that, each time, the material, aisthetic basis of art, which is the sine qua non of aesthetics, comes under threat.

Aesthetic critique in each case refers to the (Romantic/avant-gardist) annihilation of the material basis required by the hegemony of aesthetics. It tends to ignore the future moment of every present, which by its very nature is hardly to be captured by aisthesis. This also explains the tendency of aesthetics, which since Hegel has laid out its arguments in art *historical* terms, to base its theory on whatever artistic movement came just before the current one: German Classicism in Hegel's case, Symbolism in Shpet's, and today the art that was most critical in the 1960s and '70s, along with its epigones. This orientation toward the past—which would be touching were its proponents not so ruthless—obviously does not impede the success of aesthetics. Quite the contrary.

That is why it would be a grave misunderstanding and a gross simplification to characterize this problem as merely the result of backwardness. Nor would it make sense to counter a previous conception of art with a conception based on whatever one sees as the latest already-established forms of art. The peculiar backwardness of the proponents of aesthetics points to the limits of their critical ontology.

> Poetically overwriting aestheticized philosophy.

The hegemony of aesthetics thus has to be countered with a different ethics (of knowledge) and poetics (of existence), with a poietic thinking (also about art and literature) that does not fall back behind the aesthetic regime but presents an alternative. Before we can spell this out, however, we need to analyze the concrete conditions governing life and work in the institution that made it possible in the first place to establish and implement what Rancière described as the aesthetic regime.

PART II

Sites of Writing, Sites of Speaking

Contexts

Qualification and (Self-)Evaluation

> All political institutions are cyberian military targets. Take universities, for instance. Learning surrenders control to the future, threatening established power. It is vigorously suppressed by all political structures, which replace it with a docilizing and conformist education, reproducing privilege as wisdom. Schools are social devices whose specific function is to incapacitate learning, and universities are employed to legitimate schooling through perpetual reconstitution of global social memory. —Nick Land, "Meltdown," 1994

One central feature of the strategies of legitimization within the aesthetic regime is the highly political self-conception of its protagonists. Artist and theorist Hito Steyerl captures this aspect when she writes: "Addressing the intrinsic conditions of the art field, as well as the blatant corruption within it—think of bribes to get this or that large-scale biennial into one peripheral region or another—is a taboo even on the agenda of most artists who consider themselves political. Even though political art manages to represent so-called local situations from all over the globe, and routinely packages injustice and destitution, the conditions of its own production and display remain pretty much unexplored. One could even say that the politics of art are the blind spot of much contemporary political art."[170]

170 Steyerl, "Politics of Art."

I would like to propose an analogous hypothesis for academia: the political theories making the rounds in the university, to their proponents' minds, deal critically and radically with each and every aspect of politics; however, they do not address the politics proper to the university (bar some very few exceptions). Adapting Jean-Luc Godard's take on so-called political films and truly politicizing filmmaking, we might say that the task now is not to do theory that is political, but to politicize theory, to politicize academic thinking, or, at least, to question the political and ethical foundations of its material dimensions (the settings in which writing takes place, the spaces in which communication happens, etc.).

The lack of theoretical engagement with the political work conditions of the university has practical consequences. Shortsightedness concerning concrete material work situations leads to a kind of isolationist blindness. Both aspects are linked, of course: to shy away from a precise but conflictual analysis of the situation in which one speaks and writes, or to avoid a thorough examination and reconstruction (meaning interventions that manipulate given settings) of the academic power mechanism within which one operates is to invite a loss of orientation. The resulting inability to advance is only partially concealed by small career steps. In this chapter, cursory glances at the settings of contemporary communication and writing are intended to show the extent to which academic work obeys the regulations and possibilities of the aesthetic regime implemented around 1800 as well as the difficulty the subjects produced by this regime have in effectively resisting it.

The depressing and depressive condition of the academic subject is partly due to the fact that the university maintains its ideological promise of freely developing one's creativity despite a massive loss of job security that renders this promise increasingly untenable. The situation is aggravated by the post-1960s concealment of the power relations that remain intact even while academic authority is eroded: in a community or society that thinks of itself as egalitarian, as guided by ideals of unfettered communication, objective knowledge without authoritarian masters, and (self-)education without external instruction, the critical mechanisms of the university lead directly to the depression of those who are animated by such ideals.

Most commonly, the power relations prevalent in the university are either completely ignored or described in such an abstract manner that they are unrecognizable as the superstructure of concrete practices of writing and speaking. Instead of an accelerationist transformation of the status quo, nostalgic folk politics (invoking the good old times of Humboldt et al.) and political daydreams of radicalism (rants about a new political beginning) reign supreme.

One of the consequences of the psychological and cultural finish of the ironic research university is that it constructs an institutional space that, in most cases, succeeds in deflecting any inquiry into the concrete power structures of research institutions as much as possible. (Sometimes institutions cannot avoid scrutiny; for example, when they establish satellite campuses in autocratic regimes. That, however, remains the exception.) What I would like to do here, though, is to guide our attention back to the inside, to the concrete political and ethical organization of knowledge within the university as it relates to the written and the oral.

> Political orientation presupposes an ethical localization.

As we've seen, the Romantic university shifts the emphasis from the oral *disputatio* to the written *dissertatio*, the latter having turned out to be one of the lasting pedagogical achievements of implementing an aesthetic ideal of research. But in which contexts, in which scenes of writing and reading does it come about? What is the setting of the academic production of knowledge? What are the concrete sites in which we write? How and where do we talk about texts, ours and those of others? How have the oral reproduction and written production of knowledge in the humanities been connected since 1800? What are the usual forms in which critique of the status quo is voiced?

Let's recall the double transformation of the status of books in nineteenth-century academic philosophy, as described by Kittler. Philosophers after Kant no longer read from canonized textbooks in their lectures. This is tied to a complete revision of the relation

between text and interpretation. The result of an original inquiry into the text, the interpretation, is precisely no longer simply to be found in the text, and it does not belong to the reader or to the author being read. Fichte, for example, wrote that the interpretation of poetry and, in its wake, of texts in general now means: "What we must declare for him [the Reader], is precisely that which the Author has not said, but from which he has drawn everything which he has said; we must lay bare what the Author himself really is, and how all which he has said has become to him such as it is;—we must extract the spirit from his letter."[171]

The appeal to the Romantic researcher concerning the books he draws on is, *Depart from the text!* In this context, Kittler makes a very interesting observation regarding one particular setting of verbal training in thinking: "Another ideal form of such oral recovery from the old-fashioned reading of books are the seminars invented at the same time by Humboldt and others. In these seminars, books are no longer literally commented on; rather, lecturers and students relax by saying anything about a book except what is actually in the book."[172]

Kittler describes university seminars as platforms for a new conception of literature and theory as aesthetic interpretation: the appeal to depart from the text in an original fashion. This description allows us to outline the situation of collaborative research today. It differs from the "original" Romantic university not in its basic aesthetic structure but in several schizophrenic symptoms already mentioned above. The historical shift is especially apparent in a quasi-transcendental a priori of the modern research university; namely, the potentially unbearable tension between a (self-)critical claim to creativity and the desire for producing public effects (a largely futile desire, given how irrelevant most research and writing in the humanities is to the general public, policy makers, social movements, and so on). In an earlier, more authoritarian society incessantly striving toward progress, the psychosocial ties between the youth from so-called good families and their masters were stable. Broad or even mass access to higher education, however, increasingly abolished ways

171 Johann Gottlieb Fichte, *The Characteristics of the Present Age*, trans. William Smith (London: John Chapman, 1847), 110.
172 Kittler, *Philosophien der Literatur*, 146.

QUALIFICATION AND (SELF-)EVALUATION 113

of resolving the dilemma. A good two hundred years after the *Policeyminister*, education policy (shaped, not least importantly, by the leftist epigones of '68) has tried once again to boost creativity and originality.

The problem is that attempts at creating critical spaces and better work conditions still do not transform the very basic structures of academia. In practice, they end up placing more demands on young academics in particular. Collaborating on a research project, joining a PhD program, winning a fellowship, and so on, entail a combination of obligations, from teaching courses via participating in departmental colloquia and reading groups (the latter voluntary, of course!) to organizing conferences, not to mention, as the case may be, course work and exams or administrative responsibilities. Graduate schools and collaborative research centers thus not only have a tendency to get in the way of writing books (which seems to puzzle everyone—after all, these students have been chosen and endowed with generous funding for just this purpose); more often than not, their mode of operation actively opposes even the reading of books in their entirety. Already on this most basic level, any discussion of a text's more complex theoretical implications and connections is excluded.

Where the theory of the text remains invisible or inexplicit, it is always one's own (often unconscious) theory that takes over. In that case, the indexical function of the texts discussed is the only thing picked up. *That's exactly what …, That's just like in …, It's like what …* are just a few formulas varying the effect of the rhetorical "exactly" that Anke Hennig and I have described as symptoms of an unquestioning obedience to an internalized theory that thinks each and every text in terms of one's favorite author.[173] Reading texts in this manner, "against the grain," reduces them to collections of indexes, repositories of isolated theses, and quotations.

Another instance in which the university serves as willing spearhead of neoliberal transformation is the compulsion to communicate. "The typical sign of post-democracy," as Metz and Seeßlen write, "is the exhortation to 'participate' and

173 Avanessian and Hennig, *Metanoia*, chap. 1.

to 'be a part of it.'"[174] The strict discipline of "network capitalism" (Boltanski/Chiapello), on the one hand, turns academic discussions into desperate struggles for distinction. On the other hand, few art critics, as Isabelle Graw admits, "are prepared to write a well-founded negative review. […] People are unwilling to make unnecessary enemies, especially as their support might one day be needed."[175] And for fear of burning the bridge that could lead to the next job, as one literary scholar has discussed, junior researchers tend not to publish much against the establishment.[176] Within the field of expanded academia, we find an aestheticized intelligentsia constantly writing proposals and applications in order to produce even more innovative writing and speaking that belongs to the forms of immaterial labor producing and reproducing our current model of (aesthetic) subjectivity.[177]

Picking up on Adorno's polemic against the dilettante's hunt for "beautiful passages" in music, we may speak of an aestheticized reception of fragments of theory-Muzak devoid of any context (not to say of any sense).[178] And what does such an attitude do to the great books and authors whose singularity and resilience continue to serve as abstract ideals? They are filleted, their applicability sounded out and yanked out of context. Ultimately, however, it all comes down to rehashing a theory canon everyone is familiar with (bar the occasional addition of a new theory celebrity for the sake of maintaining the claim to innovation). The most important activity is sounding texts out for isolated ("beautiful") ideas from which to fabricate an unstable framework for one's own research. This necessarily unsystematic way of dealing with alien text fragments, carefully quoted and separated from one's own text, can be seen as the opposite of an overwriting.

174 Metz and Seeßlen, *Geld frisst Kunst*, 333.
175 Isabelle Graw, *High Price: Art between the Market and Celebrity Culture*, trans. Nicholas Grindell (Berlin: Sternberg Press, 2010), 107.
176 Remigius Bunia, "Risiken und Nebenwirkungen fehlender Personalplanung an deutschen Universitäten," in *Das deutsche Wissenschaftssystem und seine Postdocs: Perspektiven für die Gestaltung der Qualifizierungsphase nach der Promotion*, ed. Hanna Kauhaus (Bielefeld: UniversitätsVerlagWebler, 2013), 99.
177 "The concept of immaterial labor presupposes and results in an enlargement of productive cooperation that even includes the production and reproduction of communication and hence of its most important contents: subjectivity" (Lazzarato, "Immaterial Labor," 140).
178 See Theodor W. Adorno, "Types of Musical Conduct," in *Introduction to the Sociology of Music*, trans. E. B. Ashton (New York: Seabury Press, 1976), 9.

> Overwriting leads to an integration of the whole framework of a theory or a book into oneself (at the same time writing over the text and being overwritten).

The discrepancy between admiring and minimizing authors and their texts, cut up into digestible morsels, gives rise to a performative self-contradiction whose extent can be measured by its divergence from a (central) categorical imperative of academic research. The maxim might be to maintain the desire for truth and to treat texts as ends and not as means, to refrain from ignoring their concrete shape, form, and genesis. The result of my research should thus (aim to) live up to the kind of text that I read as primary texts—i.e., as texts of primary importance. This demand, this claim of an ethics of knowledge, is blatantly ignored by most research in the humanities, which nibbles on the great books and, while living off primary literature, ultimately subsidizes secondary thinking—dissertations and theses and their decorative montage of quotations, essay collections, and articles, all kinds of secondary literature tailored to consumption in the routines of teaching. Under the conditions of critical knowledge, the relationship between text and theory has become deadlocked. And the effects are even more wide-ranging when a critical interdisciplinarity is brought in to boost indexical intertextuality.

> Research and write only according to the maxim that makes them universal!

Here, too, we cannot but marvel at the deep institutional roots of critical thinking—the mutual implication of aesthetic thinking and critical interdisciplinarity I invoked earlier with Judith Butler: "The operation of critique and even the subsequent petition can emerge from the interstices of institutional life (which is not the same as emerging from a transcendental field); it may emerge precisely from those interstitial sites where

disciplinary boundaries have not been firmly maintained."[179] In other words, critical knowledge itself tends toward interdisciplinarity. Critical knowledge, interdisciplinary humanities, and political aesthetics go hand in hand. The real achievement of the humanities in the aestheticized research university today is not only the academic results they produce, but rather the production of a corresponding subjectivity. It is almost as if the medieval college structure, or at least its metaphysical educational core, sidelined by the modern research university, made a comeback through the back door—which, perhaps not coincidentally, is all the more the case the less large-scale universities are able to live up to their own claim to produce original or paradigm-shifting research.

As critical knowledge spread, so did an economy of evaluation to measure the circulation and accumulation of knowledge. "Like many bureaucratic devices investigated in this study," writes William Clark in *Academic Charisma*, "the grading system recast academics' own mentalities, and cast its own academics. It forms a key part of the modern ideology of objective evaluation."[180] It is fascinating to see how the qualifying paper that marginalizes the disputation functions as an evaluation tool. We then have to ask about the impact of the criterion of "originality," whose validity has gone unquestioned since Fichte and the other founding fathers of the Berlin university tradition. What is it like to obtain a doctorate in the spirit of the ideals of Hegel and Humboldt? Let's look at the way PhD candidates are evaluated.

I should now bring up an unsettling practice quite common in the German system of evaluation: recommendations written by candidates themselves. The situation, witnessed by almost everyone in academia, is as follows: a graduate student asks a current or former professor for a letter of recommendation only to be told something along the lines of, "Yes, of course, just send it and I'll be happy to sign it." This may leave the student surprised, speechless even (if it leaves you speechless as you're reading this, just go ask anyone familiar with a German humanities department). Yet this approach to recommendations is so widespread that it cannot be put down to the quirkiness of some overworked academic manager.

179 Butler, "Critique, Dissent, Disciplinarity," 786.
180 Clark, *Academic Charisma*, 139.

> Self-evaluation is an instrument entirely consistent with the *ironic research university* (William Clark).

The student may have the suspicion that the whole thing is somehow immoral or that it undermines academic evaluation procedures. But a closer look reveals the opposite. To force a self-evaluation is an admittedly insidious but no less consistent instrument employed by the ironic research university. Initial indignation is thus usually followed by cynicism in dealing with the mock objectivity of such evaluation tools. This kind of "enlightened false consciousness," to employ Peter Sloterdijk's still-accurate definition of cynicism, is merely an intermediate step toward embracing the performative truth of self-evaluation.[181] Indignation, however, is completely unfounded, since the demand is to live up to an ideal of self-evaluation. At most, the procedure is dishonest in that young researchers are not told or aware that they are being tested. In a historical perspective, the unconscious presupposition of professors who leave the evaluation of their students to the students themselves is not careless negligence on the part of an overworked professoriate; rather, it expresses the cunning ideal of an academic habitus cultivated for more than two centuries. As I have already noted, since the time of Fichte and his contemporaries, the main thing a doctoral dissertation in the modern research university has had to be is *original*. We can now see that it also implies a certain form of evaluation. Since "originality," by its very nature, can hardly ever, and despite claims to the contrary, be evaluated objectively,[182] it can only be discovered by the candidates themselves and must therefore also be expressed by them. What, then, would be more consistent than to have them evaluate themselves? This approach is based on the old Rousseauian fantasy of a pure, natural self-education. "Any man who is taught is only half a man," is the succinct formula of Jacques de Chabannes La Palice, as discussed by Rancière in his brilliant book *The Ignorant Schoolmaster*.[183]

[181] Peter Sloterdijk, *Critique of Cynical Reason*, trans. Michael Eldred (Minneapolis: University of Minnesota Press, 1987), 5.
[182] See Ochsner et al., "Four Types of Research in the Humanities."
[183] Jacques Rancière, *The Ignorant Schoolmaster: Five Lessons in Intellectual Emancipation*, trans. Kristin Ross (Stanford, CA: Stanford University Press, 1991), 21.

The German dissertation is to be understood along the same lines. Practically devoid of any requirements other than enrollment at the beginning (and often not even that) and submission of the text at the end, it is the perfect example of the kind of self-education or self-formation Foucault refers to as the school of the missing teacher. Gerald Raunig highlights Foucault's remark that this teacher "is of course *logos* itself, the discourse which will give access to the truth."[184] Raunig also observes: "That the teacher is missing, absent, does not mean abandoning every notion of the subject position. It means conceiving subject positions as relations, positing relations and modes of subjectivation."[185] In other words, the modern researcher's personality is confronted front and center with the demand to internalize a standard academic habitus.

Self-written recommendations thus test an essential skill—the internalization of the standard academic habitus—and supplement the skill proven in the dissertation of organizing oneself independently, subject only to one's own will to knowledge. Young German researchers thereby internalize a relationship to the Other, the missing teacher, and its evaluation. For the moment we can summarize this as follows: young researchers are placed within a scenario in which they assume the position of a different superego instead of liberating their own.

A typical self-evaluation, in any case, yields no insight about anyone's qualities as a candidate. It is not a tool for evaluating scientific achievement. Instead, it demonstrates the extent to which students have managed to adopt a general academic habitus: Have they been able to apply this standard to their own ego (to internalize it) and to embody the result of this recursive operation as the image of a successful subjectivation? We may surmise that this practice is the symptom of a deeply asocial (inter)subjectivity and the site of a multitude of inner resistances and writer's blocks on whose horizon the typical pathologies of neoliberal education await the future PhDs.

184 Ibid., 151–52.
185 Gerald Raunig, "Intensifying Theory Production: The School of the Missing Teacher," trans. Aileen Derieg, *Transversal*, October 2010, http://eipcp.net/transversal/1210/raunig/en.

On the Use and Abuse of Formulas for Thinking

The Discourse of the University Gives Free Reign to Hatred

> The planetary petty bourgeoisie is probably the form in which humanity is moving toward its own destruction. —Giorgio Agamben, *The Coming Community*, 1993

Ressentiment and (competitive) aggression have become pervasive in the contemporary university. To capture them analytically—and in this case that means psychoanalytically—I suggest we take a theoretical model articulated by Lacan as our guide. "The discourse that gives free reign to hatred is the one Lacan calls *University* discourse, whose common form is the moral discourse," writes Alain Juranville.[186] This discourse's rationalizing knowledge, according to Lacan, blocks the access to sublimation, to truth as the production of the subject—an access available to psychoanalysis alone.[187] Lacan's four discourses, which diagnose different forms of structural constraint, will help us come to a theoretical understanding of the hatred omnipresent in the university and the depression widespread

186 Alain Juranville, *Lacan et la philosophie* (Paris: Presses universitaires de France, 1984), 348.
187 "In university discourse," Lacan says, there is a "gap where the subject is engulfed that it [this discourse] produces from having to suppose an author to savoir." Jacques Lacan, "Radiophonie" (1970), trans. Jack W. Stone, accessed September 1, 2016, http://www.book.dislib.info/b1-other/4191375-9-radiophonie-scilicet-2-3-paris-seuil-1970-55-99-translated-jack.php.

among humanities scholars. Lacan developed this model in examining the student movement of the 1960s (which considered itself to be revolutionary). The analysis of different discursive positions and functions is a way for him to respond to and reject academic attempts to appropriate the knowledge of psychoanalysis (which is certainly one reason for the deliberate hermetism of his formulas).

At the basis of his four discourses are the following positions:

$$\frac{\text{agent}}{\text{truth}} \rightarrow \frac{\text{other}}{\text{product}}$$

Roughly speaking, Lacan's discourses are structures that can be formalized and are to be situated between (universally given) language and (individual) speech. Although unspoken most of the time, they are inscribed in the language of individuals as in that of institutions.[188] What is decisive is less the subject (*who*) or the content (*what*) of speech but the localization of speech: *Where do I speak from, and what position do I assume in doing so?* This question concerns the setting and thus the recursive process in which the production of knowledge or truth takes place.

Each of the four discourses starts from an apparent *agent* and is addressed to an *other*. The *product* is thus already under the threshold of consciousness (basically a leftover), as is the reference to *truth*. And every discourse finds its true agent in the position of truth even if (or perhaps because) this agent remains hidden.

Discourse of the Master Discourse of the University

$$\frac{S_1}{\$} \rightarrow \frac{S_2}{a} \qquad \frac{S_2}{S_1} \rightarrow \frac{a}{\$}$$

188 On this point, see Alexandre Leupin, *Lacan Today: Psychoanalysis, Science, Religion* (New York: Other Press, 2004), 68; and Levi R. Bryant, *The Democracy of Objects* (Ann Arbor, MI: Open Humanities Press, 2011), 40.

Discourse of the Hysteric

$$\frac{\tilde{S}}{a} \rightarrow \frac{S_1}{S_2}$$

Discourse of the Analyst

$$\frac{a}{S_2} \rightarrow \frac{\tilde{S}}{S_1}$$

S_1 = the master signifier
S_2 = knowledge (*le savoir*)
\tilde{S} = the subject (barred)
a = the *objet petit a*

The tension between two agents—the apparent agent and the agent occupying the position of truth—leads me to formulate a first hypothesis to address the question of precisely why, if we follow Lacan, the alleged ivory tower of the university produces not truth but disjointed, fragmentary knowledge and, as a result, despondency. (The very first look at the schema reveals the specificity of the discourse of the university—namely, that the master signifier appears in the position of displaced truth.)

The discourse of the university starts from knowledge (S_2) and addresses—via the barred subject \tilde{S}—the legendary object a as cause of desire. The tension between knowledge and truth that the discourse of the university cannot resolve also exists between the bureaucratic battery of signifiers of knowledge (S_2) and an absolute authority (S_1) or, in other words, between master and servant or slave. As Pierre Macherey puts it:

> The funny thing is that he [the slave] thus comes to pass off his submission as autonomy. […] The discourse of the university fosters the illusion that it has succeeded in establishing a new form of mastery, a most paradoxical mastery since it presents itself as a mastery without masters that accepts no other law than that of pure knowledge, as if knowledge could ever be pure, that is, independent once and for all of any external conditioning. The only imperative this discourse admits is the imperative of intelligibility, which it considers a guarantee of successful communication. The discourse of the master, on the contrary, defies this imperative, which would limit the mas-

> ter's sovereignty by forcing him to explain himself, to justify himself, a demand that the discourse of the university promises to satisfy, even to satisfy in advance before it's been formulated, by taking the form of a discourse of necessity that is by definition accessible to all, democratically transmissible and consumable because it has been formatted according to the principle of universality, a principle that rational knowledge proposes to promote.[189]

In Lacan's university formula, it is striking that the lacking subject and the master signifier have no part to play in conscious discourse. In the discourse of the university, the castrated subject is the product and the master signifier is the hidden truth. The subjugated academic subject bars itself from doing what the masters (who are beyond all laws of argument) are free to do—namely, to speak in its own name. Instead, it fashions itself into an allegedly humble (that is, resentful) proponent of an impersonal academic morality. This neutral—ethically neutralized—knowledge claims to be the result of successful, knowledge-producing communication, to be innovative and original, and to be independent of any power external to the objectivity of knowledge. Thus, the discourse of the university ignores the poietic effects of different settings— their performativity and, not least of all, their ability to perforate the conclusiveness of official discourse. There would be immense potential for achieving this in other settings if only one managed to not be stupider than one really is. Macherey notes what university morality, according to Lacan, does not consider:

> Every communicative operation is based on a deception, that is, on an abuse even more harmful than the *coup de force* with which the master literally takes possession of the discourse when he has the courage to admit and to declare loud and clear, "Because I say so!" The academic does not have this courage: he will take shelter behind the defense provided to him by the objective knowledge he claims, which is a convenient excuse to evade

189 Pierre Macherey, "Lacan et le discours universitaire," *La philosophie au sens large* (blog), December 2, 2009, http://philolarge.hypotheses.org/87.

the obligation to speak in one's own name and to assume full responsibility for what he says, a responsibility that the discourse of the master, however inacceptable it may be in many respects, has the merit of not shirking.[190]

It stands to reason that this targeted training of subjects who distance themselves from both themselves and their desire—who, in other words, deny themselves—is one of the main reasons for the latent self-hatred and manifest ressentiment among academics. Hardly present in younger students (still eagerly attached to their masters, whom they initially associate with the authors of the books they worship), not uncommon among graduate students (the insight that the department kings and empresses of outside funding are quite naked is not long in coming), what Spinoza would call "sad affects" become more dominant the more subjects are drilled in blocking the ethical transformation of knowledge into their truth. This is tied to the impossibility—in the discourse of the university, according to Lacan—to deal with the master, the master signifier that cannot be resolved into meaning (and is significantly excluded from the discourse of the university).

An ethical and poietical transformation of the academic setting therefore has to intervene in the relation between subject and truth. The academic settings described above tend to sever this connection, and that is why they produce such hatred: the ideal of subject-independent objectivity can only be attained at the cost of a moral leveling, of a self-annihilation. No wonder, then, that the university succeeds, sooner or later, in wiping the smile off everyone's face.

> University discourse characterizes all institutions led by scholars or bureaucrats in which no one can learn anything (Jacques Lacan).

The discourse of psychoanalysis helps bring out the specificity of university doctrine and the understanding of why the discourse of the university is the institutional anchor of hatred and academic frustration. According to Lacan, the discourse of psychoanalysis is the only one to offer the subject

190 Ibid.

the possibility of sublimation—true learning. The discourse of the university, on the contrary, has to suppose that the agent acquired his knowledge elsewhere, and it works by making the other feel this "lack"—a fitting description of a phenomenon ubiquitous in academic discussions. For, as Juranville writes, "the sublimatory knowledge (the written) that one has acquired, and without which he could not be the agent of this discourse, cannot be transmitted to the other. The discourse of the university characterizes all institutions of the bureaucratic or clerical type in which powerful ministers base their might on their knowledge of texts and its reference to absent masters. Nobody can learn anything in an institution whose functioning aims at *selection*. More than once, Lacan has rejected it as a model for psychoanalysis."[191] All the protagonists of the institutional history outlined earlier return here as psychoanalytic figures: the ghostly writers of secondary literature bereft of their proper names, the bureaucrats, and the absent masters, whom Lacan calls "master signifiers" because they are "not the product but the truth of the University."[192]

Lacan was the first to tinker with his four discourses, and he came up with at least one more variant. It is no coincidence that this fifth discourse responds to the ambiguity about whether the discourse of science and the academy belongs to the discourse of the university, of the hysteric, or even of the master.[193] This has allowed Levi Bryant to take up the suggestion implicit in Lacan's intentionally

191 Juranville, *Lacan et la philosophie*, 349.
192 "Il est évident que c'est à ce que le plus-de-jouir qui s'incarne des gosses de maître, ne reste en rien enseigné, sauf à se servir de l'enseignant, que ceux qui en ont de famille la recette, relèveront les signifiants-maîtres qui ne sont pas la production, mais la vérité de l'Université." Jacques Lacan, "Allocution prononcée pour la clôture du congrès de l'École freudienne de Paris le 19 avril 1970, par son directeur," *Scilicet*, nos. 2–3 (1970): 395.
193 See the detailed reconstruction of the hysteric's discourse in Bruce Fink, *The Lacanian Subject: Between Language and Jouissance* (Princeton, NJ: Princeton University Press, 1995), 133: "In the lower right-hand corner, we find knowledge (S_2). This position is also the one where Lacan situates jouissance, the pleasure produced by a discourse. [...] In the master's discourse, knowledge is prized only insofar as it can produce something else, only so long as it can be put to work for the master; yet knowledge itself remains inaccessible to the master. In the university discourse, knowledge is not so much an end in itself as that which justifies the academic's very existence and activity. [...] In 1970, in Seminar XVII, Lacan views science as having the same structure as the master's discourse. He seems to see it as serving the master, as did classical philosophy. By 1973, in *Television*, Lacan claims that the discourse of science and the discourse of the hysteric are *almost* identical [...] and in 1975 he identifies them quite unreservedly."

hyper-abstract models to keep on fiddling with them. He suggests multiplying the four discourses. Lacan starts with the discourse of the master (which proceeds $S_1 \to S_2 \to a // \cancel{S}$) and keeps turning it, as it were, to obtain a schema of discourses that Bryant calls the "universe of the master." Bryant, for his part, conceives of a discourse of capitalism ($\cancel{S} \to S_2 \to a // S_1$) from which he constructs, on the same principle, three more discourses (of bio-power, immaterial production, and critical theory) that, all together, stake out the universe of capitalism.[194]

What is so fascinating and stimulating about these variations is that they allow for a number of thought experiments. I read them speculatively, as attempts at exploring unfamiliar territory: catalysts for thought experiments and setups for rendering visible what usually remains invisible, giving rise to new hypotheses. It would then be possible to systematize completely different discourses (and corresponding universes)—starting from, for example, desire—that conflict with the discursive order of the universe of the master (i.e., with the discourses of the master and the university). Which structural order would describe, say, a fetishistic discourse starting from the object a of desire? What would a formula look like that captures the transformative dimension of an ethical practice of knowledge aiming for truth instead of an accumulation and repetition of knowledge? Since I believe that perversion can play an important role in a non-neurotic, post-oedipal confrontation with the law (of the master or of the university),[195] I will try the following setup (in analogy with the discourse of psychoanalysis, which also starts from the object a):

$$\frac{a}{S_1} \to \frac{S_2}{\cancel{S}} \quad //$$

194 Bryant is "convinced that we're now living in the age of the object, of the *objet a* or j-symptoms (*jouissance*-symptoms), rather than the age of s-symptoms or signifier-symptoms as were characteristic of the universe of the master." Levi R. Bryant, "Lacan and the 4 (or 16) Fantasies," *Larval Subjects* (blog), March 26, 2013, https://larvalsubjects.wordpress.com/2013/03/26/lacan-and-the-4-or-16-fantasies/.
195 A fetishistic desire would have to be different from the *hysteric* desire for the desire that *cannot be satisfied* and the *obsessive* desire for the *impossible* desire, which Lacan associates with the masculine master.

What this setup gives us, what it tasks us to do, is to think a discourse in which the barred subject assumes the position of the desiring product. As in the discourse of the depressive university—which I seek to shift and alienate to articulate as fetishism—the master signifier is in the position of truth. But the difference is striking: it concerns the tension between (relative) knowledge and (absolute) truth. Fetishism is characterized by its identification with a symptom as the source of its own jouissance (an identification in which the symptom becomes a self-conscious *sinthome*); the decisive feature of the discourse of fetishism is not the (masculine) phantasm $\barred{S} <> a$ (to be read as the fundamental structure of desire of the discourse of the master) nor a hysterical desire for an unsatisfied desire, but a "forbidden" jouissance. But, of course, such a reading goes completely against the grain of the academic understanding of Lacan.

Earlier, I attempted to mark the Romantic research university's unproductivity threshold in a number of configurations of writing and speaking. The more smoothly the research university fits in with the neoliberal zeitgeist, the easier it is to conceal this unproductiveness from the academic-artists who populate it.

To this day, *Think critically! Be yourself!* is the imperative addressed to Romantic youngsters who are ill-equipped to oppose it. Under the aesthetic regime, critical writing fails with alarming regularity to perform the ethical task of producing new subjectivities—i.e., of writing differently or of rewriting (oneself). In the eighteenth century, the appeal that blended a Protestant culture of writing with the modern maximization of knowledge was, *Write to become yourself!* This task can still be either accepted as an ethopoietic one or evaded by an aesthetic fashioning of the self. Historically it was both a demand for originality in the written text and an appeal to the author whose text makes him out to be original. "Writing came to be thought of as the highest form of academic labor," William Clark explains. "German seminars would fashion charisma in writing."[196]

This has grave consequences for the subjects who define themselves via their disciplines and in whom the discourse of the university produces the (untrue) knowledge proper to it. Their desire is aimed not so much at real knowledge as

196 Clark, *Academic Charisma*, 158.

at what they take to be the object of their research. One phenotype encountered with increasing frequency comes from some sort of creative or artistic domain, ends up taking refuge in the university, and is perpetually on the verge of leaving again because the dream of attaining the object (*dance* or *cinema*, say) is never fulfilled. Dancers in performance studies, photographers in visual studies, or screenwriters in media studies seek institutional security in the university (a security made all the more regressive by precarization)—but these phenotypes never reach an ethical transformation through knowledge or truth, because they already underwent this transformation and its concomitant aesthetic experiences in their former creative existence. Thus they go about their research with an ignorance that undercuts all motivation. What all too often drives them is their fear that this ignorance could cause them to run afoul of the institution they have chosen as their perpetually temporary workplace (without any better ideas, they return to the stabilizing discipline of educational routines they know from their childhood). Bad compromises with the political-economic mechanisms of this workplace are practically unavoidable in this situation.

Although everyone knows better, the call for innovative research is meekly obeyed. Two modi operandi are particularly common: on the one hand, the constant reorganization and variation of the same knowledge with reference to one new (artistic) object after another; on the other, combing through the same canon with whatever innovative theory is to be extracted from the godparents of theory (Foucault, Deleuze, Rancière, Stengers, Haraway, Butler). The preferred media of innovative research are smartly organized conferences, well-selected collections of essays, interesting grant-renewal applications, and a host of other goodies. Each of these activities accumulates a knowledge that only distances the researcher even further from the truth. What this type of researcher suffers from, however, is not just the absence of truth, but rather the exploitation of the objects investigated and the exploitation of the researcher him- or herself. This suffering is explained away as the price to be paid for social security.

Although of course still valid, the reasons for the depression that plagues these researcher-subjects are thus much more complex than the critical reflex against the expansion of austerity policies in the universities would have us

believe. The practices of neoliberalism that weigh on and exhaust the subject intervene on a much deeper level—namely, on the level of the university responsible in the first place for establishing the form of subjectivity characteristic of the third spirit of capitalism. The aesthetic researcher-subjects have been and continue to be the pioneers of this critical self-exploitation—with little hope for (ethical) success. That's why depressives in the universities are not isolated cases but representatives of clinical normalcy.

Fetishism as Antidepressant

In Praise of Conflict

> If, as Foucault says, there is no happiness, and certainly no human happiness, all that remains is the hope for a life without masters. —Friedrich Kittler, "Das Jahrhundert der Landvermesser," 1997

According to Freud, the investigation of pathologies yields not just knowledge about clinically sick subjects but also insight into the crises and mental states of "normal" subjects. Drawing on Lacan, Slavoj Žižek notes that various pathologies (neuroses, perversions, psychoses) are at the same time attitudes of knowledge or relations to the world. In Lacan, they "become names for existential-ontological positions, for what Hegel [...] called [...] 'attitudes of thought toward objectivity.'"[197]

The fact that those pathologies appear simultaneously suggests a connection. In his study on depression in contemporary society Alain Ehrenberg writes: "The distinction between a mood disorder that one had (in the course of a depressive episode) and the troubled personality that one was lost its former meaning. The chronic nature of the condition jeopardized the idea of a cure." It is no longer a question of curing; what matters is "to be *accompanied* and *modified* more or less constantly" by the mood disorder and its treatment.[198]

[197] He continues: "The neurotic clings to his doubt, to his indeterminate status, as the only firm support of his being, and is extremely apprehensive of the prospect of being compelled to make a decision which would cut short his oscillation, his neither-nor status." Slavoj Žižek, *Tarrying with the Negative: Kant, Hegel, and the Critique of Ideology* (Durham, NC: Duke University Press, 1993), 69.
[198] Ehrenberg, *Weariness of the Self*, 164–65.

I would like to sketch a perspective that is non-neurotic, or at least post-oedipal: the perspective of the fetishists who define themselves by their own desire. From the fetishist's point of view, most academics (like all subjects parading the law as an excuse) are the best behaved of neurotics—while they feel themselves to be depressed victims or just simply depressed. Where both logics meet in practice, conflict is inevitable.

Let me clarify what I'm getting at by confronting the perspectival differences between *alter* and *ego*. From the outside perspective, the average academic's neurotic constitution is clearly marked by a belief in the law. With a heavy heart, the ironic researchers' beautiful souls still cling to their authorities. Thanks to a tradition maintained since the heyday of Romanticism by an insidious double bind, they still longingly place their faith in a sovereign who is inaccessible to them and whom they do everything to evade. This naturally depressive constellation is difficult to resolve, especially because of the perspective of those concerned: while they maintain ostentatiously friendly and close relationships with their superiors or advisers (who, incidentally, are not necessarily more autonomous than they are), they consider themselves to be much more progressive and, in principle, more innovative—if it weren't for the contingencies of life: relationship problems, burnouts, apartment trouble, food allergies, etc.

> All of life, it seems, gets in the way.

The academic progeny takes over this blind spot through their obsession to align with both sides. They confirm the desire of the paternal or maternal other and believe they have found an oedipal free space in the proximity of those in power. Every way out from this dilemma is naturally impeded by the double bind of a neurotic and depressive constitution.

Ehrenberg's analyses of depression and society in the contemporary age can help us articulate the connection as well as the difference between neurosis and depression in more detail. His writing also allows us to take some first steps toward resolving the entanglement of the depressive subject and outlining alternatives to this subject's evasive strategies and critical

attempts at therapy. I read Ehrenberg primarily as a psychologist of the effects of the creativity dispositif created and still perpetuated by the university. This concerns, in particular, the frustrating effects of the Enlightenment-Romantic ideas of lifelong learning (in the service of developing one's personality) and constant self-critique, to which I will later oppose a positive ethos aiming for a poetic transformation.

For Ehrenberg, depression at first appears as a reversal of neurosis, as "an *illness of responsibility* in which the dominant feeling is that of failure. The depressed individual is unable to measure up; he is tired of having to become himself."[199] Decisive for our purposes is his hypothesis "that the success of depression lies in the *decline of conflict as a reference point* upon which the nineteenth-century notion of the self was founded."[200] This is where "the notions of the self and conflict overlapped to the point where they were one and the same: a self was the self of its conflicts." As a depressive personality, the career-oriented academic is "unable to bring her conflicts to light, to give them form," leading to familiar feelings of emptiness and fragility, and an incapacity for dealing with frustrations. All this accounts for the depressive's inability to recognize conflicts.[201]

> A self is the self of its conflicts (Alain Ehrenberg).

These analyses suggest a possible way out of the depressive state via productively engaging with tactically calculated conflicts. Conflicts are the necessary corollary of positioning oneself (as a speaker) and thus the precondition for recursive thinking—the emancipatory connection between the ego and the world. That is why the conflicts arising from the elucidation of (university) discourses are naturally external. They differ in every respect from the inner buildup of conflicts, which fosters depression. Inner conflicts are the inevitable side effects of abstract cri-

199 Ibid., 4.
200 Ibid., 10.
201 Ibid., 102–3, 123.

tique. Evading external conflicts via aesthetic critique establishes both the legitimacy of the criticized object and the bias of the criticizing subjects.

Conflicts potentially allow us to break through to an objective and no longer just subjective dimension. When Deleuze, for example, encourages us to live up to our conflicts, he is not talking about issues with other people or intrapsychic problems. To live up to one's conflicts, rather, is to search for objective truth in the conflict (with the law) in which the subject is entangled and in which it threatens to lose itself. The alternative to the regressive loss of self is a transcendence in the direction of the superego, a poetic overwriting of the subject. According to Deleuze, this would constitute "not a psychology, but a politics of the self."[202]

What allows us to determine whether a conflict is legitimate and objective? Are there any criteria at all to decide whether a conflict results in more than subjective insufficiency, individual ressentiment, or badly concealed aggression? The most important criterion will turn out to be whether subjects succeed in liberating themselves by means of their conflicts, in transforming and expanding themselves and in thereby becoming an other.

The first task to be derived from Ehrenberg's analysis is to articulate and put into practice a progressive ethics of conflict—i.e., an ethics that is externally effective. Such a concept of conflict as thinking through doing avoids a regression to the inner strife of psychological pathologies. From an ethical perspective, the insufficient (and, not by coincidence, barely distinguishable) possibilities of affirmation and critique are to be countered by the search and *pro-duction* (creation of truth) of conflicts and their expression.

If the critical attitude only ever serves the purpose of (self-)legitimization, the question remains of how one is to counter the obtuseness of cultural rules and the arbitrariness of laws. Perhaps the law can only be manipulated by means of funny, ironic, or humorous tactics (an approach taken up frequently since Bakhtin). Analogously, the clinical disposition that

[202] Gilles Deleuze, "Pericles and Verdi: The Philosophy of François Châtelet," trans. Joseph Hughes, in Gilles Deleuze and Claire Parnet, *Dialogues II*, rev. ed. (New York: Columbia University Press, 2007), 155.

refuses, without a loss of reality, to acknowledge the law would be perversion (sadism, as good violence against the obscene law, and fetishism). Fetishism is the most apt at bringing out the productive force of conflict.

The usual reproach is that the fetishists' activities come at the expense of others, or that they work on their own account or just produce hype (when in fact tinkering with hyperstitions).[203] These criticisms—all of them declarations of intellectual ressentiment—express the depression of the culprits who consider themselves to be victims. Those who have settled into their own traps do not want to understand the fetishist's tactical sense, responding to every alienation with further alienation or estrangement.

Fetishistic exaggeration is thus rewarded by the system and simultaneously regarded with suspicion. The ambivalence of the fact that the outsider, on the one hand, is given preferred treatment and, on the other, can be (and is) punished at any moment, corresponds to the neurotic's attitude toward the outsider. If every desire has a fetishistic component, then neurotics sin against their desire by evading it or punishing its affirmation. Fetishists are, for this very reason, enviously supported because they get what everyone should have a right to (if they stood by their desire). But they must be punished because they take what is kept from others (or what these others keep from themselves in anticipatory obedience). For the majority of neurotics, there is something fishy about success and joy because, for them, in the world (of signifiers) there are no material fetishes. Nor can they stomach it when someone goes looking for success off the beaten institutional track.

> "For all I've written I seem to remain like a monk fornicating a goose in a coal mine." (Charles Bukowski)

Not to participate in the whole business—and to express this, for example, by irritatingly showing up everywhere and for everything—comes with great personal risk and is, if only for that reason, of greater ethical consequence than the usual critical attitude. Many forms of excess—of the superego,

203 See de Certeau, *Practice of Everyday Life*, 29.

FETISHISM AS ANTIDEPRESSANT

of fetishism, or, as in Deleuze, of humor—lead to conflict not via an emptying or a withdrawal (the pure event, Bartleby, the beautiful soul). Instead of *I would prefer not to*, the fetishist slogan is *I would prefer all of it, and may I please have some more.* Those who make the law transparent by overfulfilling the demands of discourse, those who make desire their own, have found their form of resistance. That is why, in the context of the ethical constitution or transformation of the subject I'm fascinated with, I want to make a rigorous distinction between the subject's neurotic dealing with the law and perverse passage via the law. Such a passage does not critically legitimate the law but appropriates it in an illegitimate manner, usurps it, and makes itself the author of its laws without being called upon to do so.

Alain Juranville spells out Lacan's existential understanding of perversion in philosophical terms as an alternative form of existence that submits to the *name* and to the *no* of the father (*le nom/non du père*) under certain conditions. The imaginary presence of the phallus in the fetish has its origin in a perverse identification with the first maternal object. A transgressive desiring would thus be one that imputes an imaginary fullness to an object. This is entirely different from neurotics with their harried submission, whose transgressions, no matter how far they go or how self-destructive they aim to be, never get to the point. But to overwrite, to overstep, "to transgress is always to provoke. But we can't have it both ways: either the Other executes exactly the punishment he had announced, in which case the transgression loses its meaning and the desire to transgress fades away; or the Other is 'beside himself' and his violence unleashed."[204] Only this second case of sadistic refinement unnerves the representatives of the law and leads to an acknowledgment of the truth: *I am a pathetic law, I exercise puny violence— only violence allows me, imperfectly, to hide my arbitrariness.*

Jurainville continues: "The pervert is thus not 'outside the law,' he does not ignore the Other of the law. Hence Lacan's criticism of those who hold that the sadist 'denies the existence of the Other.' The Other exists for the pervert as a 'will to *jouissance*' and the subject makes himself an instrument of this will."[205]

204 Juranville, *Lacan et la philosophie*, 261.
205 Ibid., 262; Juranville is referring to Lacan's 1963 essay "Kant with Sade."

> I am the one who makes us happy. You are (yourself) only when I am around, only because I change the world for you. I endow things with meaning.

Speaking "in one's own name" seems to remind the elegant daughters and equally oedipal sons of their badly concealed egotism, to which they react with neurotic hatred and depressive envy. They just can't stand the logic of the fetishist, a logic according to which "the signifier of the law is to arise in reality—as object."[206]

On a good day, when the moment is right, when things get going and the fetishist's performance is believable, the neurotics believe in the fetishist's secret knowledge of enjoyment, his or her will to truth—and excessively reward and punish him or her for it. Not to believe in the law and at the same time to enjoy transgressing it—this can only happen at the expense of the law. And the character of the perverse act of transgression as an attempt at defining oneself (*faire la loi*) goes to show, once more, that the pervert is perfectly rooted in reality and is brilliant in dealing with it. The unreserved acceleration particular to the fetishist is the direct opposite of the depressive "style of action" and its "psychomotor slowing."[207] An unrestrained activism distinguishes the fetishist from the exhausted constitution of the depressives, and his fetishes are pleasure-charged alternatives to the sad symptoms of the neurotics.

> "Isn't fetishism an opportunity for intensities? Doesn't it attest to an admirable force of invention, adding events which could not be more improbable to the libidinal band?" (Jean-François Lyotard)

206 Ibid.
207 Ehrenberg, *Weariness of the Self*, 163–64.

FETISHISM AS ANTIDEPRESSANT

In 1905 Freud defined fetishism less as an abnormality than as, at most, a "variation of the sexual instinct that borders on the pathological."[208] And in his 1927 essay "Fetishism," he expressed a mixture of respectful restraint and slight irritation—not about the fetishistic "object-choice" but about the attitude of the men he had analyzed: "There is no need to expect that these people came to analysis on account of their fetish. For though no doubt a fetish is recognized by its adherents as an abnormality, it is seldom felt by them as the symptom of an ailment accompanied by suffering. Usually they are quite satisfied with it, or even praise the way in which it eases their erotic life."[209] So, on the one side, fetishistic abnormal ease and a satisfactory love life; on the other, most of the time, normalized tristesse.

Instead of seeing it as a prohibiting authority, Lacan defines the superego via its perverse-ironic imperative, *Enjoy!* According to this encouragement, the subjectification projected by the pervert takes an entirely different form than the subjectification of those who desperately try to live up to the law or constantly attempt to evade it. When sadists wholeheartedly submit to the violence of the law, it is certainly not the Freudian law of the pleasure and reality principles, but the wholly different Lacanian (affirmative, fetishistic) imperative to enjoy: "Desire and law are the same thing in the sense that their object is common to both of them."[210] What now appears on the horizon is the possibility of dealing with the superego in a non-neurotic way.

> Take me and tell me what to write. Write what I should do. Allow oneself to be overwritten by the other.

208 Sigmund Freud, *Three Essays on the Theory of Sexuality*, trans. James Strachey, in *The Standard Edition of the Complete Psychological Works of Sigmund Freud*, vol. 7, ed. James Strachey et al. (London: Hogarth Press, 1953), 153.
209 Sigmund Freud, "Fetishism," trans. James Strachey, in *The Standard Edition of the Complete Psychological Works of Sigmund Freud*, vol. 21, ed. James Strachey et al. (London: Hogarth Press, 1961), 152.
210 Jacques Lacan, *Anxiety*, bk. 10, *The Seminar of Jacques Lacan*, ed. Jacques-Alain Miller (Cambridge: Polity Press, 2014), 106.

Inscribed in the pervert's strategy is the knowledge, emphasized by both Freud and Lacan, that the superego "operates according to an economy such that the more one sacrifices to it, the more it demands."[211] Following Mehdi Belhaj Kacem, we can articulate the libidinous "logic of the sadist" as the compulsive repetition of a movement that leads, quite prosaically, from "desire to jouissance."[212] Perverse fetishists do not neurotically obey the law, nor do they psychotically reject it. In their overwrite, I want to say, they are falling out with the law and thereby expose the indigence of its representatives. They submit *themselves* to the law or to violence, thereby making themselves the instrument of the Other's enjoyment.

How, then, does the pervert take care of the Other's enjoyment? Juranville provides a Lacanian response: "By acting in such a way that the transgression takes place through him and, therefore, that the signifier arises in reality, as object. But such an 'erection' of the law contravenes the essential signification of the law of castration, which is the effacement of the object-side of the signifier of the law, both as phallus and as Name-of-the-Father. The phenomenon proper to perversion comes to light as the constitution of what is called a fetish; and the presence of the fetish makes it possible to avoid castration."[213]

We will see how the transition from the dyadic imaginary (the reflex of the mirror stage and its tendency to annihilate one's counterpart) to the triadic symbolic (the introduction of an organizing and law-like third) differs for the neurotic and the pervert. In both cases it is a transition from a pre-oedipal to an oedipal stage. Unlike neurotic acknowledgment, however, sadistic falling out unmasks the paternal law. Perversion, in the form of good violence, is the Mephistophelian means by which something exhilaratingly beautiful can be obtained from every apparent evil. Thus the production of conflicts makes the meanness of the law visible by precisely not presenting it as a legitimate object of critique.

211 Jacques Lacan, *The Ethics of Psychoanalysis, 1959–1960*, bk. 7, *The Seminar of Jacques Lacan*, ed. Jacques-Alain Miller, trans. Dennis Porter (New York: W. W. Norton & Co., 1997), 302.
212 Mehdi Belhaj Kacem, *Protreptikos zur Lektüre von Sein und Sexuierung*, trans. Ronald Vouillé (Berlin: Merve, 2012), 35.
213 Juranville, *Lacan et la philosophie*, 262.

The sadistic phantasm of a violence that is good because it is necessary is completely unacceptable to the neurotic. Whereas neurotics tend to drag the law down to their level (and in so doing mystify and conceal it), sadists produce a paradoxical equalization, a democratizing gesture, by claiming to be on the same level as the representatives of the law. From the neurotic, law-abiding perspective, such conflictual self-aggrandizement is illegitimate and contradicts the normal forms of coded critical legitimization. Every struggle for true equality results in a conflict; true equality cannot be obtained without conflict.

After decades of an institutionalized doctrine of enlightenment, calls for a critique of authority that have deteriorated to mere clichés, and centuries of indoctrinating academics with the demand for original research, there is only one tactic left that makes sense: to reject the avuncular or maternal embrace of the elders, to push their terror of intimacy back to a distance at which perception is possible, in order to stop this cuddly power in its tracks. After all, the task is to fall out of favor with the authority thus becoming visible, to joke with the law such that it bares its disciplinary teeth. "It is always through some beneficial crossing of the limit that man experiences his desire," says Lacan[214] — this is what fetishists' affirmation of desire aims for. They are then reproached (explicitly or implicitly) for showing and following their desire. *That's disgusting!* But isn't this exactly what the superego demands — that desire be shown? In any event, it always wants more, or everything (anything rather than compromising — for wanting nothing at all or not wanting something for a price is also a scandal). What the morality of the university prohibits is the only demand of psychoanalytic ethics according to Lacan: "From an analytical point of view, the only thing of which one can be guilty is of having given ground relative to one's desire."[215]

Letting the superego speak means, first, reinforcing an Ehrenbergian ability to engage in conflict; second, it lets the law become visible by simply complying with the superego's law, by joyfully following one's desire. The academic program of normalization, of course, consists in repressing the fetishistic dimension of desire. The existing order fosters the

214 Lacan, *Ethics of Psychoanalysis*, 309.
215 Ibid., 319.

standardization of desire. Promotion is granted to those who don't let their eager striving get into contact with the law (of critically tamed desire).

We can also distinguish between two kinds of sublimation, the neurotic and the perverse. The pact of the neurotic is: *Your modest wishes are fulfilled, and there's no need to have a bad conscience—just don't show your desire, please.* But that is precisely what the fetishist does. To make a name for oneself, to stick up for one's jouissance in one's own name, this amounts to a violent act, a crime, a crime of passion. *Sublime desire.* "To bear a name," E. M. Cioran tells us, "is to claim an exact mode of collapse. Faithful to his appearances, the man of violence is not discouraged, he starts all over again, and persists, since he cannot exempt himself from suffering. His occasional efforts to destroy others are merely a roundabout route to his own destruction." The fetishist does not merely superelevate the ones he loves, his good sadism affects first of all himself: "Hence it is among the violent that we meet the enemies of themselves. And we are all violent—men of anger who, having lost the key of quietude, now have access only to the secrets of laceration."[216]

[216] E. M. Cioran, "Thinking against Oneself," in *The Temptation to Exist*, trans. Richard Howard (Chicago: University of Chicago Press, 1998), 34.

Abductio ab nihilo

Jokes and Their Relation to the Superego

> So that they [our readers] consider our flight into libidinal economy for what it is, a solution to a long pain and the breach out of a difficult impasse; and so that they understand these few lines of hatred as the expression of our laughter, behind our anger. — Jean-François Lyotard, *Libidinal Economy*, 1974

In our neurotic universe, perversion—sadism in particular—gets bad press. Violence is always understood as destructive and regressive, which is why it has only negative connotations. The idea of a "perverse sublimation," the possibility of a good violence that transforms *ego* and *alter*, seems entirely implausible. And there is the suspicion (not wholly without foundation) that the many affirmative references to the Marquis de Sade's philosophy in the last few decades have a chauvinistic and regressive dimension. (We will have occasion to look at the difference between the post-oedipal passage via symbolic law and a regression to the dyadic confrontation of the pre-oedipal imaginary.) Perhaps we have to go back to before the very long and serious nineteenth century if we want to think, by way of contrast to such a fixation on destructive (physical) violence, a positive or "good" violence. This Sade would be closer to Laclos's *Dangerous Liaisons* and the eighteenth-century court culture's emphasis on language, conversation, and wit. In what follows, I analyze the joke as a linguistic practice made for rendering norms transparent and brittle, which can provoke change or transformation. The witty attack on what has been taken for granted

comes with an abductive production of new rules. These rules do not immediately evolve into new laws but are, first of all, associated with the discovery of a new singularity.

Jokes raise the question of applying rules to singular cases. Paolo Virno has discussed this problem against the backdrop of the entire ethical-aesthetic tradition, from Aristotle's *Nicomachean Ethics*, via Kant's *Critique of the Power of Judgment* and Wittgenstein's *Philosophical Investigations*, to Carl Schmitt's reflections on a singular state of exception beyond all laws. What I am looking for here is the *poietic dimension* of jokes, their potential for fostering change. This marks the difference between the infamously humorless and unironic aesthetic critique—the Frankfurt School's "transcendental miserablism," as Nick Land phrased it [217]—that remains referentially tied to the present and the entirely different inferences of jokes. What is needed is a switch from reference to inference, to, more precisely, abductive inference. As Lorenzo Magnani writes, "Abductive manipulations operate on models that are external and the strategy that organizes the manipulations is unknown"— i.e., oriented toward the future.[218] Abduction, which has recently been the object of in-depth investigations, particularly due to its centrality for research on artificial intelligence, aims for a rational recuperation of the imagination.

According to Charles Sanders Peirce, who added abduction as an alternative form of inference alongside deduction and induction, "Deduction proves that something *must* be; Induction shows that something *actually is* operative; Abduction merely suggests that something *may be*."[219] Critique, on the contrary, operates primarily with the reflective power of judgment imposed by Kant's aesthetics. It opposes deduction— the determinative power of judgment starting from the universal— to the holy grail of the singular, exemplified by the singular (art)

217 Nick Land, "Critique of Transcendental Miserablism," *Hyperstition*, January 15, 2007, http://hyperstition.abstractdynamics.org/archives/008891.html. On the tradition of German theory, with Schlegel, Heine, Nietzsche, et al., on one side, and German idealism all the way to (the offshoots of) the Frankfurt School on the other, see Karl Heinz Bohrer, ed., *Sprachen der Ironie – Sprachen des Ernstes* (Frankfurt am Main: Suhrkamp, 2000).
218 Magnani, *Abductive Cognition*, 61.
219 Charles Sanders Peirce, *Collected Papers*, vols. 5–6, ed. Charles Hartshorne and Paul Weiss (Cambridge, MA: Belknap Press of Harvard University Press, 1965), 106.

object. The aesthetic power of judgment thus proceeds inductively even though—and this, too, is part of Kant's strict rules—it fails in classifying and sublating the singular for only then is the singular beautiful (and sad and very serious but, in any case, impossible).

> Ethical abduction produces new regularities between the individual and the general.

If we conceive of ethics as the attempt to work on oneself, to become someone else, provoking a break with oneself, we begin to see what is at stake in inferring something through abduction. It produces a connection between the singular and the universal without presupposing either as given. Jokes can be understood as a corollary or even as a trigger of such transformative manipulations of the singular.[220] When abductions take the form of (tactically employed) jokes, they concern not only the connection of the singular and the universal but also that of *ego* and *alter*. This allows them to bring out the conflict potential of a situation for which there is no universal law, a potential directed *against* the (behavioral) rules of academia or any other institution. Instead of simply subsuming the singular under a universal law, abduction produces a *positive* association with other singular cases and thereby also confounds the established universal.

The meaning produced by abductive jokes is thus not aesthetic and sensual but poietic and linguistic. In this context, we can signal a definition of Kant's, not from the *Critique of Judgment* but rather from *Anthropology from a Pragmatic Point of View*, in which he writes about the "faculty of using signs" (*facultas signatrix*): "The mental activity of bringing about this connection is signifying (*signatio*)."[221] This definition, firmly rooted in the eighteenth century, follows an entire tradition in which wit is understood

220 These reflections on abduction owe much to many long conversations (and train rides) with Reza Negarestani.
221 Immanuel Kant, *Anthropology from a Pragmatic Point of View*, trans. Robert B. Louden, in *Anthropology, History and Education*, ed. Günter Zöller and Robert B. Louden (Cambridge: Cambridge University Press, 2007), 298. "The *dull head* lacks wit; the *idiot* lacks understanding. The agility in grasping something and remembering it, likewise the facility in expressing it properly, very much depend on wit." Kant, "Essay on the Maladies of the Head," in ibid., 66.

to be the faculty that mediates between the particular and the general, or even the cause of the general. Wit as the faculty of signifying is thus a "faculty of *language*," as one literary scholar has pointed out.[222] This is important for our concern with describing the poietic dimension of jokes: jokes are the purest form of the manipulation of meaning that is embedded in every production of signifiers.

According to Paolo Virno, jokes are "*logicolinguistic resources* of innovative action"[223]—when, for example, they break through to a terrain prior to the establishment of the relevant (linguistic) rules and reveal their contingency.[224] Jokes proceed linguistically against the ideological apparatus: "The joke is a meaningful discourse about the crisis of signification, given that it boldly emphasizes, with impudence, the independence of the application from the norm, that is, the unbridgeable distance between semantic and semiotic."[225] Such a linguistic disorientation, however, leads neither to an archaic, pre-semiotic chaosmosis of the kind mobilized by Guattari for an "ethico-aesthetic paradigm,"[226] nor into a nonlinguistic zone of direct political intervention. It recalls, rather, the ontological dimension of language, and this is what makes it possible to give Virno's theory of the joke a poietic turn.

Jokes are poietic in more than one respect. To begin with, their abductions aim for the new. They have two genuinely poietic operators at their disposal. As Virno writes, "The logical form of jokes consists of a deductive fallacy, or rather of an unmerited inference, or of an incorrect use of a semantic ambiguity. For example: attributing to the grammatical subject all the properties pertaining to its predicate; interchanging

[222] Oliver Kohns, *Die Verrücktheit des Sinns: Wahnsinn und Zeichen bei Kant, E. T. A. Hoffmann und Thomas Carlyle* (Bielefeld: transcript, 2007), 66.

[223] Paolo Virno, *Multitude: Between Innovation and Negation*, trans. Isabella Bertoletti, James Cascaito, and Andrea Casson (Los Angeles: Semiotext(e), 2008), 145.

[224] The function of jokes in Virno's thought is particularly evident against the background of his colleague Maurizio Lazzarato's analysis of the semiocapitalistic status quo. "The ensemble of ideological products constitutes the human ideological environment. Ideological products are transformed into commodities ever losing their specificity; that is, *they are always addressed to someone, they are 'ideally signifying*,' and thus they pose the problem of 'meaning.'" Lazzarato, "Immaterial Labor," 145.

[225] Virno, *Multitude*, 106.

[226] Félix Guattari, *Chaosmosis: An Ethico-aesthetic Paradigm*, trans. Paul Bains and Julian Prefanis (Bloomington: Indiana University Press, 1995).

the part for the whole or the whole for the part."[227] Jokes change the traditional relation of poiesis and praxis through recursion, also breaking the ethical paradigm of aesthetic experience. It is in this disruptive sense that I read Virno's definition: "Jokes are the logico-linguistic diagram of the undertakings that, on the occasion of a historical or biographical crisis, interrupt the circular flux of experience."[228] Rearticulating this point from a poetic perspective—with regard to the question of what meaning contributes to truth—we can say: the practice of ethical jokes, as manipulations of situations, is based on a tactical evaluation of a given situation and the experiential patterns it imposes, even if the perps posing as victims don't consider such distortions to be funny at all.

Jokes and witty behavior allow for disclosing the contingency of values imposed in a given situation and for confounding the language games that correspond to these values. What is thereby achieved is the exact opposite of the effect of critique: instead of secretly legitimizing both the criticized and the critic, witty behavior lays bare the connections that link us to an other, to the alter ego as much as to the superego. Morally impure jokes relieve the id, ethically good jokes unshackle the superego.

In *Jokes and Their Relation to the Unconscious*, Freud famously attributed to jokes a capacity for expressing pent-up instinctual impulses and a short-term release of pressure. The ego can express fantasies prohibited by the superego only in the form of jokes, which thus allows the id brief expression. Freud does not assign jokes a capacity for encouraging the strict fetishistic commandment to enjoy. This commandment, for him, is an auxiliary of a constant repression of drives that has a short-lived "liberating" effect on an ego torn between id and superego, only to make the ego comply all the more willingly with the principles of a bad reality. In this sense, jokes function as safety valves only thanks to the law that they thereby confirm. But is that true of all jokes?

[227] Virno, *Multitude*, 74. Later, Virno writes on the shift even beyond language: "The transferring of property from one domain to the other veils a truly innovative hypothesis only when it concerns the most idiosyncratic properties, that is to say, the most specific and apparently the least sharable properties of the secondary domain. In Aristotelian terms: the innovative hypothesis emerges when we ascribe to the grammatical subject also the *accidental* properties of its predicate (fallacy 'of accident')." Ibid., 141.

[228] Ibid., 73.

Are jokes always in league with the law? Does this only seem to come at the expense of the law when in reality it comes at the expense of the ego? Or aren't there jokes that lead to a release of the superego rather than to short relief of the id?

Simon Critchley presents a reading of humor that is more optimistic than Freud's pessimistic treatment of jokes. His aim is to liberate the ego from the effects of the superego (which he, as usual, thinks in purely negative terms) or even to domesticate the superego. Normally, he asserts, "the super-ego is the cause of suffering in the subject. [...] What is evinced or glimpsed in humour is a non-hostile super-ego, a super-ego that has undergone what we might call 'maturation', a maturity that comes from learning to laugh at oneself, from finding oneself ridiculous. We might say that in humour the childlike super-ego that experiences parental prohibition and Oedipal guilt is replaced with a more grown up super-ego."[229]

Humor, in this reading, is the attempt to let the superego reach adulthood, to nudge it toward a contemplative laugh at itself. Besides it being unclear who should teach this to the superego (the weak ego? an id endowed with reason?), it seems to me that Critchley's suggestion is too conciliatory. Taming the superego via amusement is a hopeless endeavor and it makes no sense to obtain, as Critchley suggests, a mildly disposed superego that would counter a negative parental figure. What is of interest in Critchley's description, however, is the observation that all attempts at liberating the ego from the superego reveal the superego to be more childish and more archaic than the id. We could even say that while the id has found its reality in the pleasure principle of consumer capitalism (or, to put it in more bourgeois Freudian terms: while the true reality principle is the pleasure principle), the superego clings to its archaic and cruel desire. The superego thus conceived does not pronounce the Lacanian imperative *Enjoy!* but instead institutes moral laws and demands their impossible observance. The superego, to be sure, is conscience incarnate; the problem, however, is how to avoid an ethical discourse that reverts to the cruelty of doctrine, how to avoid the cruel flagellation of the ego. Given that Critchley sees

[229] Simon Critchley, *Infinitely Demanding: Ethics of Commitment, Politics of Resistance* (London: Verso Books, 2008), 83.

(humorous) self-identity as ever divided, he places his hopes in the "anti-depressant of humour," which "works by finding an alternative, positive function for the super-ego."[230]

Going back to and beyond Freud, Lacan conceives of the superego not as simply castrating or prohibiting but as encouraging us to enjoy. What would an analogous conception of jokes and their relation to the superego look like? I suggest a double inversion of perspective, as regards both the function of the superego (fetishistic imperative or prohibitive law) and the manner of dealing with it (witty intensification or polite evasion); in short, I plead for a witty release (enlightenment, clarification, discovery) of the superego instead of well-intentioned attempts at mitigating it. The fetishistic joke then indicates the triumph of a jouissance capable of standing its ground against the unfavorable conditions of reality. For it is by no means the case that the pleasure of jokes necessarily serves the purpose of aggression.

The irritation jokes provoke always affects the superego as well. Enlightening and freeing the superego from the menacing clutches of the law could get an Othering of the superego going; it might also show us a way out of the tragedy that still serves as the ultimate backdrop of ethics in Lacan (in the unyielding figure of Antigone). Instead of giving in to the fear of the superego inoculated in all of us, I advocate the exuberance of the superego.

> My superego demands the right to act out, and I have nothing to say against that.

Fetishistic jokes do not give the unconscious id short-lived expression; they rather address the equally unconscious law in order to reveal the true nature of the emperor's clothes. The emperor, naked, has difficulty concealing the violence that establishes his rule. But with a little witty shrewdness we can find new rules; with a little perseverance we can reinvent ourselves.

230 Ibid., 82.

I've already pointed out that non- or merely seeming participation in institutional activities has a further tactical reach (and thus comes with a much higher personal risk) than critique of the institutions concerned, which tend already to define themselves as critical. It is overfulfillment—rather than not playing along, it is not *quite* playing along or playing too much that potentially triggers conflict, because it leads the hegemonic strategies of dominance to the brink of collapse. Permanently thematizing the law (in allusions, usurpations, overfulfillment) is tied to delegitimizing the law; and it is fundamentally different from appeasement via critique. If, then, conflicts possess a certain psychological and ethical imperative, and if the strategy of dominant academic discourse is to nip every potential for conflict in the bud, the most urgent question becomes how to discern and activate such potential.

In Foucauldian terms, jokes are the counterparts of a strategy focused on concrete goals. They are a short-term tactic "to change the situation"[231]—to change what we are always already confronted with, the traps in which we are always already caught. A tactic, according to de Certeau, is "a calculus which cannot count on a 'proper' (a spatial or institutional localization), nor thus on a borderline distinguishing the other as a visible totality."[232] As a tactic, jokes thus do not simply poach in the field of the other, they refuse to be fixed or assigned something substantially their own.

In accordance with the accelerationist credo, jokes aim at turning our constraints against themselves (by manipulating their settings, for example) or, to employ Isaiah Berlin's famous distinction, moving from a concept of *freedom from* to one of *freedom to*. We can play with the law if we pretend to take it seriously and expose it to laughter as mere appearance. The tactics for doing so are the tactics of the joke, or of the "weapons of the weak" related to the joke: plotting, spreading rumors, pretending to play along (for a while).

231 Critchley quotes from Trevor Griffith's 1976 play *Comedians*: "A joke releases the tension, says the unsayable, any joke pretty well. But a true joke, a comedian's joke, has to do more than release tension, it has to *liberate* the will and the desire, it has to *change the situation*." Quoted in Simon Critchley, *On Humour* (London: Routledge, 2002), 10.
232 De Certeau, introduction to *Practice of Everyday Life*, xix.

Jokes help us linguistically to shed light on the traps in which we are caught. We have to understand our traps to make them productive for us and make ourselves productive in them. To this end, it can help, as suggested by design theorist Benedict Singleton, to turn oneself into bait, into a fetishistic object of desire: the origin of our intelligence, what Richard W. Byrne and Andrew Whiten have called our Machiavellian intelligence, lies in "social manipulation, deceit and cunning co-operation,"[233] and lines of flight are possible only from out of the concrete localization of our own discourse.

Jokes, as tactics of manipulation, do not aim for the kind of comic, humorous, carnivalesque inversion of the world described from Rabelais via Bakhtin to Critchley.[234] Rather, they are the intensification of a tactical linguistics appropriate in the age of real subsumption today, *after* the strategy of overcoming the law or liberation from the trap has lost its plausibility, when the appeal to critical freedom and creative autonomy itself belongs to the strategies of power. The joke's short-term intervention does not discount it as a tactical maneuver. Even when only tactically (and not strategically) employed, jokes can produce more than just short-lived irritations for everyone involved: they are capable of making these permanent, of keeping the potential for conflict at an elevated level. *Infinite jest.*

233 Richard W. Byrne and Andrew Whiten, "Machiavellian Intelligence," in *Machiavellian Intelligence II: Extensions and Evaluations*, ed. Andrew Whiten and Richard W. Byrne (Cambridge: Cambridge University Press, 1997), 1.
234 "The comic world is not simply 'die verkehrte Welt', the inverted or upside-down world of philosophy, but rather the world with its causal chains broken, its social practices turned inside out, and common sense rationality left in tatters" (Critchley, *On Humour*, 1).

Formation of the Self and Speculative Poetics

Needs, Demands, Desire

> [Soldier and explorer Hans] Staden managed to get away with his life because he did not seem courageous and therefore attracted no desire toward him. —Winfried Rust, review of documenta 12, 2007

To explore how we become subjects of desire for truth and, in particular, of desire for an absolute knowledge (instead of merely making modest claims to possessing objective knowledge), we have to understand the position of the subject in Lacan's analysis. According to Lacan, the satisfaction of a subject's needs, demands, and desire, at all stages of its biography, depends on an Other. (The preferred example is the desire for the mother's breast, which cannot be reduced to a need for milk or to a demand for food.) Three dimensions are in play as the subject establishes an imaginary, a symbolic, and finally a real relation with the Other.

Following Lacan's logic, the first task of the subject, which can only find itself in the Other, is to obtain wholeness. The experience of early childhood is that the satisfaction of its needs depends on the mother's love. The experience that this satisfaction may just as well be denied immediately leads the subject to develop an unconditional demand for this love—for only the Other's unconditional love can assure me that the Other will not deny me the satisfaction of my needs.

In the early, imaginary stage of the relation to the Other, the possibility of negation plays a decisive role. At this stage there is not yet any symbolic asymmetry. The insight that the unconditional demand for the love of the Other can never be honored because the Other is marked by a lack—

is a desiring subject herself—then confronts the subject with a choice: either relinquish the demand or posit the desire as absolute. The latter option, for Lacan, is always tied to a kind of knowledge: the self-consciousness of the subject as it recognizes its own irredeemable demand. It is a consciousness of negativity, which we can also conceive of as the transformation of an unconscious symptom into a sinthome that the subject is conscious of. As it also implies an awareness of contingency, I would like to call it "speculative consciousness." *Desire makes conscious.*

We are here once more at the point where the imaginary and the symbolic cross paths. The decisive question of a self-conscious desire is that of a post-oedipal passage via the law. I've already suggested fetishism as one such option. Yet two related questions immediately arise: Does delegitimizing the (symbolic) law not constitute a regression to a pre-oedipal imaginary? And does the (sadistic) violence the fetishist unleashes by addressing an unconditional, absolute demand to the Other not threaten the Other with annihilation? In both cases, we would be dealing not with self-conscious post-oedipal desire but with a regression from the triadic symbolic, which offers a way out of the confrontational dyadic logic of the imaginary (a way out available not just to the neurotic). In what respects does post-oedipal fetishism differ from pre-oedipal regression? The dyadic constellations we are familiar with from the imaginary are indeed capable of questioning the dominance of symbolic law. Yet the conflicts of the fetishist bet on a reintroduction of the imaginary (we'll see in which settings later) that is recursive and produces difference. The differentiating and distancing function of recursion prevents regression (the withdrawal of the beautiful soul) and repression (the oedipal clinging to an exasperating law).

Of relevance for an ethics of knowledge is that, in the unconditional demand for absolute knowledge, the Other is being addressed, indispensible as a "subject who is supposed to know"—a subject supposed to possess otherwise inaccessible knowledge. The fetish is certainly tied to a denial of a lack in the Other, but as I will show in the discussion of dyadic knowledge-ethical settings (two subjects writing; writing with the Other), an awareness of the lack of the Other remains inscribed in the awareness of one's own lack. This is the only basis on which the Other can be supposed to have absolute knowledge. *You must*

know precisely does not mean that the Other knows. This makes all the difference vis à vis the *You know it yourself* of the modern research university: saying *You must know* to someone's face supposes a reciprocity, which therefore also always addresses oneself.

Only those who have invented a method (in literary theory, art history, or philosophy), who are familiar with this intoxicating discovery of a new world in which one finds oneself as another—only they can be familiar with how this absolute knowledge disassembles one's system. Whenever someone else applies "one's own" method—that is, whenever someone doesn't simply tinker with some historical find or interpretation—this method becomes another and leads to different results. Such an experience of the partiality of one's own knowledge is entirely different from the relativism of the theory tinkerers and topic scouts among academics, not to mention those whom Foucault called "historians in short pants."[235]

> In the humanities there isn't anything nearly as wild as being taken apart by one's own method.

In terms of an ethics of *knowledge*, then, to hold on to the desire for absolute knowledge, to an absolute desire for truth, is to confront and gain insight into the partiality of all knowledge. Ethical experience differs from the compulsive phantasm that says that once one has found a truth one owes it eternal allegiance, as well as from the Romantic longing for an absolute posited as eternally unattainable.

The practice of a subject relating to always contingent real others or real objects has a speculative dimension—but not in the already invoked Hegelian sense of an ethical transformation. The thesis of the radical contingency of the absolute is speculative in Meillassoux's sense, according to which the necessity of facts cannot be proved without getting caught in a correlationist circle. The insight into the radical contingency of the absolute—the absolute necessarily including its negation—also

[235] Michel Foucault, *The Archaeology of Knowledge & The Discourse on Language*, trans. Alan Sheridan (New York: Pantheon, 1982), 144 (translation modified).

plays a decisive role in the transition from need to demand: the subject is never completely satisfied, and its unconditional demand cannot be redeemed. The real is contingent and its relation to an absolute needs to be produced (a poiesis) in the first place.

Unconditional, the demand goes beyond need and it is undermined by desire, which it partly satisfies. Pure desire is satisfied only in an endlessness that is often indistinguishable from frustration (jouissance ≠ pleasure). As absolute condition, desire is without measure. That is the only reason, according to Lacan, why the imperative not to give up on one's desire acquired "the force of a Last Judgment," a judgment whose question is: "Have you acted in conformity with the desire that is in you?"[236] The only guilt one can incur is to give up on one's desire, to forsake the symbolic structure for the deceptive happiness of the imaginary or some other kind of compromise. This is relevant not only when it comes to psychoanalytic self-knowledge but also for the production of knowledge in general.

What drives me here is the idea of a conscious desire. Such a desire would be post-oedipal insofar as it refers to the demand, whereas pre-oedipal unconscious desire is entirely dependent on the Other (and its desire). By positing the demand as absolute, as I'm claiming, desire becomes conscious. It is itself a form of knowledge and is therefore as relevant to an ethics of knowledge as it is to a poetics of existence. What is decisive here is that each of the three levels or stages of oedipal subject formation implies different kinds and degrees of knowledge.

First, metaphorically speaking, prelinguistic action relates to the satisfaction of the subject's needs and remains unknowing. A second kind of action aimed at fulfilling the unconditional demand of the Other speaks the language of love and creates an unconscious knowledge. Yet responsibility for all action proceeding from this knowledge is accepted only when further steps are taken and negativity (the frustration of satisfaction, the impossibility of living up to the unconditional demand) is translated into an absolute desire. In a third reading, which Anke Hennig taught me, Lacan's (in)famous formula according to which desire is always desire of the Other, therefore indicates a will to become other. Only in the form of such a production of knowledge—which

[236] Lacan, *Ethics of Psychoanalysis*, 314.

is always also an ethical transformation—does action lead to a formation of the self, pushing the subject into its truth, dragging it into another world in which its knowledge will have become true.

The mandate to act is tied to a becoming-conscious. As we have seen, abductions are not to be reconstructed, they are to be constructed: the subject must take responsibility for its poietic constructions. In this sense, one's own truth differs from secondary knowledge. Every modally introduced imperative is linked to an ethics on the part of the experimenter. And, as Anke says again and again, the grammatical category of tense precedes the category of mode. By that she means, I think: In every experiment, a new past emerges. It's not just the future that is contingent, the present and the past are too.

If the superego is to be put to use in an ethics of knowledge, it is imperative to understand the superego not only as an authority that judges and gives orders, not only as morally judging, but also as an instance of observation at the interface of ethos and logos. One of the reasons why this book assigns a central place to Lacanian psychoanalysis is that, for Lacan, the subject itself is based on a kind of knowledge; the subject is preceded by (its) knowledge. Even if, nominally, Freud's id—ego—superego does not play a role in Lacan, we may put the point as follows: the knowledge preceding the subject is the knowledge of the id and superego from which the ego emerges in the first place.

How are we to deal with this omnipotence of the superego in the domain of knowledge (production)? In general, the position of writing, like its relation to (tendentiously psychotic) absolute knowledge, depends on its relation to the law in a given instance. In both relations to the law, neurosis and perversion, authorship—an intensified production of signifiers, the attempt to make shifts of meaning permanent—is essentially characterized by tension.

Above, I sought to find ethical ways out of depressive academic morality, looking for them in perversion or a fetishistic writing that succeeds, rudimentarily or in thrusts, to liberate the superego. This, of course, is a perverse liberation *of* the superego, not a liberation *from* it, which is what neurotics constantly hope for. Permanent doubt, the avoidance of answers, and, in consequence, an inability to act, constitute the figure of a

very specific neurotic educational morality, which is to be replaced by a fetishistic insistence on an absolute. However, this breaking through to a poetics of existential truth (a demand of a superego liberated and let loose) can never take place without conflictual challenges and post-oedipal transgressions of the law.

Following Lacan, the existential positions of neurosis and perversion—with their different courses of action (critique or conflict) and attitudes of knowledge (methodical relativism in the service of the law or a sadistic desire for the absolute that relativizes the law)—are different reactions to an originary loss. But what ways around the necessary confrontation with the law are there for the subject? What possible exit from the domain of neurosis? How can unconscious solutions to the conflict with the (imaginary) Other be made conscious? Lacan describes two ways of going about this—in terms objectionable from the point of view of gender politics—between the signifier as initial position of "masculine" desire and the object as initial position of "feminine" desire. The first route is that of subjectifying the cause—i.e., the "masculine" attempt to become the cause of one's own desire. The second is the metamorphosis of desire into jouissance as a kind of "feminine" subjectification.[237] His theses on the "sexuation" of the subject, as Bruce Fink has shown, thus describe a gendering in which "those with masculine structure must subjectify or find a new relation to the object, while those with feminine structure must subjectify or find a new relation to the signifier. Both sexes subjectify that which is Other at the outset, yet their approach to this Other, the facet of the Other they deal with, differs."[238]

An ethics of knowledge oriented by a poetics of existence has to ask how the two options—on the one hand, the fetishistic objection to the supposed castration (qua insistence on the absolute) and, on the other, a transformative production (qua transformation of a polymorphic writing)—can be

[237] "I characterized Lacan's first conceptualization of a beyond of neurosis as the subjectifying of the cause, becoming one's own cause, as paradoxical as that may at first sound. By Seminar XX it seems that Lacan views that as *one* path beyond neurosis, the path of those characterized by masculine structure. *The other path—that of sublimation—is particular to those characterized by feminine structure.*" Fink, *The Lacanian Subject*, 115 (italics in original).

[238] Ibid., 118. See also Jacques Lacan, *On Feminine Sexuality: The Limits of Love and Knowledge*, ed. Jacques-Alain Miller, trans. Bruce Fink, bk. 20, *The Seminar of Jacques Lacan* (New York: W. W. Norton & Co., 1998).

NEEDS, DEMANDS, DESIRE

thought and transferred into a different kind of action. Or, how is a different (knowledge) practice and poiesis of truth possible and how is it to be conceptualized?

With the castration of the Other—the discovery of its lack, the discovery that the mother (as signifier of love) also has a desire—the Other splits into an object *a* and a signifier of desire. Those who choose the position of the object from now on seek (through writing, enjoying) to clear up the nature of the signifier, while those who, discovering a lack in the Other, choose the position of the signifier are now tasked with completing the object (fetishistically). The pervert, Juranville writes, *denies* castration, "the presence of a radical evil and finitude," rejects "the deletion of the object-side of the signifier," and "with the fetish, makes the law and institutes the world."[239]

In these gender relations, the "man" (the manager) chooses as his partner the object, and the "woman" chooses the signifier of lack (the meaning). While the Other as object is necessarily tied to a person, the signifier of lack does not have to crystallize in a particular person. Fink writes, "Each sex seems to be called upon to play a part related to the very foundation of language: men play the part of the signifier, while women play the part of '*l'être de la signifiance*,' as Lacan puts it."[240]

> Making the law and instituting the world with the fetish (Alain Juranville).

Gendering thus has to be understood as a linguistic phenomenon—as a dimension not accessible to aesthetic reflections, only to a poetic ethics. In the entry into language, the Other splits into an object *a* and a signifier (of lack), and what makes the latter significant is not some dictionary definition; the signifier marks a difference, a gap between meaning (signified) and referent (the thing), and this irreconcilability is what makes it significant. Yet the increase in significance (in the Lacanian sense)

239 Juranville, *Lacan et la philosophie*, 263.
240 Fink, *The Lacanian Subject*, 118.

that is typical of academic work in the humanities also means a heightening of the conflict between the thing (which becomes more and more of a referent) and the signifier (which is charged with more and more meaning). Significance is nothing but this difference, which can take various forms but is both indelible and never total (language is neither arbitrary nor can it be dissolved into pure meaning). When the relationship between thing and signifier is stabilized contractually, the signifier becomes meaningless (boring, mere use, simple reference to the thing), and the thing appears as a rightful possession. We are more than familiar with this from the everyday practices of academic or journalistic writing. The fetishistic aspect of text production is to be situated within this tension, a fact proved not least of all by its failure (writer's block, taking refuge in repetitive essays, lectures getting lost in historical details, etc.). The academic subject can nonetheless succeed in metanoetic transgression, a self-overwrite, particularly in books, where signifiers complete themselves within an object.

Let's look at writing under the aspects of thingness and meaning. From the perspective of thingness, the production of signifiers is liberating. In accelerating, this production detaches the signifier from the law, decoding it (in the sense in which the accelerationist *Anti-Oedipus* demands a decoding of fluxes that might go beyond capitalism) by valorizing or fetishizing its object-like aspect (books or magazines as obscure objects of desire). It culminates in an ethics of fetishism, whose danger, of course, lies in the fact that it is based on sadism and always has destructive facets. The question of overcoming this potential for destruction becomes acute in the collaboration with an Other, when the dialectic of sublimation and jouissance makes it impossible to tell what kind of violence one is dealing with and where it comes from: Will we end up repressing our own violence or do we succeed in releasing the violence of the Other? In my experience, when writing with someone over a longer period, for example, a change of setting, a change of the connection to the signifying principle, provides a way out—a way out of sadism, which, as systematic breakdown, is the destruction and annihilation of the Other.

A "good" violence, on the other hand, is justified by the necessity of violence to change oneself with the other (in passion, in overwhelming friendship, in drugs

and all experimentations on the self, in every overwriting). The power of overwriting is not repressive. Instead, we may follow what Foucault writes on the reversible exchange between two (equivalent) subjects and understand overwriting in terms of an ancient ideal: becoming a free human being via subjectification is the ethical precondition for being able to form others. In this sense, the "sadistic" annihilation of the other ego would be ethical as an undoing of the self, as a stage in the transition toward another self. Such an ethics features a migratory moment. The territory of the law must be violently evacuated; the overwritten subject must detach itself from the conditions to which it owes its genesis. It is not only an ethics of migrants or outsiders. Fetishism also tends toward an ethics of giving: the Other is being completed through self-consciousness, things, money, admiration, and everything that elevates him and makes him perfect.

From the perspective of meaning, the ethics of the production of signifiers is an ethics of renewal, metanoetic and polymorphous. We are all familiar with the failure of many contemporary debates in ethics that come to a dead end when the subject is confronted with the ethical demand of the figure of the Other, a demand it cannot fulfill. If ethics is based on an internalization of the infinite demand of the Other, which we incorporate into ourselves and thus create as superego, the subject tries to live up to it by striving for autarky and authenticity. There is only one way out of this potential self-destruction: to let the superego become significant, we have to get it, our Other, to write.

Following Lacan, I spoke of the "masculine" choice of the object and the "feminine" choice of the signifier (fully aware that these are not biological characterizations). How is the corresponding "feminine" conception of absolute knowledge to be integrated into writing, and what role does sublimation play in this process? On a Lacanian reading, such "feminine" writing is integrated into a fetishistic logic simply by enjoying the signifier; it nonetheless idealizes the Other, which triggers in the "masculine" interlocutor problems with his superego (as well as a massive defense mechanism). Hence the question of whether there are, to oppose this, possibilities of integrating the two (gender) positions or projecting them onto each other.

What would a setting analogous to psychoanalysis look like, in which "truth" is not just an ephemeral ideal? Is it possible to construct productive machines in which one outgrows one's gendering or at least discovers a transformative writing? One such possible setting is two subjects writing, which Anke and I experimented with a lot. In this setting, knowledge is not just remembered/repeated/reworked, it is produced — and it is produced not as "merely" subjective knowledge (as in psychoanalytic self-knowledge) but as a knowledge that objectively claims to withstand the latently psychotic knowledge of the (great) Other.

The unclear position of sublimation allows for only one possibility: instead of positing it solely on the "feminine" side, as Fink does, it must be found outside of jouissance, in "masculine" fetishism as well. Sublimation, too, is gendered. What for masculine subjects is sublimation (to regard signifiers not by their object character but by their possible meaning) for feminine subjects is perverse enjoyment. Conversely, feminine sublimation (as translation of the signifier into an object) seems no less perverse an enjoyment to masculine subjects.

Let us recall that sublimation requires a passage through the oedipal stages (and that there are insufficiently oedipalized psychotics as well: paranoid, schizoid subjects). According to Lacan: "In the definition of sublimation as satisfaction without repression, whether implicitly or explicitly, there is a passage from not-knowing to knowing, a recognition of the fact that desire is nothing more than the metonymy of the discourse of demand. It is change as such. I emphasize the following: the properly metonymic relation between one signifier and another that we call desire is not a new object or a previous object, but the change of object in itself."[241]

Both picking up on Lacan's reflections and going beyond them, we can develop an ethics of transformative writing: the transformation of the object (of knowledge) implies at the same time a transformation of the subject. This recursive transformation, in which the whole world becomes another world, foreshadows the fulfillment of the desire to be an Other.

241 Lacan, *Ethics of Psychoanalysis*, 293.

Othering of the Ego

The Desire of the Other

> The task (of research) must be perceived in desire. If this perception does not occur, the work is morose, functional, alienated, impelled solely by the necessity of passing an examination, of obtaining a diploma, of insuring a career promotion. For desire to be insinuated into my work, that work must be *demanded* of me not by a collectivity seeking to guarantee my labor and to gain a return on the loans it grants me, but by a living collection of readers expressing the desire of the Other (and not the control of the Law).
> —Roland Barthes, *The Rustle of Language*, 1984

In what sense should the Lacanian determination *Desire is the desire of the Other* be understood as definitive? To begin with, the structure of the phrase is ambiguous. Taken as a predicative proposition, it seems to be tautological: it defines desire by desire (of the Other). Yet when we conceive of it as a speculative proposition, desire can be understood only from out of the *desire of the Other*, and thus aims either at the objects of the Other (and accordingly at taking the position of or eliminating the Other) or at being the object (of the desire of the Other). The recursive dimension that comes into view here is central for a third reading, the most productive for an ethics of knowledge: the subject is itself the knowing (self-conscious, post-oedipal) subject of desire, and ethopoietically desires being (an) other. This othering is speculative insofar as it obeys the logic of the subject's submersion in the desired object.

 The first reading refers to the (imaginary) desiring of what the Other desires, the second to a desire

for the Other. Here, the subject, in a *symbolic* identification with the Other, foregoes *being* the Other and thereby temporarily overcomes its (always present sadistic) aggressiveness. As I've said, I am fascinated mainly by the third reading, by which alienation is self-formation. The primary attraction of othering is the wish to change oneself, to become a stranger to oneself as much as a stranger to others, literally alienating them, as it were. *Real transfomation.*

I follow Lorenzo Chiesa here, who uses the term "alienation" to designate the development of an (inexistent) positivist self on the threshold of the mirror stage. The concept functions like a symmetrical negation, and the existential form of the ego can be expressed in the formula: "The ego is an Other."[242] At the same time, Chiesa employs the concept of castration, which may be described as an asymmetrical negation on the threshold of the symbolic: as a nihilation. Such a dialectical move, such a negation of negation, however, is not to be taken as a speculative-idealist sublation of negation; in a speculative-poietic conception, the negation of negation aims for a transformative change.

> The self-conscious and post-oedipal subject is aware of its desire and desires its being-other.

This third, ethopoietic dimension of a radicalized desire that has passed through the speculative negation of negation can be clarified with the help of Chiesa's analyses. In particular it is the new concept he comes across when he turns (after considering the imaginary and the symbolic Other) to the real Other. The encounter with the real Other comes with an *undoing* of the subject's fundamental fantasy, which arose from the imaginary identification with the imaginary Other and the (castrating) submission to the symbolic Other. What emerges here is a positive Othering as a radical new beginning. *Start all over again.* It revises the presumption that the real is some sort of given and therefore potentially destructible totality.

242 See Lorenzo Chiesa, *Subjectivity and Otherness: A Philosophical Reading of Lacan* (Cambridge, MA: MIT Press, 2007).

Othering understood as undoing relates to a real Other (or another Real). This speculative-poietic negation is characterized by a recursive (onto)logic. The danger of regressing to a point prior to the initial figure of alienation exists only as long as the negation of negation is understood merely in the sense of its reflexivity. The mechanism of recursion, on the contrary, brings the positive (to which alienation relates) and asymmetry (as the reflexive negation of negation) back to themselves. Recursive processes are distinct because something really new (as opposed to aesthetically innovative) emerges. The new is not simply some given positivity; nor is it the negation of the positively given. The recursively produced new is speculative insofar as it does not coincide with the reflexive negation of negation. When a real change takes place, reality is no longer identical to itself—thinking, subject, and world become others. The *recursive* negation of negation does not cancel itself out qua *nothing* but leads to a *new* difference.

We can now name the three central aspects of a transformative ethics of knowledge: *alienation*, as negative mirroring of a given reality; *negation*, as the construction of an asymmetry (of self and Other or of concept and being) that initiates an annihilation of the positively given; and a *recursion* of alienation and negation through speculation. Anke and I have written on this aspect of conversion in our book on metanoia, which recursively goes back to the reality from which it has distanced itself. Only from the point of view of an ontology of language can the new be understood as the distance that emerges between an initial reality and reality after metanoia.

The recursively produced new would then also be the site onto which the self-destructive or suicidal consequences of a self-negation are shifted. The dialectic that comes into view here and in which something emphatically new emerges no longer works via sublation (Hegel), nor is it a disjunctive synthesis (Deleuze) or a difference in repetition: it produces recursive distance, which could be the figure to think the release of the superego. We can now articulate this release as an increase in the superego's negativity by way of a recursive negation of its negativity. Only a recursive-dialectic movement can redeem the superego from its infinite (and bad) negativity.

Such a speculative ethics of conversion takes place via a renewal of the Other in passion, friend-

ships, collaborations, and all conflicts (whatever their trigger) that expose themselves to a fundamental asymmetry and let themselves be pushed further by it; as Nietzsche wrote, "Beyond 'me' and 'you'!"[243] The integration of the other into a recursive process is not to be confused with an infantile regression in the dyadic form of an imaginary reconstruction of the great Other. The recursion is based on an ineffaceable difference in going back, over an irreducible distance to the Other—it must never be the Other to whom I go back. *What else could we hope for?*

The transformation still needs a moment of negativity. The Other must be maintained as other, and the subject must learn to live with this moment of incommensurability—which is made all the more difficult by the fact that the Other remains the index of the self's insufficiency. The last cynical grimace of the superego, as it makes fun of all the subject's misperformances, is exemplarily captured in the characters of the Marquis de Sade, who are completely caught up in senselessly serving the totalitarian ideal of the Other, an ideal that they can't live up to. The only way for the ego to try and become identical with itself would be to pay the price (too high a price) of paranoically destroying the Other (within itself).

Anke has shown me how the subject of a post-totalitarian ethics must learn to live with its own insufficiency and with that of the Other. In the Other's difference, in the distance from the Other, we find the index of something new—this is what is good about difference. The new thus understood primarily does not produce singularities but creates a distance. It is not a productivist, avant-gardist, or otherwise aesthetically constituted innovation, but a poietic change that emerges from the production (not the reproduction) of a distancing difference.

> Ethics of difference, poetics of distance.

243 "Über 'mich' und 'dich' hinaus!" Friedrich Nietzsche, fragment 11[7], in *Nachgelassene Fragmente, 1880–1882*, vol. 9, *Sämtliche Werke*, ed. Giorigo Colli and Mazzino Montinari (Munich: Deutscher Taschenbuch Verlag, 1999), 443.

Let me return once again to the formula from the last chapter—holding on to desire. What form of poiesis does it present us with? In what respects does this insistence (on desire) not only *not* oppose but necessarily imply a transformation (of the subject)? Once again, this recursive-dialectic operation can be grasped thanks to the way in which it exceeds aesthetic determinations. Here, an ethics of desire has to go beyond Lacan, where it remains aesthetic insofar as it encourages the subject to bring out or to name the master signifier within it. The nature of the Lacanian signifier is fundamentally aesthetic. Like the phallus, it is an appearance; something that is not, that does not "exist" (in the way all language is fundamentally fictitious).

The abolition of a fundamental fantasy of the subject allows the subject to create a new language and thereby a new narration of itself. It now differentiates the symbolic, into which it had entered with the Oedipus complex and otherwise only "experienced" (as castration), by way of an integration of imaginary parts into a new symbolic whole, a recursive process not to be confused, as noted above, with regression and repression. That is why a poetics of existence lets itself be guided by a poietic transformation that widens the scope of navigation and liberation by means of symbolic and linguistic manipulation, a changed production of signifiers. But the concepts "symbolic" and "language" might be misleading here. "Speech," or rather "speaking," would be more appropriate, for it implies authorship; thus, more fittingly, "text," or, even better, "poetic text" or "poetic narration." Understanding language no longer aesthetically (as inexistent appearance) but poietically is to conceive of it as instituting reality. In language and, to a greater extent, in writing, a poiesis of knowledge unfolds.

> Poietic language and writing institute reality.

From a purely aesthetic perspective, language is fundamentally tragic: all it can do is express the alienation of the human being from speechless nature and testify, indirectly, to its apparent existence. Yet such an aesthetic understanding of language overlooks the fact that language is

an achievement; it didn't just come from nowhere to suddenly or slowly overwhelm human beings. Language is the human being's second, inhuman nature, constantly developed (and to be developed) poietically, as we speak. That is why the perspective of poetic ethics is so different: because a poietic impetus drives the development of language we can combine an ontology of language with a poetics of the subject called on by psychoanalysis to recreate itself. To keep this project of the self from falling back into an aesthetic matrix (appearance, mirror, self-image), first knowledge and then practice (making) are necessary. Objects of knowledge have to be generated, which can only take place in conjunction with a formation of the self, which in turn changes the world as it changes the subject.

Setting

Against Local Amnesia

> From this point of view, the "objects" of our research cannot be detached from the intellectual and social "commerce" that organizes their definition and their displacements. In "forgetting" the collective inquiry in which he is inscribed, in isolating the object of his discourse from its historical genesis, an "author" in effect denies his real situation. He creates the fiction of a place of his own (*une place propre*). [...] Every particular study is a many-faceted mirror (others reappear everywhere in this space) [...] but it is a broken and anamorphic mirror (others are fragmented and altered by it). —Michel de Certeau, *The Practice of Everyday Life*, 1984

So far, I have discussed psychoanalysis only as a discourse, but have not yet reflected on its concrete setting, which for Lacan makes it the only discourse capable of sublimation. I would now like to collect arguments to support the thesis that a sublimation that leads to truth is possible in other discourses as well. To make this point, I will have to find analogies to the discursive *situation* of psychoanalysis, its setting, by which I mean the software, as it were, of a discourse that materializes in certain external characteristics (in psychoanalysis: the couch, the frequency of sessions, their length, etc.). Adjusting and manipulating the hardware of psychoanalysis is always also a thinking through doing, rather than abstractly considering the materiality of thinking or penning edifying reflections about writing and *écriture*.

The way Alain Juranville presents it, Lacan's psychoanalysis is a philosophy to the extent that it describes a genuinely epistemological situation. Its salient feature,

for an ethics of knowledge, is not the concept of the unconscious but the constellation of subject, object, and Other that endows both meaning and knowledge. Hans-Dieter Gondek reminds us that Lacan speaks of the "psychoanalysand" who "'experiences' his unconscious knowledge in the form of symptoms which he suffers from and enjoys."[244] Of particular significance here is the entirely asymmetric distribution, or rather fragmentation of knowledge; knowledge is being partialized. Analysis gathers together the scattered parts of knowledge, framing and (recursively) relating them to each other in a certain setting. Thus changed, the constellation—and not the (critical) self-reflection of those concerned, which may or may not accompany the process—makes a different structure of knowledge possible, a structure in which the subject appropriates (its) truth.

In the psychoanalytic setting, the subject learns about its unconscious knowledge only indirectly, from its symptoms, which it has to turn into its (ethical) truth. But there is also a writing that creates knowledge, a writing capable of shifting the positions of the production of knowledge—even if it does so in a way entirely different from psychoanalytic speaking. I tried earlier—already going beyond Lacan, overwriting him—to explore a fetishistic logic and track down a perverse desire for absolute knowledge. In a third step, I am interested in a nonanalytical setting for the production of knowledge, a post-oedipal machine that goes beyond the knowledge-creating subject and at the same time overwrites the rules and methods that previously governed the production of knowledge.

Such settings, such knowledge machines, show up time and again on the fringes of academic writing. A setting of this kind is perhaps best described as a mobile non-site, a trap we may have set ourselves—set, in de Certeau's terms, by "a calculated action determined by the absence of a proper locus. No delimitation of an exteriority, then, provides it with the condition necessary for autonomy. The space of a tactic is the space of the other. Thus it must play on and with a terrain imposed on it and organized by the law of a foreign power."[245] The manipulation of the

244 Hans-Dieter Gondek, *Angst, Einbildungskraft, Sprache: Ein verbindender Aufriss zwischen Freud–Kant–Lacan* (Munich: K. Boer, 1990), 9.
245 De Certeau, *Practice of Everyday Life*, 37.

academic rule book (whether it concerns methodology or habitus) is inseparable from the manipulation of the object investigated—or, more precisely, prepared. The ethical (knowledge-based) quality of a setting can also be gauged by how much productive deviance, exteriority, and transformation it catalyzes.

One example is two subjects writing, a setting in which a knowledge that one does not possess oneself is imputed to an other—i.e., not to a text given to the other nor to an absent master. A famous older example is the so-called Socratic method, both as a conversation technique and as the analytics of Platonic discourse.[246] At the same time, the Socratic method implies the quite un-Platonic idea of thinking where we do not know anything, of communication among different sorts of knowledge whose common ground is no longer based on positively given properties—that is, a *communitas* whose connections are established on the model of subtraction and not addition (*munus*, as Roberto Esposito discovered, lack and gap).[247]

We find in these two examples the unorthodox ideal of writing something that isn't otherwise known, and the quintessentially philosophical idea of a truth that precedes knowledge and needs only to be recalled (Plato's *anamnesis*). Love for truth, then, would not refer to what a subject possesses in terms of positively given capabilities but rather to what exceeds and transgresses these capacities and knowledge. That which we don't want (in this form at least) can be true as well, but for it to be true (and this marks the difference from the esoteric concept of wisdom), it must have been produced by argumentation, proof, and debate.

Accordingly, psychoanalytic discourse differentiates between truth and knowledge (being and having, recursion and reflection, speculation and critique): the analysand does not have the truth. The truth is hidden in the details of the symptom; it isn't available to the "whole" subject (and it can't yet be self-consciously enjoyed as a sinthome). Truth only emerges in a recursive appropriation of this symptom, as a part, into the subject as a whole. Analogous to the speculative proposition, the subject of knowledge does not possess truth as a

[246] See Armen Avanessian, *Irony and the Logic of Modernity*, trans. Nils F. Schott (Berlin: De Gruyter, 2015).

[247] Roberto Esposito, *Communitas: The Origin and Destiny of Community*, trans. Timothy Campbell (Stanford, CA: Stanford University Press, 2010).

predicate, it only attains truth in the dialectic movement in which the predicate becomes a subject; that is, in a metamorphosis. The subject does not equal the predicate (in the logic of equivalence on which a theory of correct knowledge is based); the logic of true knowledge is that the predicate becomes the subject. Ethical truth is always tied to the becoming or emergence of a subject. Knowledge cannot know itself—truth intervenes as a knowledge that does not know itself, that I do not know. This is what connects ethically significant knowledge (i.e., truth) with speculation and recursion.

> The truth is hidden in the details of the symptom; it isn't yet available to the "whole" subject.

A setting prescribes the kind of knowledge that emerges, the way it can be produced, and the position from which the speaking or writing subject sets out to find its truth. The conceivable forms of knowledge and truth under the conditions of today's research university—and the inconceivable ones—are determined by the social economy that regulates how researchers relate (or think they relate) to their academic work and objects of investigation.

The problem in this context is the egotistical structure of most academic writing (applications, exams, MA theses, dissertations, etc.), which aims at establishing one's authority (qua qualification, expertise, etc.). But I want to explore the possibility of a different setting. In addition to the psychoanalytic definitions developed, I want to bring in some fundamental insights from scholarship on writing, starting from one philologist's observation that writing almost always takes place "with respect to a real or virtual reader [...] whose expectations are anticipated and integrated into the writing process."[248]

In the case of most academic writing, of course, this virtual reader is a very real authority or, rather, an instance of power to be respected; it is terrifying because it decides

248 Almuth Grésillon, "Über die allmähliche Verfertigung von Texten beim Schreiben," in *Schreiben als Kulturtechnik: Grundlagentexte*, ed. Sandro Zanetti (Berlin: Suhrkamp, 2012), 161.

careers. Yet this anticipated reading is not the only one to be integrated into the writing process: so is the reading the writer has done in anticipation of writing. "For all preparatory phases of writing (collecting materials, checking existing knowledge, clarifying concepts, etc.), the much-invoked long-term memory usually does not suffice: external sources of information are consulted, or notes are taken from them, such that these sources are so closely combined with the process of writing that one has every right to say, 'writing is rewriting.'"[249]

These two points allow us to see the fundamental dilemma of (exclusively) career-oriented academic writing. The first addressee of the qualifying papers, who is so important for the question of why we write, tends to be the institution (represented by whomever is most influential, depending on the discipline and job market). On the hierarchical level, as it were, this concerns the ambivalently pursued presence of the supervisor authority (advisers, thesis supervisors, etc.). Add to this the subtle control exercised on the horizontal career level. For often it is not so much despite but because of all the friends and colleagues who read and comment and help (not to mention the disastrous proximity of supervisor-friends) that the egos boosted by them are denied the right to a truth that would overwrite them—if ever they dared question the prohibition to overwrite.

This distance from an ethically unconditional and absolute knowledge does not, of course, go unnoticed, but rather is constantly criticized. It is astounding how many graduate students are dissatisfied with their dissertations, from the drafting of a proposal via the long years of execution to completion and beyond. It remains surprising every time to see the blind compulsion with which those who have just escaped the dissertation's vale of tears rush to write applications to finance the next stage—of course *ego* (unlike *alter*) does everything asked of it because it lacks alternatives (external circumstances are always at fault). Indeed, even while they are still writing the dissertation, their mind is on the book proposal or projects for postdocs that are grudgingly drafted as quickly as possible.

The delimitation from *alter* claimed in this egotistical setup of writing is obviously illusory, if only because the others are not just present as first readers or committee mem-

[249] Ibid., 162.

bers but also as opponents to be refuted or overcome. The problem with this attitude is that one goes looking for the opponent in the wrong place. Seeing the chosen topic as the opponent is the best guarantee for producing secondary literature of little to no interest. Only studies that put all their effort into something more significant than the opinions of other secondary literati attain the necessary level of (theoretical, methodological, paradigmatic) conflict and the ethical transformation it entails. One ethical maxim could be to look for a concrete opponent outside one's field of research and to engage with him or her—for example, with the question of the role my research dispositif plays in contemporary culture, or with the question of the political calculation and social interest behind spending millions on investigating certain topics, millions from which I, too, might have profited at one point. The whole (political) point is to produce conflicts by manipulating and transforming the field one is working in, in contrast to the majority of critically appreciated approaches that only ever sound out a topic for its political potential, affirming and legitimizing it.

 I'm writing about the ego for two reasons: to unsettle the apparent self-evidence that there is only individual writing, and to question, in the first place, whether the writing instance must always be an I. Do we know of any other instances of writing beside the explicitly antiacademic writing attempts of the id in the avant-gardes? And with a view to the death metaphors concerning writing that were omnipresent in modernity: What productive and unproductive roles does the superego take on in academic writing? Is it possible to complement the ego's neurotic production of texts with alternative forms, an alter-academic writing? Can we conceptualize a writing of the id or of the superego?

 In ego-centered writing, the neurotic or depressive, as we have seen, legitimizes his or her compromising attitude with external circumstances. The alleged obstacles and resistances are willingly sought out in order to then be able to complain (as loudly as possible) about relationship trouble, noisy neighbors, mean colleagues, coldhearted superiors, lack of vacation, evil parents, back pain—you name it.

 What are the alternatives to an id to whom the academic ego loves to come running as it flees the superego—an id that does not want to know? (For the id, such as

it was conceptualized by Freud and put to all the more productive use as a writing instance by the Surrealists, does not want to know anything: it is hostile to knowledge.) Every form of regression is not just hopeless but (within the academic production of knowledge) useless.

But what happens when the dissociations of hand, writing tool, and writing ego that we know from historical research on writing—"thanks to which writing takes a distance from itself" and that make "'writing' recognizable as a question of relational constructs of heterogenous and antithetical elements"[250]—have a subcutaneous effect even today? With a view to academic writing or writing in the humanities: What would a dissociated, alter-academic writing be like that writes with the superego instead of just the always-compromising ego, an ego that for Freud is nothing but a compromise between id and superego and therefore produces nothing but bad compromises when it writes, and constantly evades the desire for absolute knowledge?

The smashing success of this logic, its ideological function, is that it saves the writing ego from a confrontation with its own failure to attain the truth (instead of intensifying or settling the conflict with the desire for truth). The corresponding strategy for action keeps the ego from the ethical insight that it is by no means better than those elders whose achievements, attained through compromises, I had set out to topple or than the alter egos it is in fierce competition with.

[250] "We have to emphasize that Benjamin conceives of the relationship between fountain pen and writing hand, too, in terms of a dissociation of writer, hand of the writer, writing tool, and what is written." Davide Giuriato, "Maschinen-Schreiben," in Zanetti, *Schreiben als Kulturtechnik*, 316.

Two Subjects Writing

You Must Know

> From here it emerges that *communitas* is the totality of persons united not by a "property" but precisely by an obligation or a debt; not by an "addition" [*più*] but by a "subtraction" [*meno*]: by a lack, a limit that is configured as an onus, or even as a defective modality for him who is "affected," unlike for him who is instead "exempt" [*esente*] or "exempted." —Roberto Esposito, *Communitas*, 2010

How can the partition and distribution of instances of writing and knowledge production be alienated or even structurally shifted? One experiment that helps in attaining a different relationship with the alter ego is to integrate it into a shared writing process. The first effect of two subjects writing—and this is not a psychological law or the result of contract negotiations, but a necessary result of the (experimentally altered) setting of writing—is that an otherwise inaccessible knowledge is not imputed to the ego but to the alter: it is not I but the other who knows. Not *I know*, not the ideological *You know*, but *I know you must know.* That the other has knowledge otherwise inaccessible to me means: this knowledge is not, as it is usually, imputed to the text I am reading (or to the image I am analyzing). This knowledge must first be written or, to quote Roland Barthes, "it is perhaps time to dispose of a certain fiction: the one maintaining that research is reported but not written: here the researcher is essentially a prospector of raw materials, and it is on this level that his problems are raised."[251]

251 Roland Barthes, "Research: The Young," in *The Rustle of Language*, trans. Richard Howard (Berkeley: University of California Press, 1989), 70.

Simply by confronting us with the fact that others (mis)understand texts in a fundamentally different way, the setting of two subjects writing has the potential to catalyze a different way of dealing with texts in general: not just reading different texts but reading them—in Karen Barad's ethico-epistem-ontological terms—differently and diffractively, with an "ethical engagement."[252] Instead of reading an unfamiliar text and immediately attempting to assimilate it according to one's own methodology, intensive coauthorship always tends toward and implies a bending or distorting—in any case, a violent moment.

> I know you must know.

Here, too, there is no clear separation between the methodological, ethical, and political dimensions. "The economy itself, transformed into a 'semiocracy,' encourages a hypertrophic development of reading," writes de Certeau. The alternative he proposes to the "binary set production-consumption" or "writing-reading" is a poetic art, "a way of thinking invested in a way of acting, an art of combination which cannot be dissociated from an art of using."[253]

What I said earlier about the construction of cognitive traps and the manipulation of given contexts takes place within this setting as well. Lorenzo Magnani's concept of "manipulative abduction" is relevant here. He writes how "*practical* and '*external*' *manipulations* [are] prerequisite to the subsequent work of theoretical arrangement and knowledge creation," and later continues: "Manipulative abduction occurs when many external things, usually inert from the semiotic point of view, can be transformed into [...] 'epistemic mediators' that give rise to new signs, new chances for interpretants, and new interpretations. [...] It happens when we are thinking *through* doing and not only, in a pragmatic sense, about doing."[254]

252 "Diffractive readings bring inventive provocations; they are good to think with." Karen Barad, in "Interview with Karen Barad," in *New Materialism: Interviews & Cartographies*, ed. Rick Dolphijn and Iris van der Tuin (Ann Arbor, MI: Open Humanities Press, 2012), 50.
253 De Certeau, introduction to *Practice of Everyday Life*, xxi, xv.
254 Magnani, *Abductive Cognition*, 42, 174 (italics in original).

Once the first step toward changing the (putatively external) setting has been taken, thinking and writing (putatively internal) change as well. Such a transformation allows, for example, for a (sometimes violent) exploitation of what has been read—a productive or poietic way of working *with* theory, instead of constantly working *on* Freud, Lacan, or Hegel. Shared writing reduces the distance from texts and quotations because it is less afraid of productive misunderstandings; indeed, because it always already speculates whether texts have "real" content. How else can we learn to avoid downgrading texts to simple evidence, repeatedly searching for extra material, or reducing the process of reading to a search for passages that prove a point? How can texts be productively overwritten? And in what form can the texts we have read be speculatively present in our writing? This could be the case whenever the ones writing no longer think of themselves as recipients seeking to do justice to texts but enter into the universe of each text. Even if this process does not always lead to finished texts: what is being read becomes true only if the subject transforms itself as a writing subject in the sense that the texts overwrite the subject.

Speculative writing is not "writing about" or commenting on texts, the way speculative reading is tied to an unknowing or incomprehension. This property of all transformative writing is facilitated by two subjects writing, because this setting structurally stabilizes such unknowing.

In discussing his own way of working, Niklas Luhmann describes another form of dialogic writing—"communication with card indexes." He notes: "If you do not write, you cannot think, at least not in any ambitious, relatable way. [...] But if you have to write anyway, it is useful to make use of this activity to create a competent communication partner in the systems of notes. One of the elementary preconditions of communication is that the partners can surprise each other. This is the only way of generating information in the other."[255]

[255] Niklas Luhmann, "Kommunikation mit Zettelkästen: Ein Erfahrungsbericht," in *Universität als Milieu: Kleine Schriften*, ed. André Kieserling (Bielefeld: Haux, 1992), 53.

It is thus necessary to write to get to one's truth as a different truth, a truth in the other. Reading alone does not suffice, because then the knowledge accumulated all too easily stays on familiar tracks: readers are most likely to understand what they already know. They only understand something different(ly) in moving from reading to writing, when they assume the position of authorship and become producers of signifiers themselves (which does not mean publishing texts). Being overwritten: a certain measure of undoing the self, which is the precondition for acquiring new forms of knowledge and new references to reality, can only be obtained by changing from the position of reading to that of writing. What has been read must be overwritten.

Recall Hegel's description of how we read a speculative proposition. The reading starts with the subject of the proposition and moves to the predicate, but the predicate turns out to be the substance of the subject. The subject cannot go beyond such a predicate. Consequently, the subject perishes and the proposition dialectically turns against itself (*predicate becomes subject* instead of *subject equals predicate*). This speculative movement implies two things: the demise and becoming of a subject and the recursive emergence of truth. Knowledge cannot know itself; truth as othering of the subject intervenes here as a knowledge that initially does not know itself, that the subject does not know. This connects knowledge; more precisely, it connects truth with speculation and recursion.

Luhmann sketches a delegitimization of the (critically) knowing reader in favor of the speculative production of truth on the part of the one who (unknowingly) writes, of a production (of truth) through writing. *True writing*. Most of what is read quickly becomes "useless or remains, when the occasion arises, unusable. [...] Academic publications thus do not emerge, at least in my experience, by copying what has been deposited in the card index for that purpose. Communication with the card index becomes fertile on more generalized levels; namely, on the level of the communicative relationalizing of relations. And it becomes productive only in the moment of utilization; that is, in a manner conditioned by circumstances and very much by chance."[256]

[256] Ibid., 60.

Here, too, the writer encounters a speculative conception of the production of knowledge in a poietic engagement with his other—the material. Do insights not emerge only on the symbolic level of signs? That is why it is so difficult to think without writing (or taking notes, scribbling, transcribing). A corresponding, radically anti-hermeneutical way of reading and writing does not read a text for its proper meaning and does not belabor this meaning after the fact; it dissimulates texts, dissolves them, finding their fragments everywhere in a way of living that emerged from this meaning, which usually guides how they are understood.

At the end of the long search for this proper meaning of a text, there is often a single key point, a hook on which to fix an entire network of meaning. *Suddenly it all made sense.* This hook is firmly anchored in the invisible fourth wall of our way of living, and only an uprooting of thought, a metanoia, can fundamentally reposition our thinking. Our hooks are immovable, and we are able not only to hang a noose from them, but also to tie our entire existence to them.

> Each of my insufficiencies has immense potential. Each of my failures provides us with the occasion to surpass ourselves. Write on.

What matters is not so much what, for example, the ultra-Catholic Lacan really wanted to say; whether Stengers, powering her academic politics, lives up to the ethical personality of her texts; or which event exactly it is that Badiou wants to remain faithful to. What matters is how all these texts, present only in splinters, quotations, fragments, form new (i.e., different) words in us. That is what is at stake when we look for the meaning of their texts and when we engage with authors by overwriting them.

In the setting of writing in a pair, the ego switches between being right and wrong. It is decisive for the I to experience that it is only the other who always knows. However, as soon as the two writers make egotistical demands of each other—as soon as they themselves

want to know better or are no longer able to control potential threats (not to be underestimated, especially when writing together) the individual subjects regress from the setting or from the production machinery. If the latter's potential is to fully develop, the setting must be both smarter and stronger than the subjects. The ethical power of transformation develops best when resistance and obstructions are converted into advantages. One example is the concise and accelerated transmutation of reading into writing, in which intoxicating speed renders every search for unambiguousness (and unambiguous proof) superfluous—while often making the results more precise and more evident. Supposedly unambiguous readings yield an entirely different meaning, and the talents of each of the writers lead to different results and different places. The way two subjects truly and emphatically write together—that is, write together not merely as a short-term division of labor to spell out theses discussed in advance—is that one person has excerpts and the other has to make sense of them; at one point, one of them is right and only the other knows why—at another point it's the other way around.

Ideally, everything I know conflicts with my interlocutor's theses. When the entire canon of knowledge I am familiar with contradicts your thesis and I prove to you nonetheless that you are right, my I is most likely to transform into another, my position is overwritten in that fundamental way we may call *speculative othering*. From the beginning, the ego must be confronted with such proceedings. When we properly walk into a trap, existential problems are soon brought up, and the ego feels continually threatened. The ego necessarily feels overcharged in this setting. And that is right: neither analysis (certainly not Lacan's) nor the poietic writing machinery are therapeutic practices to strengthen the I, or at least they shouldn't be. The conflicts of shared writing, the conflicts with which writing works against the strategies of the institution, are objective and necessary.

Earlier I raised the question of whether there can be a relevant writing entity other than the ego. I did not do so to suggest that this entity—the superego, for example—ought to write by itself. Beyond the question of whether it is at all possible, it would have unambiguously destructive consequences. Writing with the other or in a pair rather aims at writing with the superego, and an appropriate setting would facilitate the

rapid circulation of writing positions and a dissociating plasticity of who is writing. Why not, then, write together with your superego?

Each of the three psychic entities harbors a different danger for philosophical thinking. Were the id to write alone, an endlessly meandering stream of consciousness would emerge, which is rarely of any use to philosophy—no matter whether it produces relevant intuitions or mad ideas. When the ego writes by itself, it all too often produces self-validating academic prose. And the stronger the superego becomes, the less there will be on the page—were it to have complete control, all there would be is a single deletion (because, let's be honest, nothing is ever good enough), but no overwriting.

Epilogue

Poetic Existence

> I have not made my book any more than it has made me—a book of one substance with its author, proper to me and a limb of my life.
> —Michel de Montaigne, *Essays*, 1595

In a 1983 essay entitled "Self Writing," Foucault states, "As an element of self-training, writing has, to use an expression one finds in Plutarch, an *ethopoietic* function."[257] This intrinsic poietic connection of ethos and truth, the production of a new ethos induced by writing, holds not only for antiquity. In the Renaissance, Montaigne gave the most famous description of this phantasm of creating oneself via one's own writing.[258] And in modernity, too, this (fetishistic) phantasm was alive and well, evinced, for example, by the "care of the self" in Kafka's diaries.[259]

Yet, nonetheless, it seems that the connection of ethics and writing has been systematically investigated only for the centuries around the beginning of Christianity; namely, in Foucault's 1983–84 lectures published as *The Courage of the Truth*. In these lectures—his last—Foucault concentrates

[257] Michel Foucault, "Self Writing," in *Essential Works of Foucault, 1954–1984*, vol. 1, *Ethics, Subjectivity, and Truth*, ed. Paul Rabinow (New York: New Press, 1997), 209. "*Ethopoiein* means making *ēthos*, producing *ēthos*, changing, transforming *ēthos*, the individual's way of being, his mode of existence." Michel Foucault, *The Hermeneutics of the Subject: Lectures at the Collège de France, 1981–82*, ed. Frédéric Gros, trans. Graham Burchell (New York: Palgrave Macmillan, 2005), 237. See also Wilhelm Schmid, *Auf der Suche nach einer neuen Lebenskunst: Die Frage nach dem Grund und die Neubegründung der Ethik bei Foucault* (Frankfurt am Main: Suhrkamp, 1992), 282.

[258] See also Jean Starobinski's beautiful study, *Montaigne in Motion*, trans. Arthur Goldhammer (Chicago: University of Chicago Press, 2009).

[259] "It seems to me that the most important aspect of the conception of a care of the self as a program of writing, which Kafka develops in the diaries and which is also to be conceived of as a process of obtaining a poetology, is that it reframes the venerable metaphor of the artwork being born from the body of the artist." Gerhard Neumann, *Franz Kafka: Experte der Macht* (Munich: Hanser, 2012), 49.

on *parrhēsia* in contrast to other forms of speaking the truth. The "parrhesiast" opens up an unknown truth for his interlocutor.

> The parrhesiast is not a sage who, when he wants to and against the background of his silence, tells of being and nature (*phusis*) in the name of wisdom. The parrhesiast is not the professor or teacher, the expert who speaks of *tekhnē* in the name of a tradition. So he does not speak of fate, being, or *tekhnē*. Rather, inasmuch as he takes the risk of provoking war with others, rather than solidifying the traditional bond, like the teacher, by [speaking] in his own name and perfectly clearly, [unlike the] prophet who speaks in the name of someone else, [inasmuch as] finally [he tells] the truth of what is in the singular form of individuals and situations, and not the truth of being and the nature of things, the parrhesiast brings into play the true discourse of what the Greeks called *ēthos*.[260]

This short sketch of parrhēsia presents us with many of the moments already discussed, from *conflict* via *truth* to *speaking in one's own name*, that are excluded, at depressingly great expense, by academic discourse.

In the fourth and fifth centuries, Foucault sees "four major modes of veridiction distributed in a kind of rectangle: that of prophecy and fate, that of wisdom and being, that of teaching and *tekhnē*, and that of *parrhēsia* and *ēthos*."[261] The difference between the dominant discourses lies in the way they combine these truth modes: ancient philosophy combines the modalities of parrhesia and wisdom, medieval Christianity combines parrhesia and prophecy, and the discourse of the university, so important for the Middle Ages, brings together wisdom and teaching.

260 Michel Foucault, *The Courage of the Truth (The Government of Self and Others II): Lectures at the Collège de France, 1983–1984*, ed. Frédéric Gros, trans. Graham Burchell (New York: Palgrave Macmillan, 2011), 25 (interpolations by Burchell).
261 Ibid., 28. "If we take up again these four major fundamental modes I have been talking about, we could say that medieval Christianity produced other groupings. Greco-Roman philosophy brought together the modalities of *parrhēsia* and wisdom. It seems to me that in medieval Christianity we see another type of grouping bringing together the prophetic and parrhesiastic modalities." Ibid., 29.

Although Foucault offers no analogous schema for modern thought—"And what about the modern epoch, you may ask? I don't really know. It would no doubt have to be analyzed."[262]—his reflections on the discourse of ancient philosophy are relevant to an ethics of knowledge today. Thinking becomes philosophical by "never posing the question of *alētheia* without at the same time taking up again, with regard to this truth, the question of *politeia* and the question of *ēthos*."[263] Foucault's historical analysis of the connection between the production of truth (*alētheia*), the exercise of (*political*) power, and the articulation of ethical rules are also relevant to a poetics of existence, because they are the backdrop of his much discussed reflections on an aesthetics of existence—the attempt to show "how, through the emergence and foundation of Socratic *parrhēsia*, existence (*bios*) was constituted in Greek thought as an aesthetic object, as an object of aesthetic elaboration and perception: *bios* as a beautiful work."[264] Starting from the central function that reading and writing have in transforming a thinking ego, I want to poeticize Foucault's concept of an aesthetics of existence. For when ethics is not considered as an ethopoietic relation between language and action, an aesthetics of existence is easily misread as the synonym for a struggle for subjectivity and self-representation.

> Poeticizing philosophy and the ethopoietic relationship between language and action.

One decisive advantage of the concept of a *poetics of existence* is that it remedies an innate ignorance proper to the discipline of aesthetics since its beginnings. Aesthetics, according to literary theorist Klaus Weimar, cannot be

262 Ibid.
263 Ibid., 67.
264 He continues: "This opens up an extremely rich historical field," an alternative "history of the stylistics of existence, a history of life as possible beauty. For a long time, this aspect of the history of subjectivity, inasmuch as it constitutes life as the object of an aesthetic form, has, of course, been hidden and over-shadowed by what could be called the history of metaphysics, the history of the *psukhē*, the history of the way in which the ontology of the soul has been founded and established." Ibid., 162.

thought without "the theoretical annihilation of everything that lies 'between' the thinking of the poet and the knowledge of the reader, i.e. of writing, the text, reading. [...] The short-circuiting and amalgamation of reader and poet, and the equivocation in the concept 'sensitive knowledge' that unwillingly testifies to it, are permanently conserved in the name 'aesthetics' (*scientia sensitivae cognitionis*) and can no longer be removed from the name and its use."[265] Another important difference is between aesthetic reflection and poetic recursion, between the capitalist primacy of experience and the (truth-)producing dimension of poetics.[266]

The merit of a *poetics of existence* is precisely that it makes it impossible to confuse the recursive dynamic of writing and living with an aesthetic-reflexive mirroring of the self.[267] "The refoundation of ethics," writes the philosopher Wilhelm Schmid, "results from the critical analysis of power and a diagnosis of the present. It is in the analysis of power, which reveals struggles and conflicts, the conditions of power and dominance, that ethics intervenes. Foucault sees in an ethics of the self the 'urgent, basic, politically indispensible task' today."[268] And Foucault's agonistic ethics is always tied to a true knowledge. His overwriting never exhausts itself in an aesthetic, apolitical, individualist existence but develops from the various conflicts to be settled. Ultimately, every conflict is tied to fulfilling a promise: the production of ethical knowledge always takes place via a (rapid, affective) provocation and a (slow, rational) gathering of conflicts.

> Perhaps it is only our conflicts that have the power to overwrite us with our knowledge.

[265] Klaus Weimar, *Geschichte der deutschen Literaturwissenschaft bis zum Ende des 19. Jahrhunderts* (Paderborn: Wilhelm Fink Verlag, 2003), 72.

[266] Despite Foucault's emphatic concept of experience: "An experience is something from which one emerges transformed." See "Entretien avec Michel Foucault" (1980), in *Dits et écrits, 1954–1988*, vol. 4, *1980–1988*, ed. Daniel Defert and François Ewald (Paris: Gallimard, 1994), 41.

[267] According to Wilhelm Schmid, the "aesthetics of existence" playing itself out for others to see is "an instance of reflection" that is tied, at most, to writing, although there is hardly a trace of the ethopoiesis of writing in the literature on Foucault. See Schmid, *Auf der Suche nach einer neuen Lebenskunst*, 284, 289; on the significance of writing, 309.

[268] Ibid., 79.

Judith Butler has noted that "a certain exercise of disobedience is necessary for the inventive elaboration of the self."[269] Foucault's enduring attraction as a figure, fetishistic author, venerated subject, and metanoetic writer par excellence who has formed himself, in and through writing, into an exemplary existence, also explains how to move from action to being—certainly not simply via critical practice or self-reflective exercise, nor via the production of things or the acquisition of skills. Producing one's self, for me, is a poietic practice that rests on the transformation of having into being. It is an ontological transformation of things and properties. Such an overwriting takes place only when we live up to our conflicts. Or as Deleuze, quoting poet Joë Bousquet, writes: "'Become the man of your misfortunes; learn to embody their perfection and brilliance.' Nothing more can be said, and no more has ever been said: to become worthy of what happens to us, and thus to will and release the event."[270]

A poetic existence is led by the one who, in writing, recursively situates herself differently in the world (localizing myself-here-now). This absolute desire to speak the truth from a different point of view characterizes, as Wilfried Dickhoff and Marcus Steinweg write, "a speculative subject that acknowledges its characteristic excess by setting bounds to it, while at once also acknowledging this demarcation of bounds to be excessively delimited. The emerging autonomy of speculation proves to be the emerging heteronomy of the subject."[271]

I've returned time and again to the claim that the recursive transformation of the writing subject is an ontological transformation that most modern and postmodern theories (of language) are unable to conceptualize. Thus Hayden White, for example, in referring to Barthes, observes something that contradicts the supposedly ineffective (post)modern play of the signifier: "The modernist writer both *acts* and *is acted upon* in the act

[269] Butler, "Critique, Dissent, Disciplinarity," 787.
[270] Gilles Deleuze, *The Logic of Sense*, ed. Constantin V. Boundas, trans. Mark Lester with Charles Stivale (New York: Columbia University Press, 1990), 149.
[271] Dickhoff and Steinweg, "What Is Speculation?"

of writing."[272] Barthes, on the other hand, sees modern literature as linguistically based on a theory of empty signs—an arbitrary language detached from all reference. What we come across here, anchored in the very structure of the aesthetic regime of thinking, is an intrinsic connection between a theory of reflection and a theory of the non-referentiality of language. For me, this connection is untenable in terms of both linguistics and an ontology of language, since it's been responsible for an obsessive focus on reflexivity and non-referentiality, and not just in regard to literary modernism.[273]

What is needed to understand the ethopoietic power of writing is, on the contrary, an "altermodern" ontology of language that changes and develops the achievements of modernism.[274] Rather than relying on the modernist emptying that is operated through language and focused on the writer who is said to exist only in language, I bank on an altermodern or transmodern approach: the production of a truth that takes place in writing, the production of an ethos that the one writing can achieve soonest via reading as overwriting. Poeticizing *philosophy* thus aims for a *positivization* opposed to the modern-aesthetic obsession with emptying out and negativity. Signs are not arbitrary but contingent. That is why language refers to the world; signs are not detached from one another. Language, furthermore, is not connected with thinking via reflection but recursively connects both—world and thinking—with an I.

One author frequently cited in addressing the question of the ethical dimensions of philosophical writing is Wittgenstein. Philosophy, Wittgenstein writes, is "working on oneself,"[275] but he also writes that "philosophy ought to only be written like *poetry*."[276]

272 "The modernist writer both *acts* and is *acted upon* in the act of writing, but not in the way suggested by the reflexive form of an active verb ('I write myself'). The writer does not 'write herself' in such a way that her 'written self' could be separated from her 'writing self.' It is only *in* writing and *by* writing that the writer can be said to exist at all. The 'writer' is what exists in the interior of the activity of 'writing.'" Hayden White, "Writing in the Middle Voice," in *The Fiction of Narrative: Essays on History, Literature, and Theory, 1957–2007*, ed. Robert Doran (Baltimore: Johns Hopkins University Press, 2010), 257 (my emphases).
273 On this point, see Elisabeth Leiss, *Sprachphilosophie* (Berlin: De Gruyter, 2009).
274 On the concept of the altermodern, see Armen Avanessian and Anke Hennig, *Present Tense: A Poetics*, trans. Nils F. Schott with Daniel Hendrickson (London: Bloomsbury, 2015).
275 "As is frequently the case with work in architecture, work on philosophy is actually closer to working on oneself. On one's own understanding. On the way one sees things. (And on what one demands of them.)" Ludwig Wittgenstein, *The Big Typescript: TS 213*, ed. and trans. C. Grant Luckhardt and Maximilian A. E. Aue (Malden, MA: Blackwell, 2013), 300e.
276 Ludwig Wittgenstein, *Culture and Value*, trans. Peter Winch (Chicago: University of Chicago Press, 1984), 24 (translation modified).

Granting something a poetic quality does not mean making it aesthetic, rhetorical, or stylized. In the case of writing in the humanities, the etho- and autopoiesis of the one writing takes place not simply in dealing with certain topics but via what Anke and I have described as *existentializing one's method*.[277] To make a method entirely one's own means giving it an ethical meaning for oneself: producing and presenting reality to oneself and coping with it as a changed reality. Analogous to the semiotic triad *signifier—signified—referent*, this implies passing through the entire ontological triad *thinking—I—world*; it is as a result of this passage that the parts have transformed into a new whole and that I, thinking differently or anew, find myself in a changed reality.

The ethics of knowledge and the poetics of existence cross at the point where a method is made existential and the site of the self is shifted. But how to write, and in which genre? Which form of writing correlates with the attempt at ethical localization? This tactical procedure, a genealogical retelling, is diametrically opposed to thinking in terms of strategic positions in the history of philosophy (always with an eye on developments in the job market), a thinking whose seamless translation of texts from concepts into a politics of discourse has such unproductive and destructive consequences in academic philosophy. There is no better way of banning thinking from the institution. Reducing the texts one reads to strategic positions to be taken and front lines to be established—that, in short, is a program for ruining (speculative) thinking in philosophy. And it has been disastrous since long before the obsessive handing down of the aesthetic partition of the sensual and the critical partition of thinking came in to act as the discourse police, trying to prohibit all speculation. In this respect, too, this book is a tactical one (based on the research platform Speculative Poetics). It is borne by concrete manipulations based on "situated knowledges" (Haraway) of the dominant aesthetic power strategies and the academic field they came from (and helped to leave behind). It is written as an attempt to distort the "many-faceted mirror" de Certeau speaks of.

De Certeau situates such narratives that possess a "knowledge that is unaware of itself" between theory and practice; yet what he understands (with reference to

277 Avanessian and Hennig, *Metanoia*.

POETIC EXISTENCE

Kant's reflections on tact) as a primitive kind of reading and speaking, and as expressing an "aestheticization of the knowledge implied by know-how,"[278] is what I have claimed for a poetics of academic reading and writing. De Certeau writes, "The narrativizing of practices is a textual 'way of operating' having its own procedures and tactics."[279] That is why we may speak here of *tactical thinking*, in contrast, for example, to goal-oriented thinking. To have a different future, to live in a different present, a different past has to be narrated. That is why I have amused myself by writing this book, a polemic genealogy of academic morality, whose main characteristic parallels what Foucault describes here: "The final trait of effective history is its affirmation of a perspectival knowledge [*savoir*]. Historians take unusual pains to erase the elements in their work which reveal their grounding in a particular time and place, their preferences in a controversy—the unavoidable obstacles of their passion."[280]

The tactical strength of this kind of genealogical thinking is measured, first, by whether it succeeds in understanding narration not simply as coping with contingency— the capacity usually attributed to "homo narrans" (Walter Fisher) or the "storytelling animal" (Alasdair MacIntyre)—but, in literary scholar Albrecht Koschorke's terms, as a capacity to deconstruct or dismantle meaning and referentiality as hegemonic constraints.[281] Second, a poietic demand derives from this awareness of contingency. Narrations are to give (written) signifiers different meanings and references. A philosophy becomes ethically true when it attempts to construct a deictic *I—here—now* origin, when it situates the subject in concrete being, in space and time.

> Is there such a thing as deictic skill in thinking?

278 De Certeau, *Practice of Everyday Life*, 70.
279 Ibid., 78.
280 Michel Foucault, "Nietzsche, Genealogy, History," trans. Donald F. Brouchard and Sherry Simon, in *Aesthetics, Method, and Epistemology*, ed. James D. Faubion, vol. 2, *Essential Works of Foucault, 1954–1984* (New York: New Press, 1997), 382.
281 See Albrecht Koschorke, *Wahrheit und Erfindung: Grundzüge einer Allgemeinen Erzähltheorie* (Frankfurt am Main: Fischer, 2012); and also Michael Scheffel, "Im Dickicht von Kultur und Narration," *Diegesis* 2, no. 1 (2013), http://www.diegesis.uni-wuppertal.de/index.php/diegesis/article/view/120/131.

This genealogical endeavor concerns the ethical ramifications of a theory of fiction, understood here as a shifting reference (local, temporal, personal) to this, our world.[282] In the past, the construction of a calamitous antagonism between imaginary literature and argumentative theory obscured the philosophical potential of (a theory of) deixis qua shifts operated through language. This left as an alternative either the vague postmodern erasure of the difference between literature and theory or an ignorant insistence on entrenched positions. Given the fundamental deictic capacity of language, I understand these alternatives as two forms of poetic writing—literary fiction and poetic philosophy. Literary fiction results from readers entering the imaginary world of the protagonist. Philosophy's (much rarer) power of transformation is entirely different: there, the world of a new thinking emerges thanks to assuming a different position in the world.

> From my new perspective I now have a systematically different view of the world.

The narrative tactics that sharpen the insight into the foreignness of one's "own" production, the nonsite of the process, are not the tactics of literary fiction. Quite the contrary: they guarantee that the writer does not succumb to the "fiction of a place of his or her own" or assume a fixed position, but that he or she instead remains aware of the heterogeneity and contingency of the narrations produced or poeticized. Bringing a method into existence is a consolidation—it is the possibility of localizing oneself by writing and implementing one's projects via abduction. To become what you have understood through speculation means taking responsibility, emphatically, for new insights and, above all, new rules you have invented.[283] It is also an overwriting.

282 On this point, see the fiction-theory approach Anke and I develop in *Present Tense*.
283 See the chapter "Poeticizing Philosophy," in Avanessian and Hennig, *Metanoia*: "This is also the point where the transition from research to authorship takes place, because the rule has been invented by the researcher as an author. New rules can only find their reason through us: the difference between the difference we produce and ourselves as their interpretants, then, is minimal. The role of abduction thus concerns both the referentializing of meaning and an othering of the subject. The risk this entails is not negligible."

> My object has reinvented me. Now every part of reality must be understood differently—not for subjective but for methodological reasons.

Furthermore, an ethics of knowledge aware of conflicts—an agonistic poetics of existence—is determined by what Stengers, speaking of her method of "speculative constructivism," has called an experimental "pedagogy of the concept."[284] Conceptual experiments help us to (philosophically) *resist the present* or, to take up Stenger's definition of speculation, *open up a possibility in the now*: "We need to present ourselves as indebted to something we call concepts, because it is only through encountering the efficaciousness of concepts, through experimenting with the witch flight they produce, that we may become philosophers."[285] Experimenting with concepts far exceeds the production of neologisms; it has a *poetonomic* function (about which Anke, I hope, will soon write a book). The encounter, or confrontation, with the concept takes place only in a speculative experiment, in the "witch flight" of speculation, when writing "puts the writer in debt to what makes him or her write."[286] Only in this way does the experiment acquire the character of an experience. Speculative poetics implies generating experience that provokes change.

> Writing oneself, writing what was previously not known and thereby writing something different, writing differently, overwriting oneself.

What Stengers says about the "experimental knot," which ties "a matter of fact to a scientific function,"[287] correlates with the recursive passage through semiotics. A

284 Stengers, "Deleuze and Guattari's Last Enigmatic Message," 152, 162–64.
285 Ibid., 164.
286 Ibid.
287 Ibid., 157.

scientific (academic) existence acquires a poetic character when it creates for itself, in writing recursively, a new ethos. This circular movement is of decisive importance for dealing successfully with the fundamental trap that threatens every speculative love for the truth: "Deleuze considered the price philosophy paid when it was associated with the triple ideals, all of which imply judgement and may enter into the strategic alliance against opinion: contemplation, reflection, and communication."[288] I have tried to position alternatives to all three of these ideals. In the ethopoiesis of knowledge, speculation takes the place of contemplation. Instead of reflection, I have advocated the transformative dimension of recursion. And in the place of dialogic communication, I have outlined the alternative setting of writing with the other (in a pair, or with one's superego) that confuses the psychic (ego) entities.

"Critical theoretical discourse," Boris Groys tells us, "asks questions concerning the meaning of knowledge. What does it mean that I have a certain new piece of knowledge? How has this new knowledge transformed me, how has it influenced my general attitude towards the world? How has this knowledge changed my personality, modified my way of life? To answer these questions one has to perform theory."[289] The metanoetic claim of philosophy (not theory), a love of truth that can sometimes be very naive, aims for conversion. We can gauge the reality of change by whether the past (the past familiar to us up until then) has become unintelligible, has become a different past. Analogous to this first criterion, which concerns the world as a whole, the subject, too, has to ask itself to what extent it is undergoing an othering—to what extent it takes responsibility for what its signifiers refer to. And third, the poetic production of truth concerns the objects of theory as well.

Our desire for an absolute has us seeking to enlarge the conditions and possibilities of philosophy. This is to be understood exclusively as poiesis, as a production of truth, not as a mere expansion of knowledge by applying what is already established. The ethos of knowledge tells us how to act; namely, in such a way that the possibilities of knowledge are

[288] Ibid., 162.
[289] Boris Groys, "Under the Gaze of Theory," *e-flux journal*, no. 35 (May 2012), http://www.e-flux.com/journal/under-the-gaze-of-theory/.

enlarged—once again, a strictly recursive procedure. In this context, knowledge is an ideal object because it cannot be detached from the subject. True knowledge is not simply an acquired object; both are the result of a poiesis. This experimental process of creation concerns the constellation *subject—object—world*. Only as, and in, this triadic movement does ethopoietic overwriting take place, which for the subject is irreversibly ethical. It is an ultimate underwriting.

Armen Avanessian is a philosopher and political theorist. From 2007 to 2014 he taught at the Freie Universität Berlin, and he has been a visiting fellow in the German department at both Columbia University and Yale University. He currently teaches at art academies in Europe and the United States. Avanessian is the founder of the bilingual research platform www.spekulative-poetik.de and editor at large at Merve, Berlin. His publications include *Miamification* (Merve, 2017); *Irony and the Logic of Modernity* (De Gruyter, 2015); *Present Tense: A Poetics*, with Anke Hennig (Bloomsbury, 2015); *Speculative Drawing*, with Andreas Töpfer (Sternberg Press, 2014); and the forthcoming *Metanoia: A Speculative Ontology of Language, Thinking, and the Brain*, with Anke Hennig (Bloomsbury, 2017).

OVERWRITE
Ethics of Knowledge—
Poetics of Existence

By Armen Avanessian

Published by
Sternberg Press

Translation
Nils F. Schott

Editor
Bernd Klöckener

Managing editor
Max Bach

Proofreading
Mark Soo

Art direction & design
HelloMe

Printing
BUD Potsdam

ISBN 978-3-95679-114-7

© 2017 Armen Avanessian,
Sternberg Press
All rights reserved, including
the right of reproduction in
whole or in part in any form.

Sternberg Press
Caroline Schneider
Karl-Marx-Allee 78
D-10243 Berlin
www.sternberg-press.com